How to Arc.
Family Photos

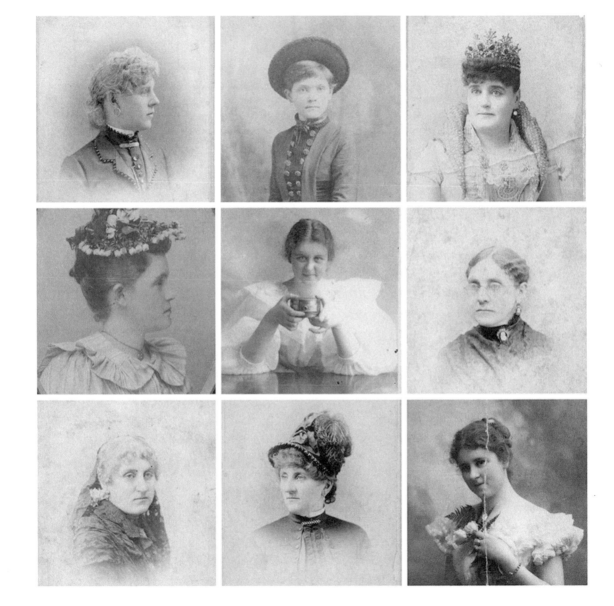

How to Archive
Family Photos

A Step-by-Step Guide to Organize
and Share Your Photos Digitally

Denise May Levenick
The Family Curator

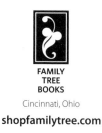

**FAMILY
TREE
BOOKS**

Cincinnati, Ohio

shopfamilytree.com

Contents

PART 1: **Organize** · 9

Discover the essential tools and skills for working with digital images. Use the Digital Photo & Video Storage Worksheet and Getting Started Checklist to prepare for organizing your photo collection.

Unsure what to do with all the images on your various digital devices? This chapter focuses on how you can transfer images to a central digital library using an easy-to-remember routine.

Photo-editing and photo-management software can help you automate your digital photo-organization routines. Learn about the software options available and key features to consider to help you manage your digital photo collection.

Photo websites for photo sharing, publishing, creating gifts, and storing a backup of your digital image files are abundant. This chapter will introduce you to some of the best photo websites and provide you with a Cloud Storage Service Comparison Worksheet to evaluate your online photo-storage options.

Put all the organization advice and information together. This chapter presents step-by-step workflows you can use to establish a digital photo-organizing routine.

PART 2: **Digitize** · 93

Remember the days of 35mm film and double prints? Inherit a collection of 1900s ancestor photos? Digitizing those old family photographs is a great way to preserve them for future generations. Learn tips and use the Heirloom Photo Inventory & Digitizing Checklist for deciding which images to digitize.

Digitizing photo collections takes time. This chapter guides you through creating a plan, setting up your computer, and choosing digital storage equipment to efficiently digitize and organize your photos.

Introduction

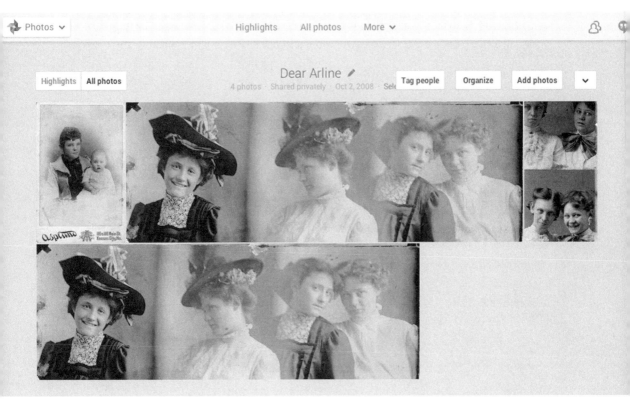

The computer hard drive has become the photo shoebox of the twenty-first century. We toss digital files into our computers (or smartphone memory) much like our parents tossed snapshots into cardboard shoeboxes. Our computer and mobile devices are soon cluttered with the digital folder equivalent of old photo-processing envelopes labeled with scrawled memos like "Dad's 80th Birthday" or "Hawaii Vacation." Sometimes the photos make their way into albums and scrapbooks, but too often the digital shoeboxes—like their cardboard cousins—fill with more photos and are stashed away to be organized "one day."

I was fortunate to inherit dozens of boxes of old family photos collected by several generations on both sides of my family tree. Although only a handful of tintypes and daguerreotypes survived, each successive generation added new photos snapped with the technology of their time to create a family photo timeline that followed the growth and popularity of personal photography, from *cartes de visite* and cabinet cards to Brownie snapshots, Polaroid prints, Kodachrome slides, and home movies.

By the time my grandmother was a young woman in 1905, she was already snapping photos with a Brownie box camera and pasting prints on black album pages. Shoeboxes bulging with black-and-white prints and negatives bear witness to her fascination with photography. My mom and aunt followed Grandma's lead with their own photos, filling more shoeboxes with a jumble of albums, slides, movies, and loose prints that I inherited when they passed away. Now I'm looking at my own life in fading Fujicolor and realizing that printed images are only a hint of the digital deluge headed our way. More than 880 billion photos were snapped in 2014, according to Yahoo!, most of them digital pictures taken by smartphone cameras. My grandmother would have loved it!

Coincidentally, the same year I inherited my grandmother's trunk filled with family treasures, I also brought home my first digital camera—a little Nikon Coolpix that snapped 1.9 megapixel images visible almost instantly on the camera's tiny image viewer. As a genealogist and the designated "keeper of the stuff" for my family's heirloom photos and documents, my digital shoeboxes were already bursting with scanned images. It didn't take thousands of new photos for me to realize that I needed a simple yet comprehensive image management system to keep up with new digital snapshots and scanned images of my family photo collection.

In my book *How to Archive Family Keepsakes*, I shared my system for preserving and organizing all kinds of inherited family treasures, and basic steps for digitizing heirloom photos and documents. But as I wrote those chapters, I knew that scanning old photos was only part of the problem facing today's family historians. It's a golden era for genealogy that allows us to

- ✴ access original records through digitized editions available online.
- ✴ preserve one-of-a-kind photos and documents by scanning heirlooms with affordable home equipment.
- ✴ share stories, pedigrees, and research through e-mail and websites.
- ✴ create our own digital legacy with new digital photos, videos, and audio.

But all of these digital files are meaningless without a way to tap into the stories they hold and share those stories with others. How many photos are "somewhere" in your digital library, waiting until you can find them again? How many digital shoeboxes filled with family snapshots do you have stashed on your smartphone, tablet, e-reader, and computer waiting to be organized and enjoyed? Isn't it time to get those images out of the digital shoebox and into your hands to be enjoyed and shared with family and friends?

HOW TO USE THIS BOOK

This book shares practical strategies for conquering digital image clutter and confusion so you can enjoy, preserve, and share your family photos and stories. In the same way that genealogists start with the present generation and work backward one branch of the family tree at a time, this book begins with the present to help you master your current digital clutter before you tackle the previous generations of photographs.

You will find techniques to import photos from multiple devices, locations, and photographers. If you are working with a large photo collection or digitizing project, you'll discover time-saving tips for working with image batches. Family historians will learn ways to organize scanned images of heirloom original documents and photos, and digitized genealogy research materials. And if you're looking for something new to do with your digital images, you'll find twenty-five creative projects featuring all kinds of digital images.

Feel free to use this book in the way that suits your present needs. Read it from start to finish, or jump in for ideas to help with your current digital challenge.

PART 1: ORGANIZE includes basic information for working with present-day digital photos and heirloom scanned images, including how to set up your computer, digital storage, and file-naming system. Refer to this section for help working with contemporary or heirloom digital files. You'll also find an overall strategy to help you organize and archive the everyday family photos captured today with smartphone and digital cameras.

PART 2: DIGITIZE highlights best practices for digitizing and preserving heirloom original photos and documents of all shapes and sizes.

PART 3: CREATE offers step-by-step instructions and project ideas to get you started using your digital images by creating unique photo gifts, family history books, calendars, and more.

YOUR PHOTOS, YOUR WAY

If you've read articles and books about organizing just about anything, you've probably heard a variation on the theme, "the best organizational system is whatever works best for you." Unfortunately, that doesn't help much when you've already discovered that "whatever" is not working very well, and you really need something different. In this book, I'm not going to tell you what you *should* do with your digital photos, but I will share with you the strategies I've found to work for me and for others. I hope you'll discover the tools you need to build your own photo-management system, one that truly does work best for you.

Denise May Levenick
Pasadena, California

Organize

The phenomenal growth of digital photography is a mixed blessing for family memories. There's no extra cost in snapping multiple images in the effort to capture the "perfect shot." Editing tools can erase blemishes, crop out clutter, and adjust poor exposure. Images are easily shared online and published in digital photo creations. Unfortunately, organizing and backing up photos isn't nearly as fun as taking pictures.

We're taking more pictures than ever before, especially with smartphone cameras that have largely replaced point-and-shoot models. But unlike our digital cameras with a removable memory card, the pictures snapped on our cellphones are saved to device memory where they accumulate until we move them or lose them.

Do any of these situations sound familiar?

- You have digital images on your smartphone, tablet, computer, flash drives, SD cards, and external hard drives, but you can't find the picture you want.
- You have duplicate images scattered across your devices and are running low on memory.
- Your photos never seem to be the right size or resolution for the photo book you're trying to create.
- You know you should back up your photos, but you aren't sure how.
- You organized all your photos in file folders, but it takes forever to find the pictures you want.
- You don't know how to manage edited and original versions of the same photo.

Part 1 of this book outlines a plan to organize and manage your ever-growing digital photo collection. The concepts will be helpful to anyone who wants more control and confidence in preserving their digital images, whether the images were snapped last week or in the last century.

If you have thousands of legacy digital images, either from your camera or from scanned heirloom family photos, I urge you to postpone adding these files to your new digital management scheme immediately. Instead, set up your system and work with it until you are comfortable with the tasks and have refined any rough spots in the workflow. Start by adding your next set of new digital images, whether they are taken on your smartphone, digital camera, or scan-

ner. Practice each step in the workflow and tweak whatever isn't working for you. As you have time, go back and add old image files to the new collection. And don't be too hard on yourself if you don't get to those old photos right away. Look to the future and aim to manage your photo collection forward from your next digital image.

I'll start with providing you the basic information you'll need to know to assess your digital storage needs, select storage devices, set up your computer folder system, and establish file naming and metadata strategies. From there, I'll introduce you to the workflow I've used for years and share tips and techniques to help you master your own digital photo collection.

It's a good idea to read through the chapters in this section before making any decisions or changes to your present photo system. Creating a plan to manage all of your digital photos may sound complicated, but it doesn't have to be. The information and worksheets in this book will help you develop and practice your new photo organization system until it's as natural as brushing your teeth.

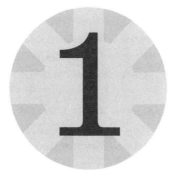

❖ Digital Imaging Basics ❖

For past generations of shutterbugs, photography always involved a financial investment. The inexpensive Brownie box camera brought personal photography within reach of most families, but film and processing were an ongoing expense.

Often one roll of film would be used for months, recording special events and holidays, two or three photos at a time. Each image had a cost, and frugal Americans who lived through wartime rationing, the Great Depression, and the Recession made every image count. Eventually the film counter clicked to zero, indicating that all the film had been exposed, and the roll was dropped off for processing and printing at the local camera shop or drugstore. Some people saved money by ordering processing only and selected individual prints directly from the negatives. Amateur photographers often set up home darkrooms to process and print their own film.

Our attitude toward photo prints began to change in the 1980s and 1990s with the introduction of low-cost "double prints" made possible by standardized automatic photo-printing equipment. New technology brought prices down to pennies per 4x6-inch print, and vendor competition introduced triple and quad print discounts. For the first time in the history of consumer photography, family photographers were taking and printing more and more photos, both good and bad, and selecting the "keepers" after printing. Instead of one roll of film lasting weeks or months, a family photographer might use several rolls of film to document a single

birthday party. This print boom lasted only until digital photography caught on, when the snap-happy mindset was a perfect fit for digital cameras.

Today's photographer needs only a digital camera or smartphone to capture thousands of images. The minimal cost per image can make us careless about preserving priceless memories until a smartphone is lost, a computer crashes, or we accidentally hit the Delete button.

In this chapter, I present the essential tools and skills for working with and organizing your digital images, including how to set up your camera and other capture devices to work with your computer and storage media.

DO YOU KNOW WHERE YOUR PHOTOS ARE?

The first step in organizing your digital photos is knowing where they are. After all, you can't organize your digital files if you don't know where to find them. You may have photos scattered across devices and storage media—from your smartphone and SD card to your tablet and your computer. It would be easy to manage photos across devices if we could just drag and drop files from one device to another, but Android doesn't play well with Apple's iOS, and your mobile devices might not be on speaking terms with your computer. It's complicated.

But it doesn't have to be difficult. Organizing your digital life will be easier if you put everything in one master location. This will be a master file for all your digital images, including:

- **new photos:** pictures of family and friends taken with your camera or smartphone
- **old photos:** family keepsake photos digitized with your scanner or camera
- **research images:** genealogy research documents you have scanned or photographed, or you have downloaded from the Internet
- **work images:** business and work-related images

Once you've set it up, you'll quickly see the benefits of collecting and managing your photos in one master location:

- one place to access images
- a consistent file structure that serves as a model for future image imports
- easier backups
- easier migration when you upgrade your computer or devices
- an intuitive, logical system that others can understand

Keep in mind that the best storage location option may be the simplest. For example, a large-capacity external hard drive you can use with a laptop or desktop and easily use with new equipment when necessary may be your best choice. My personal digital photo storage setup includes three external hard drives:

- **Photo Library:** This 1 terabyte (TB) external hard drive is attached to my desktop Mac computer at all times and stores my working image collection—the files I use on a daily basis. I think of it like a library (hence the name) where I "check out" images for viewing and editing. This is my Master Storage Location.

- **Image Vault:** I attach this 1TB external hard drive to my computer at the end of an editing session so all of my work is backed up from the Photo Library to the Image Vault using Carbon Copy Cloner backup software. I don't access my images every day and like the security of knowing this storage device can't be damaged by power surges if it's off-line.
- **Photo Archive:** This 1TB external hard drive comes out of my fireproof safe for regular monthly backups of my entire image collection. Again, I use Carbon Copy Cloner to handle the backup, and I keep this drive at home so it's easy to maintain my backup schedule. I also burn photo folders to archival DVDs to make an archival preservation set. And I keep a copy of my photos on my Dropbox **<www.dropbox.com>** cloud storage account. With multiple copies, there's less risk of images being lost.

Your decision on where to store your digital images—on your computer hard drive, an external hard drive, in the cloud, or a combination of all three—depends on three main factors:
- the size of your current and old photo collection
- the size of your projected digital collection
- your available computer hard drive space

How Much Storage Do You Need?

You may already have a good idea of where you want to store your photos, but determining your current and future collection's storage space needs can be a challenge. If you aren't sure how much storage you'll need, or want to know that you've accounted for all digital files before purchasing equipment, use the Digital Photo & Video Storage Worksheet in this chapter. This worksheet provides a quick overview for assessing your storage space needs and will help you determine if your current computer can store your digital collection or what hardware you may need to purchase.

Ultimately, when choosing a central storage location for your digital photo collection, err on the side of choosing a location with too much storage space rather than too little. Cost per gigabyte continues to drop, making it cost-effective to purchase 1 or 2TB drives rather than smaller models. If you do run out of space, the good news is that it's relatively easy to migrate a well-organized photo collection to new higher-capacity hardware. Use your answers to the Digital Photo & Video Storage Worksheet as a guide to your present and future needs and make your best guess.

Where Should You Store Your Photo Collection?

You'll want to consider these storage location options for your Master Storage Location:

DESKTOP COMPUTER: If you have plenty of room on your computer hard drive for your growing image library, designate your desktop computer as your Master Storage Location. If you do run out of space, you can add an external hard drive at a later time.

DIGITAL PHOTO & VIDEO STORAGE WORKSHEET

Consider your long-term digital photo and video storage needs by asking yourself the following questions. Circle the best answer for each question to form an overall picture of your digital storage needs.

PHOTOS			
Questions	Minimal	Average	Large
How many photos do you take each year? If you have photos in folders organized by year, check the total for two or three years to get an annual average.	fewer than 250	250 to 1,000	more than 1,000
What size are most photos snapped by your camera? Open a file and skim the image file information for a rough idea. The file size may be measured in kilobytes (KB) or megabytes (MB).	under 10MB	10 to 12 MB	more than 12MB
What format do you shoot with your camera? Most mobile devices and cameras take JPG images, resulting in a moderate file size. If you use a digital SLR model, you may be shooting RAW format, which creates very large files.	JPG	JPG	RAW + JPG
How many old family photos will you scan this year? Check folders of scanned images to gauge annual averages for future storage needs.	fewer than 250	250 to 1,000	more than 1,000
What file format do you use for scanning photos? Images scanned in JPG will be much smaller than archival TIFF files.	compressed JPG	uncompressed JPG	TIFF
How many negatives and slides will you scan this year? Film (negatives and slides) should be scanned as high-resolution TIFF files to capture the fine detail in the image, resulting in large archival files.	fewer than 50	51 to 200	more than 200
How many digital images will you scan and photograph in libraries and archives this year? Numerous research trips can add considerable bulk to your digital collection.	fewer than 250	250 to 1,000	more than 1,000
How many digital images will you download while researching online this year? Online research and image downloads can result in a large number of image files, although these are usually smaller PDF or compressed JPG files.	fewer than 250	250 to 1,000	more than 1,000

DIGITAL PHOTO & VIDEO STORAGE WORKSHEET

VIDEOS			
Questions	**Minimal**	**Average**	**Large**
How many old film movies will you digitize this year? If you are archiving a large number of old home movies, you will need suitable storage space.	none	about 1 to 5	more than 5
How many videos did you make this year? Video files are much larger than photo images. You'll need additional space if you take lots of videos. Large quantities may need additional storage space.	fewer than 15	15 to 50	more than 50
How many shared videos and photos did you save this year? Don't forget videos and photos shared with you. Videos downloaded from e-mails, cloud storage, social media, and websites can add to your storage needs but should be archived with your other files.	fewer than 15	15 to 50	more than 50
FINAL QUESTION			
How much space is currently available on your computer hard drive? Open your computer info to check free hard drive space and view how much is currently being used by your digital files.			

Analyzing Your Answers

Once you complete the Digital Photo & Video Storage Worksheet, ask yourself: In what columns do most of your answers fall?

✖ If most of your answers are in the first column, you have minimal storage needs.

✖ If most of your answers are in the second column, you have average storage needs.

✖ If most of your answers are in the third column, you have high storage needs.

Digital Storage Tips

✖ Choose one Master Storage Location for your collection.

✖ Storing your master digital images on your computer is fine for small to average size digital image collections; an external hard drive is a good choice for large or growing media collections.

LAPTOP: If you use a laptop exclusively, plan to purchase at lease one external hard drive to hold your image collection. Don't rely on your laptop hard drive for long-term photo storage: Hard drives fail, laptops get dropped or stolen, and the storage space is often too small. Instead, use external hard drives or cloud servers to help manage the digital load.

LAPTOP AND DESKTOP COMBINATION: If you use both a laptop and desktop computer, chances are you have images on both pieces of equipment. To consolidate your photo collection in one place, choose either the desktop or an external hard drive. Store your photos on equipment that is the least susceptible to damage or loss with the largest hard drive capacity available, typically a stationary desktop computer. An external drive has the benefit of portability between both devices.

EXTERNAL HARD DRIVE: Your laptop or desktop computer's built-in hard drive has a finite amount of storage space, but an external hard drive can add terabytes of storage without upgrading your computer. If you already use an external drive as a backup device, consider adding a second external drive for photos.

HOME SERVER: If you are tech-savvy, you could even set up a home server or Network-Attached Storage (NAS) to hold images for everyone in the household.

Decide now where you will store your master file of your digital images. Will you maintain your Photo Library on your computer hard drive, on an external hard drive, in the cloud, or a combination? Storing images on your computer is best for small to average size digital image collections; an external hard drive is a good choice for large or growing media collections.

EQUIPMENT FOR DIGITAL PHOTO STORAGE

Once you determine the space you'll need to store your master digital images file, you'll need to purchase the hardware and set up your devices and storage to work together so your images can be moved to a new permanent storage location.

Here are two important pieces of equipment you may need:

EXTERNAL HARD DRIVE: Most external hard drives are simple plug-and-play devices that work with any laptop or desktop computer. Follow the manufacturer's instructions for connecting the device to your computer. A boxy book-shaped external hard drive with its own power supply makes the drive stable on a desktop surface and often offers higher-capacity storage than a smaller portable drive. If desk or office space is a consideration or you need portable storage, look at portable high-capacity drives. Some models include a protective sleeve that can be helpful when traveling.

MEMORY CARD READER: Although digital cameras often include a camera-to-computer cable with software and instructions for moving images, it's much faster and easier to use a stand-alone card reader or a card reader built into your computer or home printer. Plus, you don't have to use your camera power or worry about the camera shutting off during transfer when you use a card reader. Card readers are inexpensive and come in several configurations; some accommodate multiple cards such as SD, microSD, and CompactFlash cards. Look for a USB 2.0/3.0 interface for high-speed transfer.

Many desktop and laptop computers now offer an integrated SD card slot, and many home office printers also have a built-in card reader slot. If your equipment already has a built-in card reader, you may not need additional hardware.

And remember: In addition to storing your files in your Master Storage Location, you'll need to think about backing up those files as well (but we'll get to that later in this chapter).

FILE NAMING

The key to organizing your Photo Library is using a simple and logical system. That system starts with digital photo file names. I recommend using short, meaningful file names that don't need a key to abbreviations.

Use Consistent File Names

Long, complicated file-naming schemes are difficult to maintain and cumbersome to use. The end of the name may be truncated or cut off in your computer folder view or printout. Plus, more words provide more opportunities for misspellings and inconsistency. As you develop your personal file-naming scheme, create a File-Naming Cheat Sheet as a gentle reminder to help you maintain consistency between work sessions.

As you import photos to your Photo Library, either manually or with the aid of photo-management software, take time to consistently name new files. Use these standard file-naming conventions recommended by document records agencies:

KEEP FILE NAMES SHORT. Operating systems now allow long file names, but when files are uploaded to the Internet, a long name can make the URL (aka Web address) even longer. If necessary, use standard two-letter abbreviations for states and months. Be consistent in using any abbreviated family surnames.

USE UNIQUE FILE NAMES. It is essential to maintain individual unique names for photo files. Your camera assigns a unique number to each image that remains permanently embedded, even if you rename the visible file name. But that won't help you select between two photos with the identical name: *davidbirthday2013*. Don't rely on folder names to help identify files, either. For example: If you set up folders named 2013 Thanksgiving and 2014 Thanksgiving, but each includes a photo named *grandpa-carving-turkey.jpg*, the file name doesn't provide a

FILE-NAMING CHEAT SHEET

» FIVE FILE-NAMING CONVENTIONS TO REMEMBER

1. Short
2. Unique
3. No special characters
4. Underscores and dashes
5. Consistently formatted dates

MY FILE-NAMING STYLE	
For dates	
For family photos	
For heirloom photos	
For scanned images	

clue to when or where. It's much better to use file names such as *2013_grandpa-turkey.jpg* and *2014_grandpa-turkey.jpg*.

AVOID SPECIAL CHARACTERS. Special characters create confusing and difficult-to-read file names. And most computer operating systems do not permit certain characters in file names, including \ / | { } () < > : ; * % @ and #.

USE UNDERSCORES AND DASHES. Punctuation and spaces have a special purpose when used in a file name. Periods identify the beginning of a file extension. Spaces become %20 when uploaded to a website. Slashes divide file folder locations. Instead of slashes, periods, and spaces, use underscores and dashes to separate information in your file names.

FORMAT DATES CONSISTENTLY. Choose a date scheme and stick with it. YYYY_MM_DD will sort files in year, month, and date order. MM_DD_YYYY sorts by month, date, and year.

Consider Different File Format and Document Types

Genealogists work with many different kinds of files: photos, scanned images, documents, PDF reference files, and more. I've learned that I don't necessarily need the same file name structure for each document, but I do try be consistent with each kind of file.

SCANNED DIGITAL IMAGES AND IMPORTED DIGITAL IMAGES: These files are typically TIFF scanned files, PDFs, or JPG images downloaded from the Internet or photographed for research. You'll want to find these files quickly and easily. My general file-naming scheme has four parts—name, date, place, and item—each separated by an underscore, plus the file extension. I use a dash to separate words within each part such as *smith-john_19240315_co-pueblo_theater_edit.jpg*. This file name has the following parts:

* surname-first name
* date (YYYYMMDD)
* place (from largest to smallest with two-letter abbreviation used for states)
* item

I prefer to use all lowercase characters and add version information at the end of the file name. I keep file names short and consistent. This file-naming scheme is echoed in all my computer files, although I may not use each part of the file name.

FAMILY SNAPSHOTS AND VIDEOS: I enjoy snapping photos and videos of family and friends at home and on my travels. These photos don't need extensive informational file names. I take advantage of the batch-naming function of my Adobe Lightroom and iPhoto software to rename the photos as they are imported to my computer. The software gives each file a new name and sequential number:

* *2010_david_bday-01.jpg*
* *2010_david_bday-02.jpg*

NOTES AND REPORT DOCUMENTS: This type of document might include spreadsheets, charts, genealogy research notes, or timelines. I don't need the full date and location information used in other files, so my file names for these documents look like this:

* *smith-john_research-notes.doc*
* *smith-john_military-timeline.doc*

HEIRLOOM ORIGINAL PHOTOS AND DOCUMENTS: I was fortunate to inherit a large collection of photos, documents, and correspondence from my maternal grandmother. Instead of individually naming each file, I've chosen to manage the collection using a label that indicates the series and item number. My scanner provides the unique file name, and when I transcribe or examine the item further, I enter identifying information in the metadata fields for title, caption, keywords, and so on. These file names may appear as:

* *AAK_P00012.tif*
* *AAK_OP0009.tif*

This system encourages me to move forward scanning and archiving the original material without the need to stop and transcribe information for a file name. I can work directly from the scanned image to study the source, and the originals are safely preserved in archival storage folders and boxes. My book *How to Archive Family Keepsakes* includes more popular file-naming strategies for genealogists.

How to Manage File Variations

Photo image files are likely to create more versions and derivatives than typical document files. With documents it's common to use *v01*, *v02*, or *v03* to indicate revised editions. For digital images, you can use the Save As command to create a new file after editing or changing a JPG photo. Avoid using vague names such as old, new, or revised. You may have several new versions by the time you're finished editing. Instead use *editv01*, *editv02*, *editv03* to show the version number. Save the short label *edit* for the final version and delete other copies if you wish.

If you're optimizing your images for use on multiple platforms, use an abbreviation at the end of the file name to indicate the purpose: Web, print, or e-mail. For example: *2013_grandpa-turkey-web.jpg* or *2013_grandpa-turkey-print.jpg*.

Always use standard file extensions such as TIFF, JPG, or PSD when saving files. These file extensions help differentiate archival and working files. For example, keep the scanned TIFF archive file and photo book-ready JPG together in a folder where they are easy to organize and locate when you need them.

FOLDER ORGANIZATION SCHEMES

You don't need a complicated folder structure to organize and locate your photos. I find that simple is definitely better when it comes to image management. If photos are buried three or more folders deep, it takes longer to drill down and find that file. System-wide searches are faster, too, if files are organized in fewer folders.

It's likely you are working with at least two kinds of image files:

* everyday snapshots of your home, family, and friends
* genealogy images of scanned photos and documents, source documents photographed on research trips, cemetery and tombstone images, snapshots from family reunions, and photos of heirlooms and family keepsakes

Genealogists often get bogged down trying to force all photos into one giant organizing system, but what works for one kind of photo may not be a good solution for another kind of photo. I use different file-naming schemes for different types of photos, and different folder systems, too.

How to Create Your Folder System

When creating your folder system, I recommend avoiding complicated multilevel folder schemes that create many places to look for files and photos. Instead, take advantage of a

> ✻ **TIP** ✻
>
> ### Photo Searching
>
> When your photos are organized well and have descriptive file names, it makes it easier to search your computer for the files you need. On a Mac, search for files by typing in a search term in the Search box at the top right of any Finder window. On a PC, click the Start button and type your search term in the Search box to locate a file.

file's metadata (identifying information embedded into the image file) to label photos with keywords, location, event, and tags that will assist you in searching and finding images. And make it a habit to import, organize, and tag images shortly after each photo shoot or scanning session.

Follow these steps:

STEP 1: On your main storage device (either your computer hard drive or your external hard drive), create a folder labeled PHOTO LIBRARY. If you like, personalize the folder name by adding your initials such as DML PHOTO LIBRARY (replace DML with your initials).

STEP 2: Inside the PHOTO LIBRARY folder, create a few annual folders to hold images for each year beginning with the current year. Remember, you will be organizing going forward and adding old files as time allows.

STEP 3: Inside each year, create folders for each batch of images. These can be organized by month, date, or event—however you wish.

STEP 4: Import images from your memory card and mobile devices into the folders. (Learn more about this in Chapter 2.)

Ways to Organize Your Photo Folders

Some researchers keep all personal and genealogy photos together in one Photo Library, while others prefer to maintain two distinct photo collections: personal photos and genealogy images. I like to keep new family snapshots together in folders labeled by event or occasion inside a folder for each year and month, and genealogy files in one big genealogy folder.

For my personal photos, I use a folder named FAMILY PHOTOS to hold all current family photos. Inside this folder are annual folders that hold the folders for each year and month (see Image **A**).

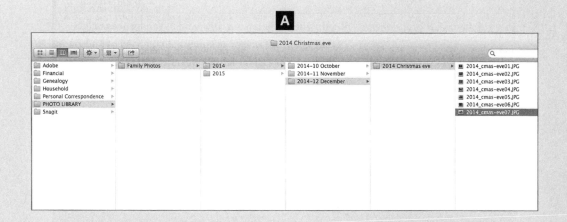

For genealogy files, I've found that it is difficult to organize those files in folders by date. We may not know a photo's date, location, or event, for example. And how would you organize a photo of a cemetery tombstone taken on a trip in 1998? Do you file it in a 1998 folder, by the date on the tombstone, or in a surname folder?

Genealogists will need to decide what method works best for their personal work style and technology expertise. Ultimately you'll need to decide what works best for you. Here are two options to consider.

1. ONE BIG GENEALOGY FOLDER: Harness the power of the computer to search and locate files. Use fairly broad subfolders inside the main folders to organize digital files. Create a main GENEALOGY folder inside your computer's Documents folder (see Image **B**). Keep research notes and documents inside this folder organized by surname, locality, or other system. Inside this big GENEALOGY folder, create a folder named GENEALOGY PHOTOS. File all of your genealogy-related images inside the GENEALOGY PHOTOS folder. For more file-organizing ideas for genealogy documents, see my book *How to Archive Family Keepsakes*.

2. ONE PHOTO LIBRARY: The simplest folder scheme of all is to place all your images inside a master PHOTO LIBRARY folder (see Image **C**). This is the central location for family photos, scanned images, genealogy images, and any image handled by photo-management software. Create subfolders within the PHOTO LIBRARY folder to hold your files. As I mentioned, I have subfolders in my PHOTO LIBRARY folder labeled FAMILY PHOTOS and GENEALOGY PHOTOS. Using this scheme, you'll continue to store and manage PDF and document files in your big GENEALOGY folder, but all your images will be stored in the PHOTO LIBRARY.

If you plan to use photo-management software such as Adobe Lightroom or Picasa to manage your photo collection, keep in mind that storing all your images in a single location is essential. That's because when you set up your software, it will look for your photos in a certain folder. When images are moved outside the software, the link is lost and must be reconnected manually. And if you create a separate folder to store photos, the software won't be able to find that additional folder. As a result, you can't take advantage of many software features.

IMAGE DATA

Have you ever viewed the information for a digital photo and wondered where it came from and what it means? That information is called *metadata*. To understand how metadata works, it's helpful to understand how cameras and mobile devices organize images internally or on a memory card.

Every image can include two different kinds of data: Exchangeable image file format (Exif) and International Press Telecommunications Council (IPTC). Some data are automatically recorded by the camera, and others are available for your input. The data are used to sort and organize images in the camera and when transferred to your computer.

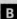

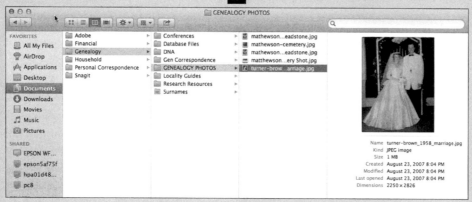

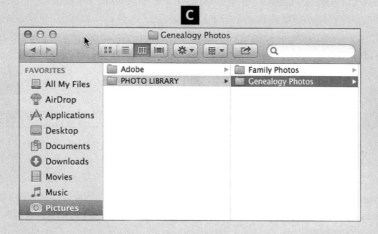

The Exif and IPTC data provide information about your digital image. The data are embedded in the digital file for JPG and TIFF format images or saved in a companion "sidecar" file for RAW images. There is some overlap between the two sets of data.

EXIF IS DEVICE DATA: Typical Exif information (see Image **D**) includes information about the camera make and model, resolution, exposure, location, and other settings, but most importantly for organizing files, Exif data record the date and time of capture with a unique file name for each image. The date and time is used to organize image files into folders, and the unique file name identifies individual image files.

IPTC IS SUBJECT DATA: The IPTC data (see Image **E**) are usually added by the user in the form of title, caption, subject, photographer, copyright, and so on. Originally designed to help

D

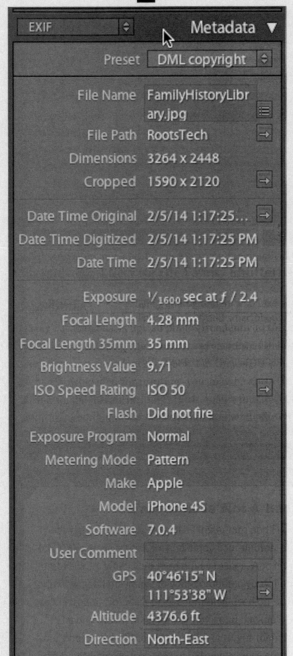

EXIF ⬍	Metadata ▼
Preset	DML copyright ⬍
File Name	FamilyHistoryLibrary.jpg
File Path	RootsTech
Dimensions	3264 x 2448
Cropped	1590 x 2120
Date Time Original	2/5/14 1:17:25…
Date Time Digitized	2/5/14 1:17:25 PM
Date Time	2/5/14 1:17:25 PM
Exposure	$^{1}/_{1600}$ sec at ƒ / 2.4
Focal Length	4.28 mm
Focal Length 35mm	35 mm
Brightness Value	9.71
ISO Speed Rating	ISO 50
Flash	Did not fire
Exposure Program	Normal
Metering Mode	Pattern
Make	Apple
Model	iPhone 4S
Software	7.0.4
User Comment	
GPS	40°46'15" N 111°53'38" W
Altitude	4376.6 ft
Direction	North-East

E

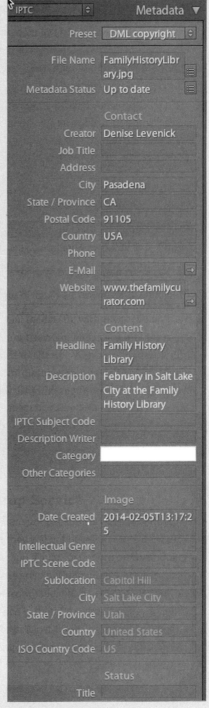

IPTC ⬍	Metadata ▼
Preset	DML copyright ⬍
File Name	FamilyHistoryLibrary.jpg
Metadata Status	Up to date
Contact	
Creator	Denise Levenick
Job Title	
Address	
City	Pasadena
State / Province	CA
Postal Code	91105
Country	USA
Phone	
E-Mail	
Website	www.thefamilycurator.com
Content	
Headline	Family History Library
Description	February in Salt Lake City at the Family History Library
IPTC Subject Code	
Description Writer	
Category	
Other Categories	
Image	
Date Created	2014-02-05T13:17:25
Intellectual Genre	
IPTC Scene Code	
Sublocation	Capitol Hill
City	Salt Lake City
State / Province	Utah
Country	United States
ISO Country Code	US
Status	
Title	

news providers locate and credit photo sources, IPTC data are a genealogist's friend when it comes to adding information about the people, places, and events shown in an image. You can set some IPTC data automatically, but most information must be individually recorded.

To add IPTC metadata to individual photos, you'll need to use the Properties panel on your PC or the Get Info option on your Mac.

* On a PC, right-click on the image and select Properties. Rename the file in the main window. Click the Details tab to add tags and keywords (see Image **F**).

* On a Mac, select an image and open the Information window with Command-I. Rename the file and add tags and keywords in the Get Info window (see Image **G**).

When organizing large collections of images, however, it's more efficient and faster to add tags, keywords, and captions to the metadata using batch functions in a photo-management program such as iPhoto, Adobe Photoshop Elements, Adobe Lightroom, or Picasa than adding it to photos individually.

F

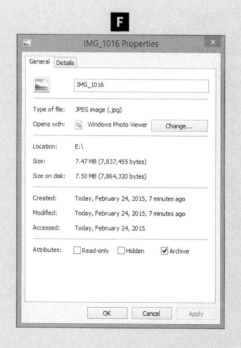

G

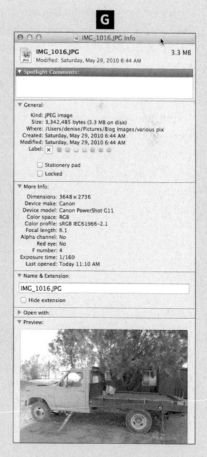

Set Up Your Camera

Depending on the kind of camera you use, you may not be able to customize each metadata option, but the date and time setting should be available on all cameras. This metadata is all recorded in the Exif data for the image. When you get a new camera or mobile device, use these steps to ensure it is set up properly.

STEP 1: SET THE DATE AND TIME. One of the first steps with any new camera or smartphone should be to set the correct date and time, and confirm the regular settings are correct. It's easy to mistakenly advance the year when adjusting for Daylight Saving Time. Your camera menu may look different from the one shown, so look for the Menu option and select Settings to find DATE AND TIME. Use the navigation arrows to set the correct information. Make it a habit to change your camera clock when you adjust your household clocks for Daylight Saving Time.

STEP 2: TURN DATE IMPRINT OFF. Confirm that your camera is set to capture images with the date imprint set to Off.

STEP 3: CONFIRM CONTINUOUS FILE NUMBERING. Some cameras offer the option to reset file numbers, but checking this option may give you duplicate numbers and create havoc in your organizing system. Opt for continuous file numbering from one memory card to the next to avoid confusion and conflicts.

STEP 4: SELECT THE RESOLUTION. Most cameras have an option to set the resolution from maximum megapixels to smaller sizes. To get the best image quality possible for all photos, keep this set at maximum. Purchase larger memory cards if needed to accommodate more photos on a long vacation or research trip.

STEP 5: INPUT PHOTOGRAPHER AND COPYRIGHT INFORMATION. Some cameras now offer an option for the photographer to include a name and copyright information. If you like to shoot photos and post them directly to social media via in-camera Wi-Fi or after transfer to your smartphone, you may want to personalize these settings.

Inside the Memory Card's Organization

All digital images are organized by the original device in much the same way, whether the image was captured by smartphone, digital camera, or mobile scanner. The date and time are essential pieces of information used in sorting and displaying image files.

> ❊**TIP**❊
>
> ### Camera File Formats
>
> If you use a digital SLR camera, you'll have the option to shoot pictures in RAW, RAW + JPG, or JPG file formats. RAW files take up considerably more room but are the camera equivalent of TIFF files, and are stable and uncompressed. You need to process RAW files in order to work with the images, so most family photographers stick with the JPG file format. If you're worried about JPG compression and image loss, consider working with a nondestructive photo editor such as Adobe Lightroom or Picasa.

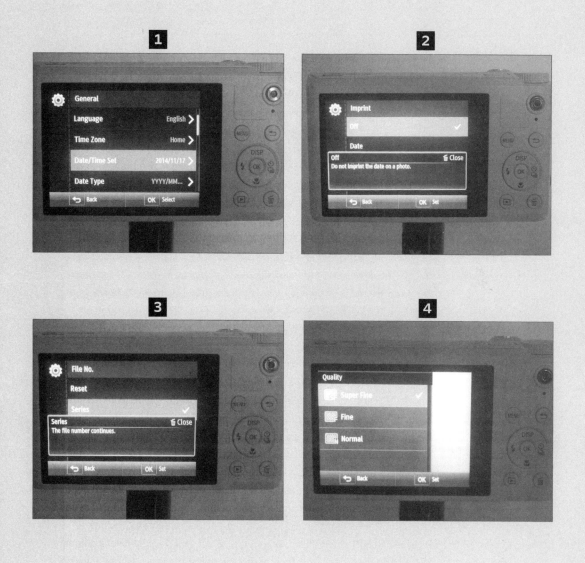

Each device uses a shortcut device name to identify the manufacturer and sometimes the device model. Insert an SD card in your computer and click twice to open the folder. You should see a folder labeled DCIM. DCIM is an abbreviation for Digital Camera IMages. DCIM is the industry standard file folder that contains the photos captured by your device. To see the individual image files, open the DCIM folder; you should see either a loose collection of consecutively numbered image files or a series of file folders.

PHOTO BACKUP

The best time to back up your photos is right after you take them. Do you want to lose the graduate's grin or the bride's smile? For this reason alone, automatic cloud syncing and storage for smartphone photos is a wonderful feature. If your phone is lost, falls into the punch bowl at the wedding reception, or is reset by an inquisitive two-year-old, your photos will be safe.

3-2-1 Backup

A backup is merely a duplicate copy of a file. A true backup is a duplicate copy stored in a different location from the original. If you use a cloud storage service with your mobile device, that snapshot you took with your smartphone at your niece's wedding is the original stored on your mobile device; the backup is a copy that gets uploaded and rests on your cloud storage service's servers, ready to be synced to your hard drive when you turn on your computer at home. One photo, three copies.

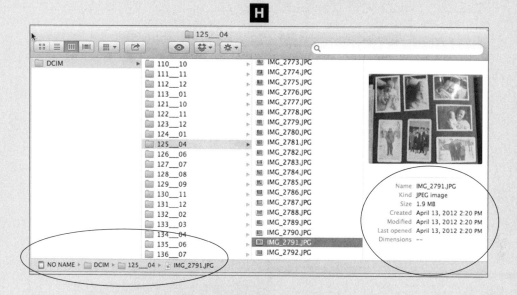

H

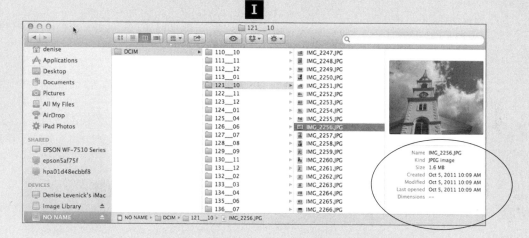

I

When backing up photos, follow this 3-2-1 plan:

✻ **Create 3 copies:** smartphone, cloud storage service, and your home computer

✻ **Use 2 different media:** computer, USB flash drive, or external hard drive

✻ **Store 1 copy off-site:** use a cloud storage service or online backup service, or burn an archival DVD and store it off-site at a relative's home or in a safe-deposit box

Back Up Your Computer Hard Drive

You have many choices for backing up your computer hard drive:

- external USB hard drive
- home network server
- online cloud storage
- online backup service
- recordable (and archival) DVDs and CDs
- USB flash drives

Select your storage hardware and set up a backup routine. Professional photographers back up their work daily or periodically throughout an editing session. Make it a habit to always back up your work after importing new images or at the end of lengthy photo-editing session.

Investigate automated online backup systems, too. (See a list of backup services in the Appendix.) Why use an online backup service? Personal external hard drives store your Photo Archive on-site and are relatively secure from hackers, but while you control the hardware (and only have to purchase it once vs. pay a regular subscription fee), your files are susceptible to fire, theft, and hard drive failure. In addition, if you use an external hard drive as your archival backup solution, you must be your own Tech Guru, purchasing and installing hardware, migrating your Photo Archive to new equipment as needed, and managing backup copies.

Alternatively, an online, cloud-based backup service does all the tech work for you: maintaining state-of-the-art equipment, providing redundancy, and protecting your data from theft or disaster. With automatic uploads, you never have to worry about remembering to manually backup, sync, or migrate images.

The main drawbacks of online backup services are cost and security. You have to pay a monthly or annual subscription fee to keep your files safe. More storage costs more money. Enhanced security features, more restoration points, and the level of customer service offered are features that drive the price higher.

Depending on how much backup storage you need, experts recommend evaluating your options to determine the break-even point between the cost of maintaining an external hard drive at an off-site location and storing your Photo Archive using an online backup service. The decision will likely be based on the size of your collection and your comfort level with storing images in the cloud vs. the work of maintaining your own equipment.

Back Up Your Mobile Devices

A good option is to set up your mobile devices to automatically sync and back up photos from your digital camera to your computer. Sync photos to an online cloud storage service and then download images to your personal Photo Library. Simplify your digital life by integrating your mobile and computer backups. Remember the acronym LOCKSS—it stands for Lots of Copies Keep Stuff Safe. Having many digital copies is a good thing when disaster strikes.

If you take lots of pictures on your smartphone or tablet and rely on the cloud to back up your images, you might be surprised to learn that cloud storage isn't automatic. Thousands of iPhone users thought their images were stored in the cloud and later discovered that those images were lost unless they had been saved to the device's Camera Roll or transferred to iPhoto or another photo-management library. The new Mac OS X Yosemite photo-management system aims to make all photos available anywhere in the iCloud Photo Library, a system similar to cloud storage services such as Dropbox and Google Drive.

The takeaway: Cloud syncing and storage is convenient and easy, but don't rely on the cloud as your sole photo backup.

Turn to Chapter 2 for more ideas to move your photos from your camera to your computer.

GETTING STARTED CHECKLIST

☐ Complete the Digital Photo & Video Storage Worksheet.

☐ Decide where to store your image collection, and purchase necessary storage device hardware.

☐ Set up your camera and mobile devices with the correct date and time and any other desired settings.

☐ Set up your storage devices.

☐ Purchase a dedicated media card reader if you don't have a built-in card reader on your computer or home printer.

☐ Purchase and set up backup devices.

☐ Decide on your file-naming and folder organization structure, and set up your PHOTO LIBRARY folder system.

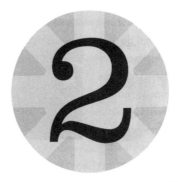

❖ Transfer Tips ❖

Digital photography has changed the way we capture special moments in our lives. If you have a smartphone, you always have a camera ready to go in your pocket or purse. We no longer only take photos of important events such as weddings and graduations. We take photos every day of any moment we want to remember. We take photos of the foods we enjoy. We take near-daily photos of our children or grandchildren. We take hundreds of photos on vacation. Digital photography has allowed us to become proficient at *taking* pictures, but we are much less efficient at *managing* them. Despite taking more and more images every day, it's harder to access and view our images now than when we took our film to be processed and ordered paper prints.

For many people, organizing digital photos may seem overwhelming, and the organizing systems you may have learned and now rely on in your business life may work moderately well with document files, but they may not work as well for your personal digital photos. For example, you might organize word processing documents and spreadsheets in a digital version of a metal file cabinet because it makes sense. The computer does the heavy lifting by maintaining strict alphanumeric order. And files enter the system from only a few locations. To find a specific document, you click through folders, looking for the file you want. As long as you use a consistent, intuitive file-naming system, it is fairly easy to locate the file you need.

This business file organization strategy doesn't work quite so well for organizing digital photos. Managing your digital photos demands a different organization system for three reasons:

1. We take and need to manage thousands of digital images each year.
2. Different uses for photos may require multiple versions of the same image.
3. We capture images on multiple devices, and our images may be scattered among multiple users.

In the same way that you'd never leave your heirloom wedding photos stuffed into the glove compartment of your car for safekeeping, keeping photos stashed on SD cards, on flash drives, and in free cloud accounts is not a reliable photo storage or management strategy.

Managing digital photos is a bit like creating an ongoing photo album where you can easily add notes and rearrange photos, all without scissors and paste. The tools you use are different from traditional paper albums, but the results are even more satisfying.

In this chapter we'll look at options to help you move the photos you've captured on any device into one Master Storage Location—your Photo Library.

BASIC IMAGE TRANSFER

All digital photo management begins with a simple strategy you already know: organizing with files and folders. Before you begin transferring images, you'll need to set up a Master Storage Location to hold your Photo Library on either your computer hard drive or an external hard drive, and create a basic file folder structure, as recommended in Chapter 1. You will transfer your images to your Photo Library using a transfer method suitable for your photo capture device. You can transfer your photos using one of three approaches:

�֍ manual image transfer
✖ automated image transfer
✖ advanced image transfer using software

Manual Image Transfer

Manual image transfer involves moving files by dragging and dropping images from your device to your Master Storage Location. In a manual approach, you are responsible for transferring files from the capture device to your Photo Library and for placing images in the correct folders. After transferring files from the capture device to the Master Storage Location, you can manually rename files and make adjustments, such as cropping or resizing.

Manual image transfer is good if you

✖ want maximum control.
✖ are comfortable with drag-and-drop organization.
✖ prefer not to learn a new system.
✖ use any computer platform: PC, Mac, or Linux.
✖ have a small- to average-sized digital photo collection.

The main drawbacks of a manual image transfer method are that

�֍ it relies on user consistency, so it can be difficult to maintain.

✖ it requires hands-on attention.

✖ files must be individually renamed and tagged.

✖ files can be accidentally deleted or misplaced.

A benefit of manual image transfer is that you can continue to manually move, sort, and access your digital library indefinitely. For many people, this is all the photo management they need.

The process of collecting, moving, and organizing your images may take some time, depending on the number of images and size of your photo collection, but you don't have to do it all at once. Start with your removable camera memory cards and any new images you've taken, and then move on to your mobile phone, tablet, and other SD cards. Work on one device at a time, double-checking to confirm that the images have transferred and are safely stored before moving on to the next device.

Transferring Photos From a Memory Card

Your camera memory card is a miniature storage drive. You can open the card, view files, and move items by dragging and dropping. You also can rename files and folders right on the card. Transferring images captured on memory cards to a computer is relatively simple. After you have safely transferred the photos to your Photo Library and backed them up to a storage device, you can erase the card's contents to make room for new images. Photo storage is nearly infinite because you can add memory cards for more pictures as needed. Here's a step-by-step example for how to do this on a Mac (the steps are similar on a PC).

STEP 1: Insert your memory card into a memory card reader and view the card on your computer. The card may or may not be named. Control-click (or right-click) on the card and rename it with your last name or initials and the year you started using it, such as DML 2014.

STEP 2: You should see one or more folders inside the card. Your photos will be inside the Digital Camera IMage (DCIM) folder. Continue opening folders until you are viewing the image files. They will be labeled with a generic prefix and consecutive numbers. Note the year the photos were taken. These photos were captured in May 2010. Identify the correct capture year from the file folder name 108__05 (2010-May) or from viewing the image thumbnail.

STEP 3: On your computer or external hard drive, open your PHOTO LIBRARY folder (your Master Storage Location) and then open a folder for the correct year, or create a new folder and label it with the year (in this example, 2010). Select or create a new photo folder inside the year and rename it with the month and event or occasion. Some users prefer to name file folders with the exact date in addition to the month to keep photo batches organized in groups. It's up to you how you want to manage the folders, but do use a consistent folder-naming structure that includes at least the year, month, and identifying name.

STEP 4: Select the image files and drag them from the memory card to the appropriate folder.

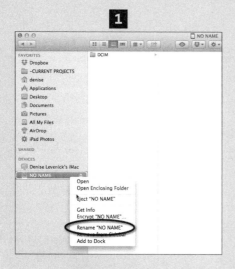

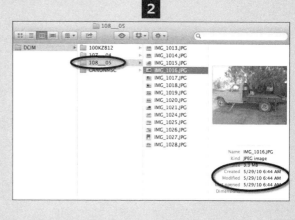

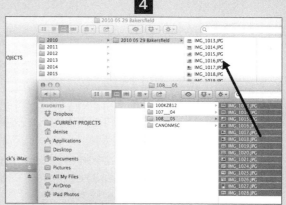

Transferring Photos From Smartphones and Tablets

Photos taken with a smartphone or tablet camera are at the mercy of limited mobile storage. If you take a lot of pictures and videos, you may find yourself frequently seeing the dreaded message: *Not Enough Storage*. Regularly transferring photos and videos to your computer will keep your device free for new images and safeguard those you've already recorded.

You can move images manually from an Apple or Android smartphone or tablet to your computer via a USB cable. This process is fast and allows you to manually organize as you drag and drop files from one location to another.

If you have an Android smartphone or tablet with removable storage media, you have one more manual image transfer option: You can insert a mini-SD card from your device into your

computer's memory card reader and manually move images to your Photo Library.

If you grow weary of the hands-on organization or want to use features such as batch file naming, tagging, and custom captions, read on to learn about photo-import and photo-management software that makes the task easier.

AUTOMATED IMAGE TRANSFER

The easiest photo-transferring solution is one that goes on in the background so you don't even have to think about it. That's what automated image transfer does. It allows you to automatically transfer images to a designated location, per your setup instructions. Automated image transfer solutions provide a good alternative to physical file transfer, and in some ways are even better because there's less chance for user omission or error. Your choice of auto-transfer and synchronization will depend on your device's platform and what online photo or cloud services you already use. Popular automated systems include Apple's iCloud Photo Library **<www.apple.com/icloud/photos>**, Dropbox **<www.dropbox.com>**, Shutterfly's ThisLife **<www.thislife.com>**, and other online cloud storage programs. All major cloud storage services offer Android and Apple iOS apps. (See more on online cloud storage services in Chapter 4.)

To use an automatic image transfer method, select the online storage service you'd like to use and configure the settings on your devices and in your online account for storage. In most cases, you'll transfer your image to a cloud storage service. The main drawback of this type of system is

※ **TIP** ※

Automated Transfer from Mobile Devices

You can automatically transfer images from mobile devices via cloud synchronization, too. Apple iOS users can use the Apple iCloud service, and Apple and Android users can move images via Dropbox and other services.

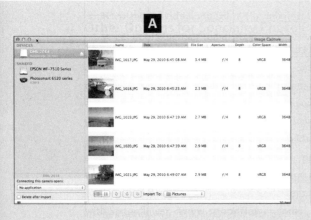

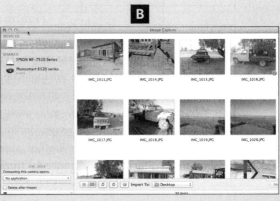

that it's still up to you to manually move those images into your Master Storage Location, where you will be able to rename and manage your images in a central location.

Transferring Photos With Image Capture (Mac)

Image Capture is a handy Mac program that helps you move files between storage devices such as memory cards or external hard drives, and from digitizing equipment to your computer. It offers a viewing window to assist you in selecting new images for import to your file folder system (Image **A**), making it easy to select images for import. The Icon view (Image **B**) shows image thumbnails. Image Capture allows you to select one, some, or all photos from your device for import to a selected location.

You also can check the option to Delete after Import, but I recommend deleting images from the camera after you have confirmed a safe transfer and backed up the files. It's a simple step to delete images using the camera's menu.

Transferring Photos With Photo Gallery (PC)

Photo Gallery offers several helpful features for managing your photos during and after transferring the images to your PC. To start transferring your images, follow these steps.

STEP 1: Insert a memory card and open the Photo Gallery to view the Import window. Select the option to Review, Organize, and Group Items to Import, and click Next.

STEP 2: In the Import window, check each group of photos you would like to import, name the group, and add tags. Uncheck individual photos if desired and click Import.

Do not erase the memory card in the computer. After confirming that the photos have been safely transferred, erase the card using the camera's Delete function.

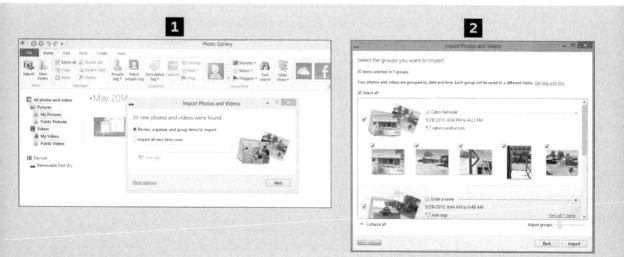

Transferring Photos From Wi-Fi-Enabled Cameras

In recent years, Wi-Fi-enabled digital cameras have brought mobile connectivity directly to digital cameras. These new models typically offer Android and iOS apps that partner with the camera so you can shoot photos with the digital camera and then view the images on your tablet or smartphone for editing, e-mailing, and posting to social media sites such as Facebook, Twitter, and Instagram.

To set up a wireless connection between your camera and your mobile device, you'll typically need to download and install the app to your mobile device and then set up a connection between your camera and the app. This direct connection between the camera and the device is turned on when you want to transfer photos from camera to device and turned off when you are finished. The images remain on your SD card, and you can transfer the images from the card to your computer later. The camera instructions and app will walk you through the steps for your specific camera model.

Using a dedicated camera for large digitizing projects will conserve your mobile device battery for other uses, and the larger sensor in a digital SLR camera may produce better images than your smartphone camera, especially in low-light conditions such as libraries, archives, and conference halls.

Some Wi-Fi camera apps also include options for other features, such as

� remote shutter release.

✖ adding Geotags.

✖ in-app editing.

✖ direct posting to Facebook and other social media sites.

I've experimented with a Wi-Fi camera for capturing microfilm images at the Family History Library in Salt Lake City. The camera recorded good-quality images directly off the microfilm-viewing table as I worked the shutter via the remote app on my iPhone. The biggest drawback, however, was the quick drain on battery life. Both the camera and iPhone needed to be recharged after a few hours of use. I think it would have been more efficient and created less

Are You Relying Too Much on the Cloud?

Cloud storage can be an essential part of any backup strategy, but it shouldn't be the only place you store your photos. Aim to create and maintain one central Photo Library (your Master Storage Location) on your own equipment that holds all your images. If you want to use a cloud service, use a cloud service to sync and store images while traveling or to help move files between devices, or to house an off-site backup of your Photo Library. Remember, you'll want to back up your Photo Library regularly so you have three copies on two different media with one copy off-site.

power drain to have used a physical remote shutter release, and then used the Wi-Fi to simply transfer the photos to my iPad.

Wi-Fi-enabled cameras are available in compact point-and-shoot to professional-level models. If you are looking to expand your digital toolbox, the slightly higher cost of a Wi-Fi-enabled camera may be a good investment to expand your photo opportunities.

Transferring Photos From a Wi-Fi-Enabled Memory Card

Another option to add Wi-Fi connectivity to a standard digital camera is with a wireless memory card, such as an Eyefi SD card **<www.eyefi.com>**. Eyefi SD memory cards provide a hybrid photo transferring solution that you can adapt to suit almost any photo-management workflow. Different models of Eyefi cards are available; we'll focus on the Eyefi Mobi SD card.

The Eyefi Mobi SD card works like any standard SD card—simply insert it into an SD card reader to transfer images directly. The real magic, however, lies in the card's tiny wireless transmitter that can transfer images wirelessly from your digital camera to a computer, smartphone, or tablet. Instead of waiting until you import or manually drag and drop files from one place to another, the Eyefi Mobi SD card automatically transfers images wirelessly (in seconds) whenever it detects a wireless connection between two paired devices. The card works with PC and Mac computers, as well as virtually all digital cameras that use an SD card and the Flip-Pal mobile scanner or other devices that store images on an SD card. The photos, which can be in JPG or RAW format, then reside within the free Eyefi Mobi app on your device. For example, if you set up the card to transfer to your smartphone, your photos will be copied from the Eyefi Mobi SD card inserted into your camera to your phone whenever the camera (and card) are within range of the smartphone and the Eyefi Mobi app is open.

After you transfer the images, you can view them, organize them into albums, and tag the photos within the Eyefi Mobi app. Meanwhile, on your smartphone, you can share images and save them to the device's Camera Roll, where they will be available to other apps for editing and photo projects. You also can pair your Eyefi Mobi SD card to your desktop PC or Mac computer. On your computer, "watch folders" collect images transferred from the Eyefi Mobi SD card to automatically import them into photo-management programs such as Adobe Lightroom.

As long as your Eyefi Mobi SD card is paired with only one device, all photos will be transferred to that device. If you install the Eyefi Mobi app on an iPad and your iPhone, however, any photos not previously transferred to any device will be copied to this newly paired device whenever the card is within range of that device. The result: Some photos may be moved to your smartphone when the card is paired to that device, and the next time you take pictures, the new images could be moved to your iPad if the card is also paired to it. In addition, the Eyefi Mobi SD card saves both JPG and RAW image files to the card, but transfers only JPG and video files wirelessly.

The Eyefi Cloud

If you use a Wi-Fi-enabled Eyefi Mobi SD card, you might want to use the optional Eyefi Cloud service as well. The Eyefi Cloud service is designed to synchronize files that may be downloaded to different locations. It works in the background to synchronize all of your images on all of your devices by hosting a full-resolution copy on Eyefi's Cloud storage website. You can use the Eyefi Mobi SD card without an Eyefi Cloud account, but your images will only be housed in the location of original transfer. Of course, images are always accessible by manually copying the files from the SD card to your computer or an external hard drive.

The Eyefi Cloud includes some organizing features to move photos into albums, but no editing or tagging features. Downloading and sharing is limited to individual photos and batch selection by date. Overall, the Eyefi Cloud is useful for sharing images or for image backup while traveling, but may be cumbersome for practical use as cloud storage because it limits you to downloading images one at a time.

Although the original digital photos will remain on the Eyefi Mobi SD card, if you aren't careful, you can end up with images scattered in different locations. To avoid transferring images from your Eyefi Mobi SD card to multiple locations, simply close the Eyefi Mobi app on devices you don't want images to transfer to. This gives you the flexibility to open the mobile Eyefi Mobi app on your phone if you want to receive photos from your camera to e-mail or share on Facebook, or close the phone app and open the tablet app if you'd like to use the larger screen to make a digital photo book on your iPad.

ADVANCED IMAGE TRANSFER

Users of photo-management software such as iPhoto or Adobe Lightroom may be scratching their heads and wondering what we're talking about with "manual photo transfer." That's because these nondestructive photo-management programs handle image transfer, file renaming, and folder destinations with automated presets that take the hassle out of routine file management.

If you work with a large heirloom photo collection or enjoy taking photos with your digital camera, you may want to investigate a program such as Adobe Lightroom, available as standalone software or as part of the Adobe Creative Cloud subscription service. See Chapter 3 for more information on photo-management software options.

MY IMAGE-CAPTURE-TO-COMPUTER WORKFLOW

Now that you have an overview of different image transfer options, I'd like to show you how I import my photos to my computer. I take a lot of pictures with both my digital camera and my

smartphone camera. In addition, I scan keepsake family photos and research materials with several different scanners. My goal is to gather all my digital images in one photo collection and use folders and tags to organize and identify present-day family photos, scanned photos, and research images.

My photos are stored in the Photo Library external hard drive described in Chapter 1 and managed with Adobe Lightroom photo-management software. Using Lightroom, I export copies of image files as needed from my photo collection to share on my blog, on social media sites, or for photo projects. I use two wireless Eyefi SD cards to simplify my photo workflow: one in my digital camera and one in my Flip-Pal mobile scanner. I have the Eyefi Mobi app installed on my iPhone and my iPad, and I have the Eyefi desktop app installed on my Mac.

At Home Workflow

When I'm working at home, I usually need photos for lectures, webinars, and article illustrations. The Eyefi Mobi SD card in my digital camera makes it easy to access new images without removing the card from my camera. I confirm that the mobile apps are closed and the desktop app is available in the menu bar. When I turn on my camera, the card connects to my computer via a wireless connection, and the images transfer to my computer. Here's how it works.

STEP 1: IMAGES TRANSFER TO COMPUTER. When my camera is within Wi-Fi range of my desktop computer, the Eyefi desktop transfer app automatically starts and begins transferring the full-resolution images to a folder on my desktop labeled EYEFI.

STEP 2: IMPORT PHOTOS TO ADOBE LIGHTROOM. I usually review the images in the folder and then open Adobe Lightroom photo-management software. I use the Import option in Lightroom to transfer the images to my Photo Library. The software prompts me for a folder location

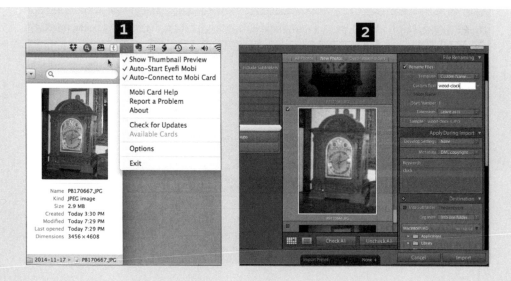

in my Photo Library (on an external hard drive), file name, keywords, and other metadata. I add my copyright information as preset data.

STEP 3: EDIT PHOTOS. Using the Develop module in Lightroom, I edit and crop the images.

STEP 4: EXPORT FOR PROJECT. I select the photos needed for my project and choose the appropriate Preset to apply the file format, file size, watermark, and other options.

Sometimes I use my smartphone to snap a quick photo. I wait for the image to sync with the Apple Cloud and for my photo to appear in my desktop Photos app. I then transfer the photo to my Photo Library and to Adobe Lightroom, where I work with the file and export it once more for my project.

Traveling Workflow

When I'm traveling and want to view photos from my scanner or camera on my mobile phone or iPad, I open the Eyefi Mobi app and allow the images to transfer to the device. Here's how.

STEP 1: TURN ON DIGITAL CAMERA. The power must be running on your digital camera for the Eyefi SD card to connect to your device.

STEP 2: OPEN THE EYEFI APP ON SMARTPHONE OR TABLET. The photos from my camera will begin to appear on my device.

STEP 3: POWER OFF CAMERA AND CLOSE APP. When the transfer of images is complete, I turn off my camera and close the Eyefi app.

STEP 4: MANUALLY TRANSFER IMAGES AT HOME. When I return home, I insert the Eyefi SD card into my desktop computer's memory card reader slot to manually copy the files to my PHOTO LIBRARY folder on my external hard drive. I do not use the desktop transfer app because some of the photos may have already been transferred to my mobile devices.

Technology-Proof Your Photo Collection

Technology for managing your photos on your devices is constantly changing. Case in point: Apple's newest operating systems, Yosemite and iOS 8, replaced Photo Stream (a popular feature in earlier Apple operating systems that allowed Apple users to view images on all connected devices) and the iOS Camera Roll with a new photo-management system called the iCloud Photo Library, a part of the iCloud Drive. As users update to the new operating systems, they'll discover their photos have been moved into these new locations. Users also will see that a new Apple photo program for desktop integration has replaced iPhoto and Aperture.

If you use an older Mac, you may not be able or want to upgrade to Yosemite. iPhoto will continue to function on your computer, but will no longer be supported by Apple. When you eventually upgrade or move to a new Mac, you'll have to find a new way to manage your photo collection.

This transition to a new Apple photo-management system is a good reminder that you should always keep current with your photo strategy and be an active and aware photo consumer. In addition, you should make sure your photos are in a safe location that you can access no matter how technology changes.

❖ Photo-Management Software ❖

Y ou can certainly set up a photo-management system using only your computer folder structure and a basic photo viewer, but if you're working with a large photo collection, you may find the task will be easier and more enjoyable with software designed for the task of managing photos.

Using photo-management software to import images to your folder system saves time and helps maintain consistency in file naming and folder organization. You never have to remember whether you are using year-month-day or month-year-day naming and folder structures; the software automatically creates and names folders as needed.

Organizing a digital collection with photo-management software is especially helpful if you have a large photo collection, as well as for anyone who

- ❖ wants automation for routine organization tasks.
- ❖ works with image files every day.
- ❖ wants batch file-naming and editing functions.
- ❖ wants nondestructive photo editing.
- ❖ uses PC or Mac computer systems.
- ❖ has large or growing digital collections.

The greatest disadvantage of using photo-management software is that it requires you to spend some time learning to master the new software. Once you learn it, though, it should help make your overall workflow much more efficient.

Use the Photo-Management Software Comparison Worksheet in this chapter to evaluate features and options most important to your personal workflow.

KEY SOFTWARE FEATURES TO CONSIDER

Throughout the years, I've used dozens of different photo-management and photo-editing programs on Windows and Mac computers, and experience has proved to me that the best software solutions for family photo management offer four key features:

* nondestructive editing
* batch editing, file naming, and file converting
* cross-platform versions
* a large, active user base that supports official and third-party training and tutorials

Photo-management software is only one piece of the digital photo-management puzzle, but it's an essential part of my workflow.

Nondestructive Editing

What is nondestructive editing? Some database-based photo-management programs process image edits by saving *instructions* for the edits rather than altering the original file. This allows you to easily return to the original version or to step back incrementally if you want to undo several adjustments. This nondestructive editing preserves your original image and your edits without multiple copies filling up your database.

In contrast, conventional image editing saves the edited version of a file by overwriting the original and losing the original data. For example, a typical editing session might involve

1. opening a JPG image.

2. rotating the image.

3. cropping the image.

4. applying auto-adjust to improve contrast and balance.

5. saving the changes with the Save command, which overwrites the original file.

Using this scenario, you cannot reopen the file and return to the uncropped version. The changes have erased the original file, and some digital information is lost each time the file is saved and compressed. After many saves the file can become degraded so extensively that it becomes unusable. This scenario ("lossy" compression) occurs whenever you save a JPG image.

❋ **TIP** ❋

Software Tutorials

Learn more about how to use photo-management software by exploring user groups, websites, and online education sites such as Lynda.com **<www.lynda.com>**.

One alternative is to use the Save As command, creating a new edited version of the file. This process doubles the number of image files and storage requirements and can create confusion as additional edited copies are added for Web versions and other projects. Additionally, even if you save an "uncompressed" JPG image, the file remains lossy and degrades each time it is opened and saved.

A second alternative is to convert all JPG images to TIFF images and perform edits on the TIFF version. TIFF is a lossless file format, which means the image will not degrade with each save. The file, however, will be permanently edited, and cropped areas will remain deleted. You cannot revert to the original TIFF after changes have been made in the same way that an edited JPG cannot return to its original version. This procedure also creates multiple image files and increases file storage requirements.

Organizing and editing images with nondestructive photo-editing software avoids the problem of having multiple copies and lossy file formats. Instead of *changing* the image file, nondestructive software writes instructions for the changes. These instructions can be reversed, like a step-by-step Undo button, to revert to the original image. Because any edits are really instructions to the software, you must export the edited image to view and use the file outside the photo-management program.

Batch Editing, File Naming, and File Converting

If you've ever renamed many files one by one, or individually changed the size of several photos for e-mailing, you've probably wished for a way to change more than one file at a time. Batch editing is a feature that allows you to apply the same changes—a file name, file format, or other file characteristic—to several photos at once. Batch editing can save hours of work when you want to convert photo files from TIFF to JPG format for a photo-book project or downsize full-resolution images for posting on the Web or e-mailing.

Explore your current photo-management software or software you are considering purchasing to see if it offers this feature. Typically, you will need to select the images you'd like to change, then modify the name, size, or other options. Some software programs, such as Adobe Lightroom, allow batch editing as files are exported.

Also look for file-renaming options that allow you to rename a group of files with a custom name and sequential number. Use this feature to quickly add a meaningful file name to photos, such as images from a recent vacation: *hawaii01.jpg*, *hawaii02.jpg*, and *hawaii03.jpg*.

Cross-Platform Versions

When I started my family archive project over a decade ago, I was a high school teacher using Apple Mac computers with my students and a Windows PC at home. I wanted software solutions to help manage my growing digital collection, but I didn't want to have to relearn a program if I decided to switch computer systems in the future. This has proven to be a good decision and

enabled me to easily move my database from Windows to Mac when I left the classroom and replaced my outdated PC with a desktop Mac.

Cross-platform software works on both Mac and PC computers. The same program may be offered at one price for PC and Mac computers, or it may require separate purchases for each version. Adobe Photoshop Elements and Adobe Lightroom (both available at **<www.adobe. com>**) offer essentially the same program for PC and Mac. Lightroom is also available as a part of the Adobe Creative Cloud subscription service offering cross-platform access to the latest version. Picasa **<picasa.google.com>** offers PC and Mac versions. Each of these programs also offers nondestructive photo-editing features.

Active User Base

Some people seek out obscure or small software companies, figuring they will get personalized service if they avoid "the big guys," but big is not necessarily a bad thing when it comes to selecting photo-management software. I recommend looking for a software company with a large, active user base, preferably with an online consumer forum. Satisfied users are a wonderful resource when you have a question or are unsure about how some features work.

If a program has an active user base, enthusiasts often post helpful videos, blog posts, and tutorials, or offer custom add-ons. A large group of users will find software bugs quickly and alert developers for fast patches and updates. In addition, being in touch with a large user base can give you a sense of the overall health of the software: Are users satisfied with the company's response to requests for new features? Do developers release periodic updates, or has it been many months since the last refresh?

PHOTO-MANAGEMENT SOFTWARE AND EVOLVING TECHNOLOGY

Unfortunately, not many software programs offer true nondestructive editing. Adobe Lightroom and Picasa, as well as the now-discontinued Apple programs iPhoto and Aperture, are popular nondestructive photo managers offering editing, batch editing, cross-platform versions, and a large, well-informed user base. Each program also offers some level of editing so you can crop, rotate, and adjust images without the need to work in a separate editing program. Lightroom and Picasa are available to Mac and PC users, and their popularity has created a market for books, tutorials, webinars, user forums, and training opportunities.

Adobe Lightroom is available in two versions: as part of the Adobe Creative Cloud subscription service where you always have access to the latest updates, and a stand-alone that can be purchased and downloaded to your home computer. Picasa is a free program that you download and use on your computer, no Internet connection required.

Until recently, Mac users also had the option to use the easy nondestructive editing features of Apple iPhoto or Aperture. With the release of the Yosemite operating system and iOS 8 for mobile devices, Apple began moving away from iPhoto and Aperture to the new Apple Photos

for OS X app and announced that it would no longer support its previous photo programs. The Apple Photos for OS X app is designed to make images and videos available on multiple devices. If you have an older Mac computer with iPhoto or Aperture, you can certainly continue to use the program, but be aware that software updates will be discontinued and all new Macs will offer the new Apple Photos for OS X app program. It's a good reminder that photo-management systems have seen fundamental changes since their initial introduction. Technology constantly changes, and the shift from computer to mobile photo management has created new challenges for synchronizing images between devices and users.

Photo archivists looking for nondestructive software options have fewer choices today than a few years ago. If you want to find a photo solution that has staying power, it's essential to know what features are most important to you and how to evaluate your options so you can move your collection to a new system if needed.

Of course, no software will solve your digital image clutter. If you dump all your photos into a program like Adobe Lightroom, iPhoto, or Picasa, you will be sorely disappointed to find those pictures looking right back at you—with the same empty metadata fields, the same useless file names. It's up to you to learn how your software can help you successfully organize and manage your photo legacy.

Adobe Lightroom

One of my best decisions for photo management was to invest in Adobe Lightroom. In 2006, I installed version 2 on my Windows XP computer and started working with my scanned images and new digital family photos stored on an external hard drive. When I switched to a Mac four years later, the move was effortless. I moved the hard drive cable from the PC to the Mac and was back in business with Lightroom for Mac. I didn't even need to purchase a new license.

New users today have a choice to purchase the stand-alone version of Lightroom or subscribe via the Adobe Creative Cloud service. There are advantages to each choice, and you will probably want to go with the option that suits your budget and needs. The main advantages to the Creative Cloud subscription are automatic updates and access to the new mobile syncing service. If you don't need or want either of these features, you may be better off purchasing Lightroom and managing your own upgrades.

Adobe Lightroom is a good choice for someone with a large and growing image collection who wants batch naming, custom metadata, presets, export options, collections, keyword hierarchy, and plug-ins. Lightroom users can benefit from tapping the knowledge of many professional photographers who share workflows, tips, and techniques in workshops, webinars, blogs, and books about using the software. And of course, Lightroom offers nondestructive editing. As with any professional-level software, however, expect to spend time learning to use this powerful program.

Adobe Lightroom Photo-Editing Example

Here's an example of how nondestructive editing works in Adobe Lightroom software:

1. The original image in Lightroom shows a photo album page with three vintage photos.
2. After selecting and cropping a photo from the album page, the edited image in Lightroom shows the final cropped image.
3. To use the cropped photo in a project, I exported the image in JPG format to my computer hard drive. The image file on the hard drive shows the new cropped photo ready for my project.
4. The original uncropped photo remains untouched in the PHOTO LIBRARY folder (the Master Storage Location) where it is accessed by Lightroom.

Picasa

Many users like Picasa because it is a free desktop program that works on either Mac or Windows computers, and photos are easily accessible online from multiple devices when teamed with Google+ Photos. For free software, Picasa is surprisingly robust and full-featured. It doesn't have as many batch options as Adobe Lightroom does, but it can easily manage file conversions, renaming, and most organizational tasks.

The Google+ Photos online photo space offers sharing and uploading features, as well as a new stories feature. If you choose to use these options, take time to read the privacy policies and settings to keep your images at the level of personal privacy you prefer.

Adobe Photoshop Elements

Strictly speaking, Adobe Photoshop Elements is not a nondestructive editor like Lightroom and Picasa. If you open a file in Photoshop Elements, and then crop, edit, and save it, the saved file will rewrite the original and you can't go back to the original. However, using layers in the editing mode, you can make successive changes and revert to the original at any time. And if you work on a duplicate file, you will also be saving a pristine archival copy.

Adobe Photoshop Elements is sometimes considered the "little brother" of Adobe Photoshop and Adobe Lightroom. The Organizer mode in Adobe Photoshop Elements offers tags, keywords, and easy organization similar to features in Lightroom. The Editor mode offers basic editing closer to the full Adobe Photoshop version. Adobe recognizes that Photoshop Elements users may want to graduate to a more full-featured product as they become more experienced users and offers instructions for moving from Photoshop Elements to Lightroom.

Many photographers use Lightroom for photo management and basic editing, but turn to Photoshop Elements for more complex editing tasks and working in layers. Photoshop Elements' low cost and user-friendly tools make it an attractive choice for genealogists who need photo software for occasional photo restoration work and don't need the full version of Photoshop.

Apple Photo Management

The Apple iPhone and iPad are among the most popular mobile devices worldwide. The integrated cameras capture high-quality images, and thousands of photo apps bring creative possibilities to any family photographer. The challenge, of course, is to make those images accessible anywhere, on any device. Apple's latest Yosemite operating system has changed the game plan for photo connectivity.

The former Camera Roll and Photo Stream have been replaced by the new All Photos album organized in one library and stored in the iCloud Photo Library. This new cloud library, unlike Photo Stream with the one thousand image or thirty-day limit, will store your photos as long as you have space in your iCloud storage account and maintain your account. All users receive 5 gigabytes (GB) of free storage; monthly and annual storage plans offer additional iCloud storage.

Apple aims to provide seamless photo management between all your mobile devices and your Windows or Mac computers with the iCloud Photo Library. As with any new software, keep current with iOS updates and maintain your own personal Photo Library with local copies of your original photos. The Apple iCloud may be a good additional backup to your photo collection, but don't put all your photos in one place and trust that it will be "good enough."

Here are some of the exciting new features of the iCloud ecosystem.

- Images will be uploaded and stored in the original format, including JPG, RAW, PNG, GIF, TIFF, and MP4.
- Optimized image versions are stored on mobile devices to save device storage space.
- New photos and edited versions are synced across all devices and appear in My Photo Stream, but original versions are always available on the iCloud.
- You can directly upload, delete, or download photos to and from the iCloud Photo Library.

For the latest information on Apple's iCloud photo-management program, refer to the Help section of the Apple iCloud website **<www.icloud.com>**.

HOW WILL YOU MANAGE YOUR IMAGES?

I hope I've convinced you by now of the many benefits of using dedicated photo-management software such as Picasa or Adobe Lightroom. You won't go wrong with any of the programs discussed in this chapter. I use Adobe Lightroom to manage my image collection, but I export images to Adobe Photoshop Elements to use its many editing features.

Organizing your Photo Library is an ongoing task. As long as you add new photos and images, you'll need to regularly import, tag, back up, and archive those files to your photo collection. You can research photo-organization methods forever in search of a "perfect" system, but the best system is undoubtedly the one you craft to suit your own needs and work style. Don't delay organizing your photos any longer. Start simply, going forward with new images. I'll give you some tips for bringing in your old digital images in Part 2.

When you first start organizing your Photo Library, your workflow will feel awkward, and some aspects will need to be tweaked. Don't give up. A good digital photo workflow grows and evolves over time until one day you realize, "Hey, this works for me!"

PHOTO-MANAGEMENT SOFTWARE COMPARISON

See how three popular nondestructive photo-management programs compare. When you begin shopping around for photo-management software, use the blank Photo-Management Software Comparison Worksheet to update information and compare your options.

	SOFTWARE #1	SOFTWARE #2	SOFTWARE #3
Software	Adobe Lightroom	Adobe Photoshop Elements	Picasa
Website	lightroom.adobe.com	www.adobe.com	picasa.google.com
Type of software (desktop, web-based)	Creative Cloud subscription or download	desktop software	download
Platform (PC, Mac)	PC and Mac	PC and Mac	PC and Mac
Software cost	$149	$79.99	free
Annual fee	with Creative Coud subscription	none	none
Mobile app available	Yes	Yes, with Adobe Revel	yes, with Picasa Web Albums
File formats accepted	JPG, TIFF, PNG, RAW, DNG, AVI, MOV, MP4	JPG, TIFF, PNG, PDE, GIF, PSE, PDF	JPG, TIFF, PNG, PSD, GIF, RAW, WMV, AVI, MOV
Ease of use	medium	easy	easy
FEATURES			
Active user forum	yes	yes	yes, on Google+
Automated importing	yes	yes	yes
Batch editing	yes	yes	yes
Batch renaming	yes	yes	yes
Converts file formats	yes	yes	yes
E-mail of photos	yes	yes	yes
Integrated sync or backup	yes, with Adobe Lightroom Mobile	yes, with Adobe Revel	yes, with Google+
Nondestructive editing	yes	with layers	yes
Printing of photos	yes	yes	yes
Shares photos direct to Facebook	yes	yes	no
Shares photos to social media sites	yes	yes	yes, on Google+
Tutorials/webinars	yes	yes	yes

PHOTO-MANAGEMENT SOFTWARE COMPARISON WORKSHEET

1. Explore your options for photo-management software. Fill in the blanks on this worksheet to compare each software's major features and options.
2. Remember that technology changes rapidly, so update your comments if you postpone purchasing decisions.

	SOFTWARE #1	SOFTWARE #2	SOFTWARE #3
Software			
Website			
Type of software (desktop, web-based)			
Platform (PC, Mac)			
Software cost			
Annual fee			
Mobile app available			
File formats accepted			
Ease of use			
FEATURES			
Active user forum			
Automated importing			
Batch editing			
Batch renaming			
Converts file formats			
E-mail of photos			
Integrated sync or backup			
Nondestructive editing			
Printing of photos			
Shares photos direct to Facebook			
Shares photos to social media sites			
Tutorials/webinars			

❖ Online Photo Services ❖

Afew years ago, modest bandwidth speeds and pricey subscription services limited online photo-storage options for most photographers. Today we have the speed we need, and services are in hot competition for our business, but new concerns over security and privacy make many people hesitant to commit their precious photo treasures to the cloud. All too often our personal tug-of-war between convenience and caution can freeze us from investigating our options and moving forward to add cloud storage to our photo-organization and -storage toolkit. Meanwhile, photos continue to accumulate on our mobile devices and storage cards, making it harder to take control of our photo confusion.

Technology is constantly changing. It's a fact that within months, the newest, fastest smartphone you purchase today will be supplanted quickly by a newer, faster model. Photo-management solutions face similar challenges. Do you remember Kodak Gallery or Apple's MobileMe? Who could have foreseen that Kodak would abandon its gallery and move users to rival Shutterfly? Or that Apple would replace MobileMe with an online system called iCloud?

This chapter explores the essential features of four types of photo services useful for family photographers and genealogists: photo sharing, shopping, publishing, and storage services. You'll find helpful screenshots to give you a snapshot of the user experience and step-by-step instructions to guide your first entry to the sites. At the end of the chapter, a comprehensive

chart pulls together highlights of each website. Because technology changes rapidly, the features and services on the websites mentioned here can change overnight, and you may find new options when you explore the sites.

FREE OR PAID SERVICES?

Although most photo-sharing websites offer some level of photo storage, their overall focus often includes a business for-profit model as a backbone. Many services such as Flickr and Google+ offer free online sharing and storage with an option to pay for extra storage space or an ad-free user experience.

Subscription pricing is not necessarily a bad thing. In exchange for payment, you often receive a higher level of service and customer confidence.

Users who become heavily invested in a free service also risk being held hostage if the website shifts to a paid-subscription model. If it's difficult or expensive to remove your content, you may lose years of photos and hours of organizing and tagging. Before signing up for any free or paid online sharing or storage service, always ask yourself how a company keeps the lights on and how you will extract your content if terms of service change (or if the website goes out of business).

PHOTO-SHARING SERVICES

Online photo-sharing services typically make it easy for you to upload your photos in one central online location, but it can be difficult to extract images if you need to restore a lost or damaged collection. You may be able only to download photos individually, by album, or by date, and photos may not be stored at the original full-resolution. But these services are adequate for many family photographers who shoot JPG images and want the easiest photo-management tool possible to gather their images in one central location.

Some popular photo-sharing services:

- Eyefi Cloud **<www.eyefi.com>**
- Facebook **<www.facebook.com>**
- Flickr **<www.flickr.com>**
- Google+ Photos **<plus.google.com/photos>**
- Instagram **<www.instagram.com>**
- Photobucket **<www.photobucket.com>**
- Pinterest **<www.pinterest.com>**
- SmugMug **<www.smugmug.com>**
- ThisLife **<www.thislife.com>**

Longtime favorites Flickr and Google+ Photos offer generous storage at no cost, reasonably priced subscription plans for additional storage, and many features. Some photo-sharing services such as ThisLife by Shutterfly or the Eyefi Cloud combine backup solutions with file syn-

chronization. Social media sites such as Facebook, Instagram, and Pinterest, and popular photo portfolio sites such as Photobucket and SmugMug fall into the photo-sharing category as well.

On photo-sharing websites, don't assume your images will be stored in full-resolution or that you can download photo albums and collections in easy batch operations. Think of these services as photo galleries or online exhibit spaces for your photos. Photo-sharing services emphasize features that make it easy for you to upload, organize, and share your images across devices or with other users. Let's take a closer look at each of the popular photo-sharing services mentioned above.

Eyefi Cloud

The Eyefi Cloud photo service includes some organizing features to move photos into albums, but no editing or tagging features. Downloading and sharing is limited to individual photos and batch selection by date. Overall, the Eyefi Cloud is useful for sharing images or for image backup while traveling, but may be cumbersome for practical use as cloud storage because of limited downloading options.

Facebook

Many Facebook users upload photos frequently to this social media site with the idea that Facebook is safely storing all of their images and that they can retrieve the images at any time. Yes, the photos are stored on Facebook, but they are downsized to a lower Web-viewing resolution. When downloaded for printing, you may be surprised to discover that your beautiful high-resolution photos are no longer print-quality for large sizes. In addition, if you want to download your images, you must download them individually.

If you are a Facebook fan, you can work around these limitations by using one of the photo-book services that offers Facebook integration and Facebook-specific print templates.

Facebook Is Not a Backup Service

That's right. Facebook, as well as Instagram and Flickr, are not backup services. They may offer unique ways to share and enjoy your photos, but they will not help you recreate your Photo Library when your hard drive crashes. And if you find a long-lost photo on Facebook and download the image to your computer, you'll find the crisp full-resolution file has been downsized to a modest pixel count best used on-screen or made into a pocket-size print.

The one essential feature of any good backup service is that it must be as easy to get your photos out of the system as it is to get them into it. Most photo-sharing, shopping, and publishing services are not in the business of selling two-way storage.

For example, AdoramaPix, Blurb, Mixbook, and Shutterfly can import albums and photos from Facebook for printing in a size and style suitable for these lower-resolution images.

Flickr

Popular photo-sharing site Flickr turned ten years old in 2014 and gifted users with 1TB of free storage. So why would you look anywhere else for free, easy-to-use, sharable storage? If your photo-storage needs exceed that generous 1TB, the low-cost paid subscription plans still make Flickr a bargain for online photo sharing.

Professional photographers use Flickr to showcase their work and promote sales on other sites (Flickr doesn't offer commercial selling). Photos from public archives such as the British Library and Library of Congress highlight collections in Flickr's The Commons **<www.flickr. com/commons>**.

The free Flickr mobile app makes it easy to auto-sync all of your photos or upload selected images for backing up and sharing via social media.

Flickr is a rich site for photo organization and sharing, but it doesn't offer batch downloading of images. The only way to download images at present is one at a time when you are viewing the individual photo or with third-party solutions. In addition, any work you do in organizing and tagging images exists only in Flickr; you will need to repeat the same tasks to create similar albums and collections on your desktop.

Step-by-Step Guide to Flickr

Flickr is owned by Yahoo!, so if you already have a Yahoo! account, getting started and registering with Flickr is easy.

STEP 1: LOG IN TO FLICKR. Log in at Flickr using your Yahoo! username and password, or create a new account, if needed.

STEP 2: CUSTOMIZE YOUR ACCOUNT AND PRIVACY SETTINGS. Before you start uploading photos, it's important to confirm your personal information and make sure that privacy and sharing are appropriately set. Click on your account name in the upper right-hand corner; select Settings. The Account window offers four tabs:

- **Personal Information:** Includes your name, profile picture, Yahoo! account information, and e-mail.
- **Privacy & Permissions:** Manage global settings for who can view, edit, and download your images; default settings for new images; and content filters. Don't worry if you're unsure how to adjust the settings for privacy. The options are in plain English with a Help button next to many items. You also can set sharing permissions individually, by album, and by collection. I like to set global photo permission as private and then extend viewing and sharing permission by album using the Batch Edit feature.
- **E-mails & Notifications:** Set contact information for uploading content by e-mail.

1

2

3

4

5

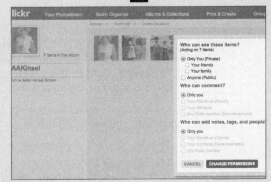

6

⚒ Sharing & Extending: Choose options for connecting to your Facebook, Twitter, and other social media accounts for automatic or selective uploading. I like to keep Auto Upload turned off and share only selected photos.

STEP 3: UPLOAD PHOTOS. Click on Upload in the Flickr menu bar at the top of the page. An upload window will open; drag photos into the uploader and wait for it to finish.

STEP 4: ORGANIZE AND SHARE. Flickr lets you organize photos in Albums and Collections and share photos to popular social media sites such as Facebook, Twitter, and Pinterest.

STEP 5: BATCH EDIT. Open an album and click the Edit option to access the Batch Edit feature. This is where you can fix an incorrect date created by your camera or quickly tag photos with the names of people, places, or events.

STEP 6: SET CREATIVE COMMONS COPYRIGHT RESTRICTIONS (IF DESIRED). Creative Commons licensing provides a way for you to grant or restrict the use of your photos by others, including placing your images in the public domain for everyone to use. Learn more about different kinds of Creative Commons licenses at **<www.creativecommons.org>**.

Google+ Photos

Google+ has absorbed the favorite online photo site formerly called Picasa Web Albums. Users of Google's suite of services may like having their photo collection accessible with Gmail and other Google apps. Chromebook users can access the exclusive Google+ Photos app that runs offline and manages all of your photos. The Google+ Photos Auto Backup option also can automatically back up photos from your computer or Android or iOS mobile phone or tablet.

The best part of Google+ Photos is all about Picasa. When teamed with the free desktop photo app Picasa, Google+ Photos appears to be the perfect photo solution. The biggest catch for many users is related to sharing and permissions. For example, to share a photo by e-mail with a single friend, you will need to deselect the default Google+ tags to limit who sees that image. If you're in a hurry, you may unintentionally share a photo you'd rather keep private.

If you're a confident Google+ user, you'll probably have no trouble working with Google's tagging and labeling system. Just keep in mind that Google+ Photos permissions will reflect your default Google+ settings until removed.

Google+ Photos is a great option for sharing photos with Google+ users, doing mobile uploads and backups, creating video/photo stories, and integrating your online photos with the desktop version of Picasa. Keywords and tags added in Picasa are embedded in the photo on export. Google+ Photos' main drawbacks are that its tricky permission labels may cause unintentional photo sharing, and limited online editing and organizing makes it harder to manage photos away from home.

Step-by-Step Guide to Google+ Photos

To manage your photo collection through Google+, follow these steps.

STEP 1: LOG IN TO GOOGLE. Sign in to your Google+ account, or create a new one, if needed. Select Photos from the menu.

STEP 2: CUSTOMIZE PHOTO SETTINGS. Under the Google+ menu, select Settings and scroll down to the Photos and Videos options. Check any options you would like activated, such as

- geolocation
- allow viewers to download photos and videos
- facial recognition and tagging
- full size (turn on if you want to back up your photos; you may need to buy more storage)
- show Google Drive photos and videos
- turn on/off Auto Enhance
- turn on/off Auto Awesome
- approve photos to be included in Photos of You

Google+ Photos permissions is locked with your default Google+ permissions. When you click a Share button to share an individual photo or album, the window will be populated with your current default choices for sharing. If you don't want to share the photo or album with these people, deselect the group or name. You also can set privacy and sharing from within the Picasa desktop program using the option for Tools (Windows) or Preferences (Mac).

STEP 3: UPLOAD PHOTOS. Click on Upload Photos in the Photos menu bar at the top of the page. An upload window will open. You can choose to add photos from your computer or use a mobile app to automatically transfer photos from your phone. To add photos from your computer, drag photos into the uploader and wait for the upload to finish.

STEP 4: CREATE STORIES. Google+ Photos offers a unique Story option that meshes videos and pictures into a shareable photo story.

STEP 5: ORGANIZE AND EDIT. Google+ Photos allows basic organizing into Albums and face-tagging. Other functions can be performed in the desktop Picasa application.

Instagram

Smartphone photographers love Instagram for fast, fun photo sharing, but you may find yourself with your best photos online and no easy way to download your own copies. The simplest way to retain some control of your photos is to activate Instagram's setting to Save Original Photos to your smartphone Photo Gallery or Camera Roll. You'll find this option under Settings.

If you want to download Instagram photos directly to your computer, check out third-party solutions such as Instaport **<www.instaport.me>**. If you want to archive your Instagram life in a photo book, use import tools on photo-book sites such as AdoramaPix, Blurb, and Shutterfly.

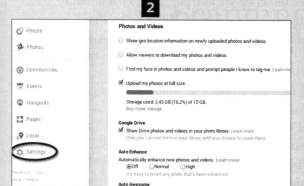

Photobucket

Both amateur and professional photographers are fans of online photo-sharing site Photobucket, where users can sell prints and other photo products made from their work. Photobucket offers easy computer and mobile uploads, full-size storage of images, storage of videos (less than ten minutes), and easy full-resolution downloads. You also can download images individually or download all images in an album. This feature is available for your own photos and photos shared publicly by other users. If you don't want others to download your photos, mark your albums Private to restrict this option.

Photobucket offers a limited amount of free storage space and linking to blogs and websites. Paid subscription accounts add unmetered bandwidth, extra storage, and ad-free use.

Pinterest

Have you ever thought about using the popular image and idea sharing site Pinterest as a sharing site for your personal or genealogy photos? You won't find photo-editing or extensive organizing features, but Pinterest can't be ignored for audience exposure.

Use Pinterest to link images on your blog or your other photo-sharing sites. Use strategic tags and descriptive terms to help other Pinterest users find your unidentified Smith Family cousins, and you may find yourself adding a new name, or a new branch, to your family tree.

Pinterest works best with short descriptions and meaningful photo titles. Be sure to include a link back to your blog or photo site, and add your contact information on your Pinterest profile so people can contact you.

SmugMug

Beautiful Web galleries, online sales, editing, tagging, and full-resolution image storage combine to make SmugMug a favorite among photographers, bloggers, and visual artists. This photo-sharing site offers mobile-friendly Web gallery templates that rival many photo portfolio sites and unique editing features for easy, fun photo adjustments.

You can send your photo to the PicMonkey **<www.picmonkey.com>** free online editor for more editing options, or select and print Moo business cards, Blurb books, and other merchandise with SmugMug's shopping options. Browse public galleries posted by other users, and order prints, cards, and products featuring favorite images.

SmugMug offers four subscription plans from Basic to Business. Photos and albums are easily marked for private or public viewing, and you can share images on Facebook, Twitter, and Google+, via e-mail, and other ways. Check out SmugMug's free trial to see if the service works for your photo needs.

ThisLife

ThisLife by Shutterfly offers a simple solution to collect all your photos at one online storage site. While Shutterfly offers unlimited photo storage too, ThisLife allows you to automatically upload images from mobile devices, cameras, and computers, and pull in images from other Web services including Facebook, Instagram, Flickr, and Google+ Photos. Because ThisLife is part of the Shutterfly family of photo services, you only need one account to log into both services.

ThisLife's free plan currently hosts thousands of photos, but no videos; paid subscription plans offer increased storage space for photos and videos. For the family that shoots and saves 250 JPG photos per month, ThisLife's current lowest-cost subscription plan would hold about eight years of photos; add video and you'll reach the storage space limit much faster. You can add more storage at an additional cost.

ThisLife is particularly good for photo sharing, mobile uploads, collecting photos from social media sites, and creating stories, books, and other projects with Shutterfly services. Best of all, your photos are never held hostage by ThisLife; the Desktop Downloader accessed through the Help menu allows easy downloading of full-size images.

Step-by-Step Guide to ThisLife

STEP 1: LOG IN TO THISLIFE. Log in to Shutterfly and then select ThisLife, or create a new account with ThisLife **<www.thislife.com>** and select a Free or Paid account. You'll see an option to link to social accounts; skip this for now.

STEP 2: CUSTOMIZE ACCOUNT AND PRIVACY SETTINGS. Click the Gear icon in the upper right corner and select Settings to customize your account information and share settings. ThisLife is totally private; you need to actively share photos and albums for others to view your photos.

STEP 3: UPLOAD PHOTOS. There are four ways to import photos to ThisLife. Click the Add button in the menu bar to open the Photo Upload window.

- **To upload from your computer:** Click Choose Files to add photos from your computer, and browse to select the folder and files to import.
- **To upload from the desktop uploader:** Click the Get Desktop Uploader button and install the application on your computer. Follow the prompts to set up the Desktop Installer to Auto Import photos from specific folders on your computer.
- **To upload from social media websites:** Note the import buttons across the top of the uploader window and select Facebook, Shutterfly, Flickr, Picasa, Instagram, or SmugMug.

> ✳ **TIP** ✳
>
> **ThisLife Help**
>
> If you need help or want to know more about a particular button, click the question mark icon in the bottom right corner to view the Help menu.

✴ **To upload from your smartphone or tablet:** Click the Get Mobile App button to send a link to your smartphone for downloading the Android or iOS mobile app. You can set the Auto Upload feature on your mobile devices to import any photos you take on your smartphone and camera directly to ThisLife.

STEP 4: ORGANIZE AND EDIT IMAGES. Photos are organized by date as they are imported to ThisLife. View photos by day, month, or year. Select and click on a photo to bring up the full editing menu. Use the tools along the bottom of the window to add ratings, add to a story, share, hide, play slideshow, add/remove tags, add/play/delete audio, rotate, crop, download, and delete.

STEP 5: SHARE. To share images, click individual photos or a timeline date and then click Share to select E-mail, Link, Share Sites, Facebook, Twitter, or Tumblr.

STEP 6: CREATE. Select a few photos and click Create to open the photo project window for options to turn your photos into photo books, cards, calendars, and other Shutterfly products.

PHOTO-SHOPPING SERVICES

Websites such as Shutterfly and Snapfish hope to meet your photo-storage needs and capture your photo book, calendar, and card business. Many retailers including Walgreens **<www.walgreens.com>**, Costco **<www.costco.com>**, and Walmart **<www.walmart.com>** have partnerships with photo-sharing sites and offer special pricing, in-store pickup, and other features to attract your business. Any photo sharing is usually done behind a registration wall to help maintain privacy and permissions, a good feature for families and groups.

Photo uploading and storage is a necessary step for crafting calendars, cards, mugs, books, and other photo gifts. Shopping services know that if your pictures are conveniently stashed on their servers, you are more likely to create and purchase items with their tools. The downside is that these sites can change the terms of their free storage at any time, leaving you with a large collection of images stuck on the company's Web space (or in the worst-case scenario, deleted due to inactivity). Think of these websites as photo shopping malls offering one-stop shopping for all your photo needs. It's great if they offer what you want, but keep shopping if you need something different.

A few popular photo-shopping services:

✴ AdoramaPix **<www.adoramapix.com>**
✴ Shutterfly **<www.shutterfly.com>**
✴ Snapfish **<www.snapfish.com>**

AdoramaPix

AdoramaPix books are a favorite with many scrapbookers who enjoy the large selection of book layouts, stickers, and photo-editing features. Three cover styles are offered: hardcover, leather lux, and leather. All printing is on archival-quality silver halide photo paper. Lay-flat style books

are offered in Hudson Albums with true flush-mount spreads and thick pages available with gilded edges in portrait, square, and landscape orientation.

Other standout products at AdoramaPix include metal prints, customizable calendars, and canvas wrap prints. AdoramaPix is unique in featuring calendar designs as stickers or embellishments, which opens options for creating custom calendar photo books, single prints, or posters.

AdoramaPix is a partner site with Adorama camera store **<www.adorama.com>**, which offers camera gear for sale and photography tutorials. If you live near the New York City store, you may want to save shipping charges by picking up your order in the store.

New users will want to check out the AdoramaPix YouTube Channel **<www.youtube.com/user/adoramapix>** for workshops and tutorials. The AdoramaPix online Help section offers limited hours of assistance and is not as easy to use as some other sites, so this site might not be the best choice if you're a new user and need to design something fast.

Overall, AdoramaPix is good for

* metal, canvas, and acrylic prints.
* archival-quality photo books.
* spiral-bound customizable calendars.
* panorama-size books.
* monthly calendar projects.
* movable calendar stickers.

Genealogists often like AdoramaPix for creating family heritage theme books, using full-page photos on projects, and creating customized calendars.

Shutterfly

Founded in 1999, Shutterfly is a longtime favorite photo site that has expanded its brand to include Tiny Prints, Wedding Paper Divas, ThisLife, and MyPublisher. You can find almost any photo product imaginable at Shutterfly or one of its partner sites.

I'm a big fan of Shutterfly's free private Share Sites, a customizable Web page where families and groups can create a secure online space to share photo albums, news, and events.

Shutterfly's generous free, unlimited, and secure photo storage promise to "never delete your photos" makes this site popular with busy photo lovers looking for a one-stop shopping, storage, and sharing solution. Users who want more storage features can subscribe to ThisLife, which supports full-resolution images, facial recognition, image duplication prevention, and account sharing.

Overall, Shutterfly is good for

* private photo sharing with friends, family, and groups.
* mobile uploads and backups.
* easy project creation and print ordering.
* storing and using high-resolution images for posters and big prints.

* downloading print-quality photos individually.
* ordering full-resolution images on an archival DVD.

Genealogists often like Shutterfly for its private photo sharing, archival DVD service, afford-able family history books, and local pickup of prints and projects.

Snapfish

Snapfish is a full-featured photo-sharing and project creation service with free unlimited high-resolution photo storage (as long as you make at least one purchase every year), social media sharing, and discount partnerships with Costco, Walgreens, and Walmart. Now owned by Hewlett-Packard, Snapfish is also one of the few services to offer print-at-home features for many projects. More important, your uploaded photos are not "stuck" in Snapfish forever. You can download up to fifty photos at one time, making this site a good bridge for sharing images.

Snapfish does a good job balancing privacy, ease of use, and features. The website might look a bit dated compared to Shutterfly or Flickr, but intuitive menu options and tutorial videos that guide new users through basic functions to make the site easy to use.

Snapfish is a good site for

* private photo sharing with friends, family, and groups.
* mobile uploads and backups.
* easy project creation and print ordering.
* storing and using high-resolution images for posters and big prints.
* downloading up to fifty photos at one time.

Genealogists often like Snapfish for its family history theme photo projects, printable prod-ucts, affordable product pricing, and its local in-store pickup services. Snapfish also offers step-by-step user guides, which is a bonus if you haven't used an online photo service before.

Step-by-Step Guide to Snapfish

STEP 1: OPEN AN ACCOUNT. Setting up a Snapfish account is relatively easy. The default pri-vacy settings are fine for most users; you won't need to change anything unless you want to set up share groups. Access your photos and albums in the Welcome menu or create projects in the Shop menu.

STEP 2: UPLOAD PHOTOS. To upload photos, click the Upload button in the Welcome menu and select Upload From Computer, Import From Facebook, or Import From Flickr.

STEP 3: SHARE AFTER UPLOADING. Snapfish makes it easy to share after uploading. Check your contacts and groups, or add new e-mails to share new uploads.

STEP 4: ORGANIZE, EDIT, AND CREATE. Select an album to view photos; select individual pho-tos to Share, Print, or Create Projects. Click the Edit Options on the far right to open the Edit menu to rotate, add tags, rate, caption, copy/move images, delete, or download.

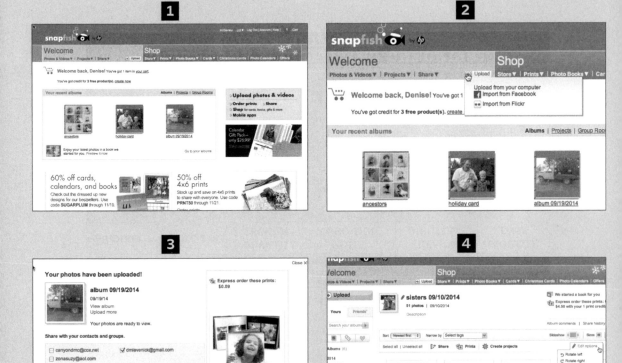

Other Options for Specialty Photo Products

You may want to create custom photo T-shirts for a family reunion and invite relatives to purchase their favorite color and size online. Zazzle **<www.zazzle.com>** and CafePress **<www.cafepress.com>** offer small-quantity printing and affordable pricing for T-shirts, baby onesies, aprons, totes, hats, and other products. Add your custom item to a personal store, and your family can buy as many items as they wish and have them shipped directly to their home address.

Professional photographers turn to MyPhotoPipe **<www.myphotopipe.com>** for quality custom printing of wrap canvas, panoramic prints, and gallery-style prints. Vistaprint **<www.vistaprint.com>** is another online company worth checking out for quantity print projects. Crafters and designers enjoy creating custom-designed fabric using photos and other artwork with Spoonflower **<www.spoonflower.com>**.

PHOTO-BOOK PUBLISHING SERVICES

Photo-book building sites focus almost exclusively on providing specialty books and products such as books, calendars, and cards. These are the sites to use when you're looking for unique design themes and publishing features, but you won't find family websites, free mass photo storage, or public photo galleries. In most cases, you'll want to upload full-resolution photos for a specific project instead of using the website to store your growing personal photo collection. Storage space on these websites is often limited to active accounts and projects.

Popular photo-book publishing services:

* Blurb **<www.blurb.com>**
* Lulu **<www.lulu.com>**
* Mixbook **<www.mixbook.com>**
* MyPublisher **<www.mypublisher.com>**

Blurb

Blurb is a paradise for total photo-book control. If you feel constrained by clunky design software or limited design themes and templates, you might like to explore the different book-building options of Blurb.

* **Bookify** offers easy online book building in five sizes, from 7x7-inch to 12x12-inch square books. It's a good fit for books made with photos imported from Facebook or Instagram, or for quick photo-book projects.
* **BookSmart** is free downloadable software that allows you to work on your book online or offline. More features and templates include notebooks, photo books, text-only books, and planners.

Photo Editing with PicMonkey

Family photos should be fun. And the PicMonkey online photo editor is all about easy, fun photo creations. This free online tool offers filters, templates, fonts, editing tools, and professionally designed theme templates to make your photos look their best.

Bloggers and Pinterest fans use PicMonkey to make quick image badges with titles and web addresses. Family photographers will find a wide selection of easy tools to adjust and tweak images for cards, photo books, and other projects.

To get started, go to PicMonkey and select Edit, Touch Up, Design, or Collage. A drop-down menu will guide you in selecting the photo you want to work with. You can use an image from your computer, Facebook, OneDrive, Dropbox, or Flickr accounts. If you want to save images to PicMonkey, you'll need to register for an account and sign in. A free account gives access to plenty of features for most users. If you want more, consider purchasing a subscription.

❋ **BookWright** is the perfect tool for creating print and e-book versions with built-in designer templates. The software download is free and lets you work online or offline.

More design control is available with Blurb's Adobe InDesign plug in, a module for Adobe Lightroom, and its PDF to Book tool.

Plus, if you want to go mobile, Blurb offers the Blurb iOS mobile app so you can create, share, and print stories from your iPhone or iPad. Samsung Galaxy users can access Blurb's book tools from the built-in Story Album app.

Blurb doesn't offer extensive photo-editing tools such as special-effects filters, stickers, or embellishments; nor does Blurb stress photo storage and sharing. Instead, Blurb focuses on custom book design. Volume pricing makes Blurb a good choice for printing larger quantities, and the Direct Sell program can handle sales and distribution for selling your books online.

Overall, Blurb is good for

❋ custom text and photo books.

❋ volume pricing.

❋ online selling.

❋ having a wide range of sizes for many different projects.

Genealogists often like Blurb for creating family history books, volume pricing, and producing e-book editions. Its online sales services are good for distributing books to family and friends.

Lulu

Authors who want maximum control over their printed book, from design to sales and marketing, appreciate the high-quality services offered by self-publisher Lulu. If you're a genealogist who wants to publish a limited-edition family history book, Lulu may offer exactly the kind of features you need.

Helpful tutorials and user forums offer ideas and advice for creating photo and traditional text-only books, e-books, and calendars. After your book is complete, Lulu will help you market and sell your book through individual online orders and give you volume discounts to sell at family reunions or genealogical society meetings.

Mixbook

Mixbook specializes in designer-theme photo books, cards, and calendars. Its mobile partner Mosaic **<www.heymosaic.com>** creates twenty-page books in minutes and delivers them to your hands in four days. On your computer, Mixbook's Montage **<www.montagebook.com>** service allows you to create a larger, lay-flat photo book online.

Every page of every project is completely customizable at Mixbook. You can mix and match design themes to create a unique book. You can even change the number of photos displayed on a holiday greeting card. Family historians love the beautiful pedigree charts and tribute designs

that can be added to any photo-book style. Genealogists also like Mixbook for its collaboration tools and its Auto Fill feature, which helps speed photo importing.

Overall, Mixbook is good for

* uploading photos from social media and photo-sharing sites.
* complete customization.
* full-bleed and two-page photo spreads.
* lay-flat book options.
* collaboration.
* fun, fast mobile book app Mosaic.

Mixbook is not a photo-storage site, so you need to upload photos as needed for a project.

MyPublisher

Now a subsidiary of Shutterfly, MyPublisher offers downloadable book-making software for Mac and Windows platforms, so you can work on your book on your computer whenever you wish—you don't have to be online to create your book. If you want to craft a book from your mobile device, MyPublisher offers the KeepShot app **<www.keepshot.com>**.

MyPublisher focuses on unique finishing options such as super-gloss printing, lay-flat pages, endpapers, slipcases, and book boxes to make your photo book a truly special product. Book sizes start at the 3.5x2.75-inch Mini Book and go up to the 15x11.5-inch Deluxe Hardcover. A gallery of inspirational "just published" books is packed with ideas for your next project.

MyPublisher is especially good for

* designing books offline.
* complete customization.
* full-bleed and two-page photo spreads.
* lay-flat books.
* unique book sizes.

Genealogists like MyPublisher for its presentation boxes, slipcovers, and unique covers, as well as for its computer-based design software. The site also has Storyteller and Vintage design themes for family histories.

PHOTO-STORAGE SERVICES

True cloud storage services are in business to sell one thing: online storage. Services may also offer different features to set them apart from the competition and attract your business. For example, the file storage and synchronization service Dropbox is different from an online backup service like Backblaze, although both store a copy of your data on the cloud.

Storage and synchronization services may keep deleted files for a limited time only, often thirty days. You may have difficulty restoring files when that time expires. Backup services focus on long-term preservation of files and may be a better choice for archiving images.

Popular storage and synchronization services:

- �֞ Apple iCloud **<www.apple.com/icloud>**
- ✖ Dropbox **<www.dropbox.com>**
- ✖ Google Drive **<www.drive.google.com>**
- ✖ Microsoft OneDrive **<www.onedrive.live.com>**
- ✖ ThisLife **<www.thislife.com>**

Popular online backup services:

- ✖ Amazon Cloud Drive **<www.amazon.com/clouddrive>**
- ✖ Backblaze **<www.backblaze.com>**
- ✖ Carbonite **<www.carbonite.com>**
- ✖ CrashPlan **<www.crashplan.com>**
- ✖ Mozy **<www.mozy.com>**

The Sync-and-Store Solution

Cloud storage is designed to provide a safe haven for your data. You can upload files from your mobile device or computer to another space (or file server) where they can be accessed by the original uploading device or by other synced devices. Synchronization keeps files and images updated and accessible from multiple devices. For example, if you crop and enhance a photo on your computer and save it to a cloud storage service, the edited version will appear when you open it on your iPad or computer. This is a real asset if you work on one computer at work or school and another at home, or if you need to access files from multiple mobile devices.

Whether you need to safeguard last week's family smartphone snapshots or last century's heirloom photos, the best cloud storage solutions should be easy, automatic, and affordable. A cloud sync-and-store strategy can temporarily safeguard your mobile photos until you have time to move them into a permanent location in your Photo Library. In addition, some people may choose to use cloud storage as their off-site backup solution as part of a 3-2-1 Backup strategy (see Chapter 1) for their entire photo collection.

I held off from adding cloud sync software to my photo organization and archiving workflow until my sister told me about all the photos she lost while migrating from old storage to newer media. She "thought" everything had transferred and didn't discover that something had failed until after she erased the originals. Now the best copies available are lower-resolution files posted to Facebook or Instagram, or ones she had e-mailed to family and friends. She is the most organized person I know, so I figure if she signed up for cloud sync, it must be a good thing.

Some of the many advantages of cloud storage include

- ✖ automatic uploading from all devices to one location.
- ✖ peace of mind in case of disaster, theft, or computer crash that you have a copy of images from mobile devices.
- ✖ remote access from other computers and devices.

CLOUD STORAGE SERVICE COMPARISON WORKSHEET

Cloud storage services constantly introduce new features and revise storage quotas, subscription plans and prices, and other services. Be careful before committing your entire photo collection to a new service. Use this chart to compare features of the cloud storage services you may want to try.

	SERVICE #1	SERVICE #2	SERVICE #3
Service name			
Service URL			
PRICING			
Free option			
Paid storage options			
Cost per 50GB			
Cost per 500GB			
FEATURES & SERVICES			
Allows videos			
Batch editing			
Batch file renaming			
Bulk downloading			
Compatible file formats			
Detects duplicates			
Facial recognition			
Location tagging			
Private sharing			
Social media integration			
Syncs with desktop photo software			
Syncs with mobile devices			
Web app available			

Begin your search for a cloud storage solution in your own tech toolbox. Look carefully at any service you are already using, such as Apple iCloud, Dropbox, Google Drive, or Microsoft OneDrive. If you want to manage and edit your photos online, you'll want a service that offers albums, collections, and extensive editing tools, such as Apple's iCloud or Google Drive. If you plan to do most photo editing and organizing using a photo-management program on your computer, you'll have more options in selecting a sync-and-store service.

Essential features to look for include compatibility with your mobile device, ease of use, and pricing. While cloud storage services typically offer some level of free storage, you can most likely expect to pay a monthly or annual subscription fee as your photo-storage needs grow. Cloud storage services want your business and set their prices competitively based on the amount of storage you need. If you already use cloud storage tools for other documents, the cost of switching services and learning a new system may not be worth a small dollar in savings. Use the Cloud Storage Service Comparison Worksheet to compare cloud storage services.

Moving Photos From Cloud Storage to Your Photo Library

As I mentioned, cloud storage services can safely store your mobile photos until you have time to move them into a permanent location in your Photo Library. Using cloud storage is a big step in rounding up your digital photos. But you aren't finished yet. To move photos from the cloud storage into your Photo Library, you'll need to manually drag and drop pictures from your cloud storage service (such as Dropbox) to the appropriate folders, creating new folders as needed. This is the same procedure used earlier to move images from a memory card to your PHOTO LIBRARY folder.

Step-by-Step Guide to Dropbox Cloud Storage

Many genealogists rely on Dropbox to sync images and documents between multiple devices, and for sharing files with other computer users. After you upload images to Dropbox, you can delete images from your smartphone knowing they have been saved to your Camera Uploads folder in Dropbox.

Let me show you how easy it is to set up Dropbox for your digital images. (These instructions are for using Dropbox with Apple devices.)

STEP 1: DOWNLOAD THE DROPBOX APP TO YOUR SMARTPHONE AND COMPUTER. To turn on the Dropbox Camera Upload feature, you'll need to download and install the Dropbox app on your smartphone or tablet, as well as on your home computer.

STEP 2: LOG IN AND ADJUST SETTINGS. Using your smartphone or tablet, open the Dropbox app and log in. Click the Settings icon in the bottom menu bar. Turn on the switch for Camera Upload. Do not turn on Use Cellular Data unless you want to use your data plan for photo uploads (this may incur extra charges). Turn on Background Uploading and click Enable to continue uploading after you stop using your iPad.

1

2

3

4

5

6

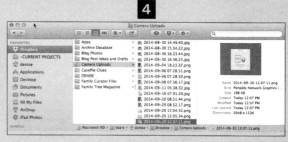

STEP 3: VIEW PHOTOS ON MOBILE DEVICE. Download and install the Carousel app to view photos within the app on your mobile device.

STEP 4: VIEW PHOTOS IN DROPBOX. Alternatively, view photos on your mobile device or desktop in the Camera Uploads folder (located inside your Dropbox folder).

STEP 5: INITIATE AUTOMATIC UPLOADING (OPTIONAL). To set up automatic uploading directly from your computer, click the Gear icon in the Dropbox menu and click on the Preferences option.

STEP 6: COMPLETE AUTOMATIC UPLOADING SETUP (OPTIONAL). If you completed Step 5, you'll want to continue your automatic uploading setup with this step. To enable uploads from a camera, mobile device, flash drive, or SD card connected to your computer, click the photo Import icon. Make your selections to import photos directly from iPhoto on the Mac or enable camera uploads for photos and videos from a mobile device, camera, or memory card connected to your computer.

If you have a large Photo Library, especially one with TIFF files, automatically uploading images will quickly fill up your online storage space. However, it's a workable option for small collections or temporary storage. Be aware of how much online storage space will be required to house your photo collection.

Privacy and the Cloud

Unless you are hosting your own private cloud, you are subject to the terms and policies of your cloud hosting service. Make sure you take time to read and understand these terms, especially the Privacy Policy and Terms and Conditions related to photo copyright or intellectual rights. Here are two questions to ask about storing your images in the cloud.

1. Are you the copyright owner? Beware any service that does not acknowledge you as the copyright owner of your own original material. You never want to forfeit your right to own and control material you created.

2. What are you giving away? As the saying goes, "there's no such thing as a free lunch." Cloud services often offer initial free storage, but be prepared to pay for storage as your collection grows. Use the trial period or free storage to try out the service, but plan to pay the regular monthly or annual subscription price in the same way you pay for household electric service. If you cancel the service or stop paying, your subscription will lapse and you may lose your photo collection. In addition, cloud services typically collect your personal information and use this for targeted ad campaigns; your information also may be shared or sold to third-party companies. Your personal information may include the names and addresses of people with whom you share photos. Read the Terms of Service carefully to fully understand what you are exchanging for use of the service.

As digital storage prices have dropped and wireless speeds increased, cloud storage has become the new buzz of digital photo management. But how it best fits into your digital photo-management workflow depends on your personal attitude toward privacy and security and your own level of tech expertise. Consumer-level cloud services may appear to be simply free storage, when the service is actually tied in with a photo-sharing or product service. For example, you may be enticed by unlimited free photo storage and later discover that your files have been compressed and are no longer available as full-resolution files. Or you may find that you can only download archived images individually or in small batches. Ultimately, you need to decide what type of photo-storage solution—on-site or cloud-based—works best for you and then select the specific hardware and/or service that suits your budget and needs.

ONLINE BACKUP SERVICE SOLUTIONS

An online backup service is different from a cloud storage-and-synchronization solution. How is it different? Online backup services focus on long-term archiving and preservation of original files. The goal of a backup is to save original files in original quality.

Preservation of photos is key for family historians. We want our heirloom family photos archived in a file that won't be corrupted or damaged by revision, accidental overwriting, or time. This is why uncompressed, stable file formats such as TIFF and PDF are often recommended for archiving photographs and documents.

Many genealogists use cloud storage and synchronization (Dropbox or GoogleDrive) for everyday working files and rely on backup services (Backblaze or Carbonite) to store an off-site archive of heritage images that's accessible when they need it to be.

Like cloud storage services, online backup services store files in the cloud and charge subscription fees. Fees are based on security features, restoration points, the level of customer service, and the amount of storage space you need. Backup services automatically upload your images, so you don't have to worry about remembering to manually backup, sync, or migrate images. Because your Photo Archive is stored on the backup service's servers, which provide redundancy, your files will be protected from theft, disaster, or hard drive failure.

❖ Digital Photo-Management ❖ Workflow

Anyone on "image overload" can learn a few things from professional photographers and graphic artists who work with millions of images every day. A successful wedding photographer, for example, must work quickly and efficiently to earn a living with his camera. He will capture hundreds of images for the event and select only the best shots to show the bride and groom. Favorites will be edited and assembled into the final product: the wedding album. The entire process from image capture to selection to editing and final product is called the photographer's workflow. By repeating the steps over and over, this routine becomes so familiar that he can do it almost without thinking.

You probably have a workflow, too, although it might not feel like a *productive* workflow if you're drowning in digital images. It might be time to step back and figure out what is and isn't working so you can bring order to your digital photo chaos and become the master of your photo collection.

The benefits of digital photo-management and a workflow routine become clearer as you work through each step of managing your files. In this chapter, I'll break down step by step how to get started managing your photos using a digital asset management workflow with a manual system as well as with photo-management software.

DIGITAL ASSET MANAGEMENT

Creating an effective workflow isn't easy. Professional photographers quickly learn that they need a comprehensive system to help with every step of the process—capturing, importing, renaming, editing, resizing, tagging, captioning, archiving, backing up, and exporting their files. This comprehensive system for managing digital images is called *digital asset management* (or DAM, for short). Professional photographers and other creatives worldwide who manage all kinds of digital files such as photos, movies, audio files, and documents use DAM. Pros take time to study and understand each step in the DAM process to develop their own efficient and personalized workflow.

Family photographers and family historians can benefit from a simplified DAM system focusing on their most typical assets—photos and video files. This is sometimes called *digital photo management* (DPM). A personalized DAM/DPM system lets you integrate the workflow into your own digital file-handling process so it works best for you and maintaining it is easy. We'll use the term DAM here because it is the preferred term for digital photo management.

How DAM Benefits You

Effective DAM involves more than a tidy file folder system and long, meaningful file names, but the benefits are greater, too. At its core, DAM harnesses the power of your computer for better access with labels and tags. For the family photographer and historian, the greatest value may be the ability to embed identification within the image file. An efficient DAM system will

- allow you to organize your images in a way that makes sense to you.
- guide you through all steps from image capture to image sharing.
- provide a structure to help maintain consistency when you work with images infrequently.
- expand as needed to accommodate your growing digital collection.
- offer data security with backups and archival protocol.
- make it easy to migrate from old to new equipment.
- offer tools for collaboration and future users.

How to Set Up Your Personal DAM Workflow

In its simplest form, DAM is all about capturing, storing, and accessing images. Each step of the workflow refines these tasks so you can easily locate images for editing and sharing the end product, and be confident that your photo collection is secure. A DAM workflow typically involves seven tasks.

IMAGE CAPTURE: Image capture includes whatever method you use to acquire an image. For a photographer, images are typically captured with a camera. A family historian might also capture images with a scanner or by downloading image files from the Internet. Digital images are typically captured to hard drives, memory cards, flash drives, or a device's internal memory.

IMPORTING IMAGES: This task refers to moving the images from the initial capture device or temporary storage location into long-term storage. Some DAM workflow scenarios also use the term *downloading* or *ingesting*. You may be able to automate some of the importing steps with software such as Adobe Lightroom or Adobe Photoshop Elements.

RENAMING: It's important to rename images from camera-generated file names to something meaningful and useful. Photo-management software can make this task easier with options to rename files on import or batch name files already in your system. Some family historians use file names as a place to include information about the people, dates, places, and events depicted in an image. In the days before metadata (information about the image embedded in the image file) was widely used, this was a helpful way to organize and access images. Even long file names, however, can't include the extensive data available through keywords and tags.

BACKING UP: One of the most important steps in your workflow is to back up your image collection securely and regularly on another kind of media. Unfortunately, this is the one step most likely to be postponed or ignored. A single copy is NOT a backup. A copy on the same hard drive is NOT a backup. A copy on Dropbox is NOT a backup.

Most photographers use a series of external hard drives as part of their backup program. Working files are located on a computer or external hard drive. An external drive is used for daily backups and stored on-site in a fireproof safe. A third copy of the Photo Library is stored off-site (such as in a safe deposit box or in the cloud) for security.

TAGGING: Adding labels, keywords, and other information is crucial to any DAM workflow. These tags are known as metadata or "data about data." Professional photographers use keywords to sort and label images so they are easier to find later. Tags and ratings help evaluate photos to select the best of the best. Titles, captions, and location information add context to an image.

Tags, labels, keywords, and ratings will help you take advantage of the full benefits of working with digital images. Anyone working with family photographs, either new digital images or scans of old photos, should take full advantage of the magic of metadata to record historical data about people, places, dates, and events.

ARCHIVING: Regular backups are an essential step in daily digital work, but archiving takes backups a step further to give you extra assurance that your digital image collection is safe for the long term. A photo archive often includes preserving images on physical media such as DVDs or another external hard drive. It's migrated to new media as needed. The photo archive is not accessed on a daily basis and can be configured with backup software to update only edited and new files to save time.

EDITING, EXPORTING, AND SHARING: All of your images might as well be in a dark shoebox if you don't export them into a shareable format. These files need different handling from your archival and working digital files. Many images will benefit from editing, cropping, and adjustments. Most will need to be resized for their intended use, such as e-mailing or creating a photo book or other photo project.

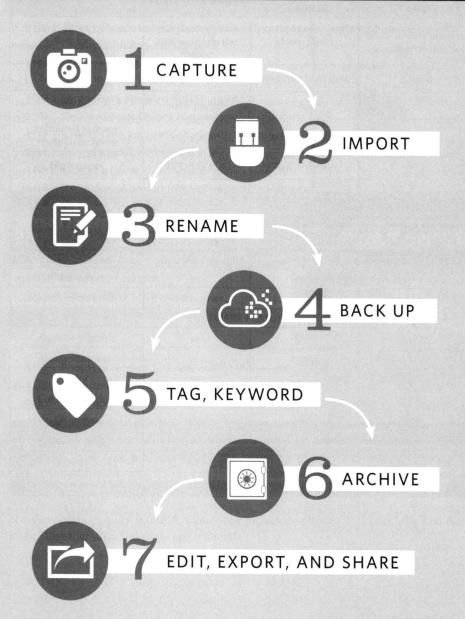

AT A GLANCE:
YOUR DIGITAL ASSET MANAGEMENT WORKFLOW

1 CAPTURE

2 IMPORT

3 RENAME

4 BACK UP

5 TAG, KEYWORD

6 ARCHIVE

7 EDIT, EXPORT, AND SHARE

What About My Current Mess?

When you're ready to begin managing your photo collection in an organized DAM workflow, start small with your new photos and work forward. Pick a "Digital Photo Birthday," the same trick I recommend when migrating to a paperless office. Decide that from your Digital Photo Birthday forward, all images will be managed with your new system. Select a date that's easy to remember such as your birthday, anniversary, or a major holiday. Gradually, as you have time, move old photos into your new system. Don't try to do it all at once. It will be overwhelming, and you'll lose the opportunity to refine your workflow while working with a smaller, more manageable number of photos.

USING A MANUAL WORKFLOW FOR DIGITAL PHOTO MANAGEMENT

If you haven't already done so, follow these steps to set up your PHOTO LIBRARY folder. Refer to Chapter 1 for more details.

CHOOSE A MASTER STORAGE LOCATION AND PURCHASE EQUIPMENT. Your master image collection should be consolidated and managed in one central Master Storage Location, preferably on your computer or external hard drive. I call this collection my Photo Library. If you have decided to store your images on an external hard drive (rather than your computer hard drive), purchase and connect the external drive to your computer.

CREATE YOUR PHOTO LIBRARY FOLDERS. Navigate to your selected photo Master Storage Location and create a folder named PHOTO LIBRARY. Inside this folder, create the following folders, substituting the current year and month for the images you are ready to import:

* 2015
* 2015_09_SEPT

If you are ready to import images from a few months, go ahead and make the corresponding folders, but remember, we are starting small with a limited number of images.

SET UP YOUR BACKUP AND ARCHIVE. You will need a backup plan for your Photo Library, preferably an external hard drive, archival DVDs, and/or a cloud storage service. I call this backup my Image Vault. I keep my Image Vault on an external hard drive stored on-site and use it to back up files after a photo-editing or transferring session. You'll also need a Photo Archive, which is a third backup copy of your collection that you store off-site. Your Photo Archive may be on an external hard drive, archival DVDs, and/or an online backup service. Purchase and set up your Image Vault and Photo Archive storage devices or services.

Step-by-Step Manual DAM Workflow

STEP 1: CAPTURE. Create digital images using your digital camera, smartphone, tablet, scanner, or other device.

STEP 2: IMPORT. First, disable your computer's automatic downloader. Your computer wants to help you manage your images and may automatically open an Import window when connected to a camera or other image-storage device using Image Capture (Mac) or Photo Gallery Import (Windows). The default destination for new images may not be the location you want for every photo upload, so I suggest that you disable this automated utility.

Next, locate the camera SD card, smartphone, cloud folder, or whatever device holds your latest photo images. If your photos are on a memory card, insert your memory card and drag and drop the images into the appropriate folders. Do not delete the images from the capture device until you've worked through the entire workflow. If your photos are on a smartphone or tablet, connect your device to your computer and drag and drop the images into the appropriate folders in your Photo Library. If your photos are on a cloud storage site, log in to your cloud service and drag and drop the images from the cloud into the appropriate folders in your Photo Library. Remember, the goal is to collect all of your digital images into one Master Storage Location.

STEP 3: RENAME. Use short, unique, meaningful file names. Do not use names that would cause confusion if moved from a containing folder. For example, *TomsBirthday.jpg* might be found in 2010, 2015, and 2017. A better name would be *TomsBirthdayCake2015.jpg*. Many photos from the same event can benefit from file-sequencing numbers added during batch scanning or import, if available.

A family photo file name should help you identify the image if you are skimming a small selection of photos for a photo book and want to position the birthday cake photo before the gift photo. Your file name does not need to include all image information such as exact date, time, full name, location, and event. (See Chapter 1 for more on file-naming schemes.)

STEP 4: BACK UP. Back up your entire Photo Library to your selected backup storage location. Automated software can selectively back up only images that have been modified or added since the last backup. This saves considerable time when working with large photo collections.

You should now have two copies of your photos: one in your Photo Library and one in your Image Vault.

STEP 5: TAG AND ADD KEYWORDS. Adding metadata such as keywords, tags, captions, and other information is undoubtedly the most time-consuming step in any photographer's post-capture workflow. And it's probably the one step that most family photographers persistently ignore. Fortunately, the most important metadata (the date) is added automatically by your camera or capture device, so if you do nothing more than import correctly dated images to your computer, you can still take advantage of the benefits of DAM.

Add tags, keywords, and captions in Properties (PC) or Get Info (Mac), or in your photo-management software. (See Chapter 1 for more details.)

STEP 6: ARCHIVE. Your Photo Archive preserves your digital photos for the future. Unlike your working Photo Library or Image Vault on an external hard drive, the cloud, or DVD that's

available for a quick restore in case of loss or damage, a Photo Archive doesn't need frequent access. Archival DVDs, CDs, and Blu-ray discs are good choices for archival media and can be added to without the need to rewrite or handle older material.

Use automated backup software or a manual drag-and-drop technique to burn archival discs or create a Photo Archive on other storage media. Know the lifespan of your chosen archival storage media and migrate files as needed to newer storage. Store this copy off-site and access it only when all other copies are damaged or lost, or when you migrate it to newer storage media.

Another option for backing up your Photo Archive is to use an online backup service. See the Appendix for a list of backup services to consider.

STEP 7: EDIT, EXPORT, AND SHARE. Everyday family photos often benefit from cropping and some editing to remove red-eye, adjust exposure, or touch up blemishes. If you're working in a standard photo editor that saves changes as it overwrites the original file, always create a copy using the Save As command when you begin an editing session. Keep track of these edited editions with version file names discussed in Chapter 1: *2010_david_bday-edit.jpg*.

You also may need to convert your photos to special sizes or resolution for different uses, such as e-mailing or posting to your blog or website. Do this by creating a copy with the Save As command or Export. These files might be named something like *2010_david_bday-web.jpg* or *2010_david_bday-email.jpg*.

If you often reuse the same image, keep a copy in your file system; otherwise, delete the desktop copy after e-mailing it or posting it to your Web page.

To assemble photos for a photo book or other project, save a copy in a separate folder either on your desktop (good for current projects) or in your Photo Library, where the folder will continue to be backed up with your other image files. This copy should be full-resolution or the size recommended for the product by the photo service.

USING SOFTWARE FOR DIGITAL PHOTO MANAGEMENT

As with a manual workflow, when using photo-management software, your master image collection should be consolidated and managed in one location—preferably on your computer or external hard drive. If you have decided to store your images on an external hard drive, you need to purchase and connect the drive to your computer. You will also need a second hard drive as a backup device.

PURCHASE AND INSTALL YOUR SOFTWARE. Download and install your photo-management software. If you are new to the program, it's a good idea to go through the tutorials and learn the basic steps for importing images and working with files.

CREATE YOUR PHOTO LIBRARY FOLDER. Navigate to your Master Storage Location (on your computer or an external hard drive) and create a folder named PHOTO LIBRARY. Inside this folder, create folders using the current year and month for the images you are ready to import; for example:

�֍ 2015

✖ 2015_09_SEPT

When you are ready to import images captured over a few months, go ahead and make the corresponding folders, but remember to start small with a limited number of images.

This folder setup is exactly the same as if you were manually organizing your photos. This is intentional so that if you want to move to a different system at any time, this standard folder and file system will be easy to understand and relocate.

SET UP YOUR BACKUP AND ARCHIVE. Once again you will need a backup and archiving plan for your Photo Library. Create an Image Vault to back up files after a photo-editing or importing session and a Photo Archive to store a copy of your entire collection off-site. Your Image Vault could be located on an external hard drive, archival DVDs, and/or a cloud storage service. Your Photo Archive may be on an external hard drive, archival DVDs, and/or an online backup service. Purchase and set up your Image Vault and Photo Archive storage devices or services.

Step-by-Step DAM Workflow Using Photo-Management Software

For this example, I'll show you how I manage images using Adobe Lightroom. This will give you an idea of the features you can expect from DAM software. Whatever photo-management software you use, expect to spend time learning and mastering the import selections and management features.

To make full use of Lightroom's features, I disable my computer's automatic image downloader. Lightroom can move, copy, or index images. This means you can use Lightroom to

✖ physically move an image from one folder to another.

✖ copy an image at its present location and place a copy into your destination folder.

✖ leave the image where it is and create an index or pointer to the location.

My photos are all stored in my Photo Library and backed up to my Image Vault. I also keep a Photo Archive off-site.

Lightroom manages files with a catalog, saving all edits and work in this catalog, so it's important to back up the catalog as well as the image files.

STEP 1: CAPTURE. I create digital images using my digital camera, smartphone, tablet, and scanner, and then open Lightroom for importing.

STEP 2: IMPORT. I click the Import function to select and move images from the device or temporary hard drive folder to my Photo Library. The Import window allows several actions (see arrows from left to right at the top of the window):

✖ Select the origination folder to view images; check All or select photos to import.

✖ Select how to import the photos: Copy, Move, or Add to Catalog.

✖ Select the destination location and any file actions. The panel to the right of the window allows options such as File Renaming, Presets, Batch Metadata and Keywords, and Folder creation.

STEP 3: RENAME. Any files not renamed on import can be renamed individually or using batch commands. (See Chapter 1 for more on file naming.)

STEP 4: BACK UP. I back up my Photo Library and catalog (which is automatically created by the photo-management software) during and/or after a work session. I now have two copies of my photos and photo catalog: one in my Photo Library and one in my Image Vault. Nondestructive photo

✳ **TIP** ✳

Always Work Inside the Software

Photo-management software can only manage your photos if it can find them. It's essential that you make all changes to file names or folders within the software itself. Never use Windows Explorer or the Mac Finder window to move or rename folders or images. Work inside the program to minimize problems.

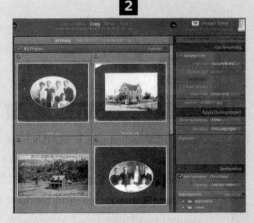

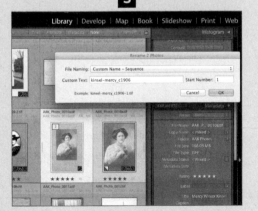

editors save the editing instructions for images in a separate catalog, so you don't need to make duplicate file copies for editing.

STEP 5: TAG AND ADD KEYWORDS. Now add tags, keywords, copyright info, location, and other metadata. I save frequently used sets of information as a Preset.

STEP 6: ARCHIVE. I copy photo files and the catalog to archival-quality media such as DVDs, CDs, or Blu-ray discs using Lightroom Export Presets for long-term preservation. I also migrate files as needed to new media and store the Photo Archive off-site. Alternately, you may want to use an online backup service for your Photo Archive. See the Appendix for a list of backup services to consider.

STEP 7: EDIT, EXPORT, AND SHARE. I use customizable export commands to streamline frequent tasks such as converting files from TIFF to JPG format or optimizing images for the Web. The Publish Services (left panel) allows easy sharing to social media and photo-sharing websites.

PUTTING IT ALL TOGETHER WITH SAMPLE WORKFLOWS

Managing digital files is all about workflow. Workflow is just another way of talking about a habit, something you have learned to do that now comes effortlessly. For example, driving a car doesn't come naturally to most of us; it's something we learned to do. We learned when and how hard to press on the accelerator pedal, when to move our foot to the brake pedal, and how to steer the wheel. At first it probably felt awkward, but with practice we could make the car move forward in a straight line and check the rearview mirror occasionally, too. Driving involves a workflow. Turn the key, release the parking brake, take the car out of Park, check for other vehicles, step on the gas. If you've been driving for a while, you probably don't even think about it, but if you fail to release the parking brake, the car rebels and lets you know you've forgotten one of the steps in your workflow.

You want your digital photo workflow to be as seamless as driving a car. It will take practice and repetition, but eventually, you won't even have to think about it. Let's hit the road.

Sample Workflow for the Family Shutterbug

Good for ...	family photographers who take photos of family and friends with multiple digital cameras and smartphone cameras
Difficulty level	time-saving and easy for collecting images from multiple devices; it takes a little more time for managing the Photo Library

If your family is like mine, everyone is snapping pictures with different devices. Young parents are busy and don't have time for complicated photo-management systems, but they do want to ensure that their children's photos are safely preserved for the future. My husband uses his iPhone to take job photos for his construction clients and needs to back up and share progress images regularly. Young-adult nieces and nephews share photos on Facebook and copy images to a computer when they think about it. And family historians use scanners, cameras, and smartphones to create digital images of keepsake photos and life in the moment.

Whatever your digital workflow may be, from the simplest manual upload to a more complex transfer strategy involving many different devices, take time to experiment with different routines to develop a workflow that works for you.

If you have multiple family photographers, you may want an overall strategy that makes it easy to collect images from multiple smartphones and cameras into one family collection. Designate one home computer to hold the master Photo Library and set up each family member's smartphone to auto-sync photos to a cloud service account. Save time by using photo-management software such as Apple Photos for OS X, Adobe Lightroom, or Picasa.

STEP 1: Use your digital camera to capture photos on memory card. Use the Wi-Fi-enabled Eyefi Mobi SD cards to automatically upload images to your computer. Configure your smartphone to auto-sync images to a cloud service.

STEP 2: Import images from memory cards and cloud accounts to the family Photo Library.

STEP 3: Rename individual images, and add tags and metadata using photo-management software, or if you don't have it, by using the Finder window (Mac) or Windows Explorer (Windows) folder.

STEP 4: Back up folders and image files to an external hard drive.

STEP 5: Burn image folders to archival DVDs and store off-site.

STEP 6: Share photos.

Sample Workflow for Travel/Vacation Photos

Good for ...	traveling photographers, family vacationers, and mobile genealogists who take photos with digital cameras and smartphone cameras at research libraries, archives, and cemeteries
Difficulty level	easy for uploading, but you'll spend more time managing the Photo Library

Enjoy sharing photos with family and friends while you're on vacation or away from home? Want to have peace of mind knowing your photos are backed up in case of accident or loss? Photo synchronization using a Wi-Fi-enabled Eyefi Mobi SD card will transfer images from your digital camera to your smartphone or tablet and make it easy to share them via e-mail or social media accounts.

Workflow

STEP 1: Set up your mobile devices to sync with a cloud storage service. Set up your camera with an Eyefi Mobi SD card to upload images to your smartphone or tablet. Set up your smartphone to sync photos with a cloud storage service such as Dropbox or Google Drive.

STEP 2: Share selected images from your phone or Wi-Fi-enabled camera directly via e-mail and social media.

STEP 3: When you return home, transfer your images from your cloud account or from any memory cards to your PHOTO LIBRARY folder.

STEP 4: Rename, tag, and add metadata.

STEP 5: Back up images to your Image Vault.

STEP 6: Include your new photos in your regular Photo Archive routine.

STEP 7: Create a travel photo book or slideshow.

Sample Workflow for the Mobile Genealogist

Good for ...	genealogists who take photos with digital cameras and smartphone cameras, use mobile scanning apps, and record images with scanners at research repositories
Difficulty level	easy for uploading, but you'll spend more time managing the Photo Library

On-site research often results in hundreds of new digital images captured on digital cameras, smartphones, tablets, mobile scanners, and research repository equipment. Many researchers also use a scanning app to copy documents with their smartphone or tablet. Syncing and backing up with a cloud storage service can make images available almost instantly for remote sharing and security.

Workflow

STEP 1: Set up your smartphone and tablet to upload photos automatically to a cloud storage service such as Dropbox or Google Drive. Consider using an Eyefi Mobi SD card in your camera and portable scanner. If you have a choice between an SD card or a flash drive when saving images from repository equipment, use your Eyefi Mobi SD card to keep images in your automatic upload strategy.

STEP 2: Share selected images from your phone or Wi-Fi-enabled camera directly via e-mail and social media. View documents scanned on your smartphone on the larger screen of your tablet or computer.

STEP 3: When you return home, transfer images from your cloud account to your PHOTO LIBRARY folder. Transfer images from any non-Wi-Fi memory cards to your Photo Library.

STEP 4: Rename, tag, and add metadata.

STEP 5: Back up images to your Image Vault.

STEP 6: Include your photos in your regular Photo Archive routine.

Sample Workflow for Photo Projects

Good for ...	photo-book lovers or anyone planning a photo project
Difficulty level	easy

Your next photo project will be easier if you assemble all copies of selected photos in a single folder on your computer desktop so you are ready to create your next masterpiece when the photo-book company announces a sale or special pricing.

Workflow

STEP 1: Select images and make copies using the Export or Save As function. Save as full-resolution copies and avoid cropping or editing extensively before copying the image. Convert from TIFF to JPG images if needed.

STEP 2: Save photos to a desktop folder or inside your PHOTO LIBRARY folder where it will be included in your backup routine. Name the folder for the project such as: HAWAII PHOTO BOOK or DAVID BIRTHDAY. Avoid mixing photos for different projects.

STEP 3: Investigate online photo services for project types and design themes. Select the service you prefer and upload images. File transfer may take an hour or more, depending on the number of images in your folder, the image file sizes, and the speed of your Internet connection.

STEP 4: When you are ready to create the book, your photos will be uploaded and ready for you to place them in the project. Adding individual photos is simple and fast.

STEP 5: Create your project.

STEP 6: Back up your photo project folder to the cloud.

STEP 7: Burn an archival DVD of the images used in your project and adhere it in an archival DVD envelope to the back inside cover of your photo book.

It's Okay to Play Favorites

When it comes to creating a first-rate photo collection, it's okay to play favorites. Whether you manage your photos individually, manually, or using photo-management software, any image collection will benefit from regular sorting and purging.

A professional photographer examines and saves only the best shots, but the family historian has other considerations, too. An underexposed, poorly framed snapshot of Great-grandfather Jack may be the only photograph of him at all. Of course, it's a keeper. But how do you decide between other photos: What to save and what to toss?

Use a rating strategy popular with pro photographers that flags each image as a Pick or Reject. To save time (and energy), quickly view an image and label it a Pick or a Reject. If your software doesn't have flags, use the star system: one star for Pick and two for Reject. Here's how this approach would work:

1. Place two similar photos side by side; choose the best of the two and reject the other. If you have other similar images, bring in a new photo to compare with the "winner" and choose again.

2. Make a new album or collection set and drag all the Picks into this set. Label the album, such as Reunion Picks or Reunion Keepers.

3. Decide if you want to get rid of the bad photos. If so, delete them. If you just can't throw them away, drag the Rejects into a new album labeled Reunion Rejects. You've saved them, but no one *has* to look at them ever again.

Sample Workflow for Personal Photo and Video Sharing With Dropbox

Good for ...	anyone who wants to share photos and/or videos
Difficulty level	easy

It can be difficult to send photos and videos via e-mail. Large file sizes are not always permitted by e-mail servers and can take ages to upload, only to be rejected as "too big." You have two options when you need to e-mail several photos or videos: downsize (which isn't always possible) or use a file-sharing service such as Dropbox.

Workflow

STEP 1: Log in to your Dropbox account or open the Dropbox folder on your computer.

STEP 2: Create a new folder and give it a name that will make sense to the recipient, such as PHOTOS FOR JOHN or DADS FISHING PIX.

STEP 3: Move copies of the photos or videos you want to share into the folder.

STEP 4: Right-click on the folder to reveal the menu and select Share This Folder.

STEP 5: When the Share window opens, enter the e-mail address of the person you want to see your photos. Add a brief message. The recipient will get an e-mail with a link to the folder where she can copy the photos and videos directly to her own computer.

Sample "I Don't Have Time for This" Workflow

Good for ...	young smartphone photographers, busy occasional photographers, older relatives who enjoy their smartphone, anyone who is just plain busy
Difficulty level	easy, easy, easy

Something is better than nothing. This workflow might be perfect for someone you know who takes pictures exclusively with a mobile device but doesn't want to think about managing a photo collection. One day, they may thank you for saving their college, vacation, or endless summer memories.

Workflow

STEP 1: Set up a cloud storage account with Dropbox, Google Drive, or ThisLife.

STEP 2: Set up your smartphone and tablet to auto-sync with the cloud service.

STEP 3: Pay the annual subscription fee for the cloud storage service.

STEP 4: Regularly order archival DVDs of your Photo Library, if this option is available.

Digitize

My experience with photographs may be a bit like yours. I've always had a camera. First a little Brownie box camera, and then a series of Instamatics. I loved using a Rolleiflex when I worked for our local newspaper, and eventually invested in a Nikon SLR. My photos were printed and placed in photo albums and scrapbooks until life with growing children took over and the 4x6 snapshots started stacking up in shoeboxes.

As we moved into a new century, two events in my personal life changed my role and focus as family photographer and historian: I bought my first digital camera, and I inherited a trunk filled with my grandmother's photos and keepsakes. My mom decided it was my turn to take care of "the stuff." The responsibility made me feel more like I was bringing home a new baby than taking on a few boxes of snapshots and vital records.

Soon the shoeboxes of old prints were pushed to the back of a closet, and digital images began accumulating on my computer hard drive, memory cards, and ZIP drives (remember those?). When I thought to back up anything, I burned a CD-ROM. My digital library grew even larger when I started scanning my grandmother's old photos and documents. I wasn't quite sure how to go about archival-quality scanning, so I followed someone's advice to "use the highest resolution available." Soon my hard drive was bursting with huge TIFF files. A digital deluge threatened to take over my equipment and engulf all my free time. I was drowning in digital images.

I learned how to manage my digital riches as I researched methods for organizing and digitizing my grandmother's treasures and discovered that I needed a seamless system for both worlds—digital and physical. I needed a photographer's workflow to manage thousands of images, and I needed an archivist's preservation and cataloging techniques to manage my physical photos, documents, and memorabilia. And both systems had to work together.

I wrote about my journey to find practical solutions for organizing, digitizing, and preserving family treasures, first on my blog TheFamilyCurator.com and then in my book *How to Archive Family Keepsakes*. The book shares an overall plan for working with inherited photos, documents, and heirlooms, and integrating our modern digital legacy with those same family treasures. I quickly discovered I wasn't alone in my challenges to care for family keepsakes.

BLESSING OR BURDEN?

We're living longer, healthier lives than ever before, and more active adults are becoming heirs to a family legacy of documents, photos, and artifacts. As family historians, we want to preserve the past, but we also need to add the stories of our own lives. Many readers of my blog and book shared feelings both of guilt and gratitude about the responsibility of their legacy. Is it a blessing or a burden? Family photos can be emotional triggers for myriad memories and feelings.

Personal photographs are among the most difficult heirlooms to discard, yet many people are quick to toss out these visual tokens of the past. Among the reasons I've heard:

- ❌ I don't need to keep it because I have a scanned copy.
- ❌ It's a duplicate.
- ❌ I have a negative.
- ❌ I have a print.
- ❌ My mother/aunt/brother has a print.
- ❌ That was a first husband/wife.
- ❌ That's a relative's first husband/wife.
- ❌ There's no caption, and everyone who might be able to identify these people is dead.
- ❌ The picture is faded/damaged/torn.
- ❌ It makes me sad to look at this picture.
- ❌ I never liked him.

SHOULD YOU KEEP EVERY PHOTO?

I'm not going to suggest you keep every photo or negative. Nor am I going to recommend that you toss those duplicates, Jane Doe snapshots, and "sad" snapshots in the trash. Only you and your family can weigh genealogical, financial, and sentimental considerations to make these decisions. But I hope you'll think about alternative ways to preserve your family photo heritage.

In Part 2, we'll look at practical tips for organizing and digitizing your heirloom photos so you can enjoy them along with your new images. This advice from the pros will be helpful for anyone working with digital photos, especially the family historian who may be drowning in digital files. We'll review options for the equipment you'll need for digitizing and organizing. And we'll also cover the basics of managing B.D. (Before Digital) old photos with new digital files. To gain control of your own digital clutter, you *will* need to adopt a system and make it your own, but it should be whatever works best for you.

If you haven't done so already, review ideas for scanning, file naming, and folder organization in Chapter 1. You'll have all the information you need in one place and can get started digitizing and preserving your heirloom images right away. I hope the ideas in this section will inspire you to start today to develop a plan and master your family photo archiving.

❖ Heirloom Photo Collections ❖

It might be hard to remember a time B.D. (Before Digital) when the cost of film and process-ing compelled photographers to "make every picture count." Special occasions and vaca-tions were measured in twelve, twenty, and twenty-four picture rolls of film that required at least a week for developing and printing. If you inherited your family photo legacy, you may have shoeboxes, envelopes, and albums filled with snapshots and negatives documenting your family history, all waiting to be organized "one day."

WHY DIGITIZE?

In my work with family collections, I've listened to many stories about family photos lost to disinterested relatives or to the confusion of settling an estate. There's nothing as disheartening as viewing a beautiful family album stripped of photos to be sold one-by-one for the maximum profit to online bidders or finding a lovely collection of wedding photos casually tossed on a table at a neighborhood garage sale.

Digitizing your family's photo heritage increases the chance that those images will survive in some form, even if it's not the original print or negative. And it's not just photos that benefit from digitizing. Slides, negatives, film, and videos also can be digitized as a way to preserve deteriorat-

ing or outdated media. Don't lose your family photos. Create a digitizing plan. Digitizing offers many benefits. It helps

- �֍ preserve heirloom photographs by creating a master copy to replace lost or damaged originals.
- ✖ preserve movies recorded on outdated film or other media.
- ✖ provide duplicate images for everyone in the family.
- ✖ find clues in old photos to break through genealogy research brick walls.
- ✖ create digital images of unidentified photos to share with relatives for possible identification.
- ✖ provide personal and unique illustrations for family history books.
- ✖ create a digital archive where you can quickly locate and access photos.
- ✖ enable reprints for framing and display without damaging the original.

Inherited keepsakes also may include original documents, letters, diaries, or journals. These items will benefit from digitizing with home scanners and digital cameras. You'll find more ideas for digitizing these items and other heirloom artifacts in my book *How to Archive Family Keepsakes*.

WHAT'S YOUR ROLE?

If you inherited a handful of loose snapshots or boxes filled with albums and generations of old photos, the survival of your family's photo heritage may depend on your next steps. How do you see your role as Keeper of the Archive? Are you a curator, creator, caretaker, or a combination of these roles? Or do you think of yourself as the family photo collector? Keep reading to learn more about these roles.

- ✖ **Collector:** Many people collect things: books, funny frogs, signed baseballs, or silver dollars. A cat lover who is gifted with themed mugs, jewelry, figurines, and clothing soon has to deal with more clutter than collection. A savvy family historian does more than gather family keepsakes to build a collection of documents, photos, and artifacts that will one day be tossed in the trash. But that's exactly what *will* happen if those keepsakes aren't cared for and treated like a valuable collection. It's up to the collector to decide the purpose of the collection and embrace a role to meet that goal.
- ✖ **Curator:** A person in this role will strive to gather, preserve, and selectively manage heirloom and digital family photos to build a meaningful gallery of images.
- ✖ **Creator:** This person uses digital versions of family photos in many ways, featuring them in everything from books to Web pages to artwork, and using them as raw source material for genealogical information on kinship and family identity.
- ✖ **Caretaker:** I call caretakers the heroes of all collectors. They may not have the time or interest to manage or create new works with a collection of family photos, but they preserve a photo heritage for the next generation by digitizing, backing up, and archiving images.

Anyone who manages any number of family photos needs to decide if their photo collection will become clutter or a family heritage. Carefully consider your overall objectives as collector, curator, creator, or caretaker. What exactly do you want for your inherited photo legacy? What challenges stand between you and your goal?

This task is relatively simple for family photographers and those who primarily capture new images via smartphones and digital cameras. But for family historians who often create hundreds or thousands of new digital images when scanning old family photographs and documents, the solution can seem inordinately confusing. If you're like me, you probably have both contemporary family photos and scanned images gathered for preservation and research.

Are you confused about the best way to scan old photos? You might be concerned about working with JPG files, which carry the possibility that image quality will be reduced after repeated editing and saving. Should you convert JPG files to TIFF format? Make master copies? Or just hope your files will be readable after an editing session? Should you use a folder system or manage your images in software, such as Adobe Photoshop Elements or Picasa?

Digital photo management doesn't have to be a complicated and dreaded chore. This chapter shares simple strategies for getting control of your hard-copy photo collection and digitizing images to preserve pixels for the next generation.

PLAN BEFORE YOU SCAN

Get to know your family photo collection *before* you make your first scan. Proceed with purpose and aim to be efficient and economical with your time and your funds. Three strategies can help you move from photo chaos and clutter to photo control:

1. Organize.
2. Categorize.
3. Prioritize.

Organize

Gather your images together and take stock of the total collection. Clear a large table and cover it with an old sheet or tablecloth, then bring out the old shoeboxes, file folders, and photo-processing envelopes. Gather every negative, film box, and loose print you can find. Remember albums tucked away on a bookshelf; you may need to work with them in a second session if your table is overloaded. Wash your hands with soap and water, or wear white cotton gloves to avoid leaving fingerprints on the photos. This is likely to be a dirty job, and it may take some time, depending on how many photos you have to organize. Also, handle prints by the edges only, and avoid working in bright natural or artificial light.

Maintain original order and groupings as much as possible for clues to unidentified snapshots. When you find an envelope stuffed with snapshots, ask yourself why your ancestor might have assembled these particular prints:

✖ Are the photos all from the same event?

✖ Do they feature the same person or family?

✖ Could they have been sent by a distant family member or friend?

✖ Was the selection prompted by a big event?

Remember, families often exchanged photo prints by mail in much the same way as we use e-mail today. Sometimes the prints didn't find their way back to the original sender. In addition, seemingly random piles often have an inherent meaning. A death in the family might call for photos to be brought out of albums for a collage or memorial book, and that same stack of photos might be tucked away as a group rather than returned to the original location.

Arrange the boxes and folders on the table chronologically or by film type: all the black-and-white snapshots together, the 1970s prints together, the Polaroids together. You may find that similar photo types will all be from about the same era. Scanning will be faster and more efficient if you work in batches to digitize similar items at the same time. Duplicate prints, enlargements, and negatives with prints should be grouped together to help locate clues in handwritten captions and dated photo-processing envelopes. Avoid reshuffling those "random" groups even if the envelope contains a mix of photo sizes and types.

Should you throw away old photos? This is the million-dollar question. Some people can't wait to digitize and toss the originals. Others carefully preserve every single photo, no matter how out-of-focus or insignificant. My own strategy is to find a middle ground. I have inherited too many large collections to keep everything. I will eventually donate some items, and others I selectively scan and preserve. I give the following to family members or discard them:

✖ obvious out-of-focus, fuzzy, insignificant prints

✖ duplicate twentieth-century snapshots

✖ anonymous snapshots of unidentified landscapes

Depending on the number of photos you want to scan, it could take several days or weeks to scan your entire collection. In the meantime, it's best if your photo collection isn't scattered across the dining table while you methodically scan each stack of images. Instead, place the newly created photo groups in temporary archival storage, and pull out an envelope or box to work with one at a time. Use acid-free archival boxes large enough to hold the entire collection or a subset of the collection. Store one family collection per container to avoid mixing up family identifications. After scanning, move photos to permanent archival storage.

Categorize

List the different photo batches on the Heirloom Photo Inventory & Digitizing Checklist. It will be helpful to have a good overview of the collection when choosing a file-naming scheme and folder organization structure, and selecting digitizing equipment. You can't develop a digitizing plan until you know what you need to digitize. And as a family historian, aren't you just a bit curious about your ancestor's photos and other keepsakes? Time spent getting to know the

person who collected the photos and the people pictured in the snapshots will help you make connections as you work with the material.

Use the blank Heirloom Photo Inventory & Digitizing Checklist to make a rough tally of the number and kinds of items you want to digitize. Make notes of photo condition, especially fragile or damaged items that you will want to digitize sooner rather than later.

Your scanning sessions will be more efficient if you work with batches of similar photos, rather than scanning a stack of assorted prints. Working with similar photos allows you to

- �w set a basic file name to speed file naming, for example: *john-grad_01.jpg*. The software will add sequential numbering to create unique file names.
- �w set the scanner mode to the Reflective for digitizing all print photos; change the mode to Film and digitize film in a separate batch.
- �w choose the appropriate resolution for scanning the entire group of photos.
- �w scan several prints of the same size in one pass of the scanner. (See step-by-step instructions in Chapter 9.) Batch scanning saves time and helps keep your collection organized for archival storage.

Prioritize

If you have a large photo collection, it's a good idea to digitize the oldest or most fragile items first before the photos deteriorate further. Continue to organize photos in groups or batches for efficient scanning. Plan to use your digital camera to digitize oversize or especially fragile items.

You may find some photos that need professional attention. While it's certainly possible to reframe old photos yourself, you may want to consult an archival frame specialist or photo conservation expert for help with photos stuck to glass or original prints that have water damage. Contact the American Institute for Conservation of Historic and Artistic Works **<www. conservation-us.org>** for recommended experts in your area.

Review your Heirloom Photo Inventory & Digitizing Checklist and give each item a priority.

1. Scan ASAP for fragile, very old, or damaged photos; deteriorating film; or items needed for an upcoming project.

2. Scan soon for old prints in good condition and negatives.

3. Scan next for twentieth-century photographs, film, slides, and negatives.

Use the inventory checklist to plan your scanning hours most efficiently. Adapt the form to note items for an ancestor biography or family history project. These may be among your first scanning priority. As time allows, scan other photos such as a box of vacation slides or a stack of twentieth-century snapshots.

When you've finished digitizing your photos, this inventory checklist will help you decide what kind of archival storage containers you'll need to preserve your heirloom originals. Read more about preserving original photos and film in Chapter 10.

HEIRLOOM PHOTO
INVENTORY & DIGITIZING CHECKLIST

» SCAN WITH A PLAN

1. Gather your heirloom family photos and film, and list each item on the inventory form, noting any damage or preservation concerns.
2. Give each item a priority number for digitizing.
3. Move your heirloom photos into temporary archival storage and digitize one box at a time, beginning with high-priority items. Save and back up the digital images.
4. As you finish digitizing, place the original photograph or film into permanent archival storage, following the guidelines in Chapter 10.

PRIORITY	PHOTO TYPE	ROUGH QUANTITY	CONDITION NOTES	DIGITIZING DEVICE	DATE DIGITIZED

SAMPLE HEIRLOOM PHOTO INVENTORY & DIGITIZING CHECKLIST

PRIORITY	PHOTO TYPE	ROUGH QUANTITY	CONDITION NOTES	DIGITIZING DEVICE	DATE DIGITIZED
3	b/w snapshots	1 shoebox	1930s–1940s good condition	office flatbed or Flip-Pal	
2	cabinet cards	12	good	office flatbed or Flip-Pal	3/25/2015
1	oversize sepia prints of house and farm	4	1890s; poor condition; damaged and faded	DSLR and tripod	3/10/2015
2	slides	20 carousel trays	need to view and select best to scan	send to scan service	3/15/2015

❖ Digitization Preparation ❖

I'm a big fan of moving slowly when it comes to working with family photos and memorabilia. My grandmother's collection was my first experience working with photos and keepsakes belonging to someone I loved. Although three decades had passed since my grandmother died, her frail voice and sweet smile were with me as I gently turned the pages of old albums and read the captions handwritten on the back of loose snapshots. I was eager to preserve her legacy and enthusiastically started scanning everything. What a mistake!

After digitizing a few hundred photos, I realized I was running out of storage space on my computer and the accumulated files were becoming a jumbled mess of inconsistent names and numbers. Each scanning session I used a different, yet meaningful, file-naming system. One time I'd begin a file name with the date, but weeks later in my next scanning session, I'd use only the person's surname. When I found duplicate photos, I started using numbers. To make matters worse, the advice I had received to "scan everything at the highest possible resolution" was creating huge files. I was scanning in the recommended archival TIFF format, but 2400-dots-per-inch files were enormous. And after scanning, it was all too easy to mix up scanned and unscanned original photos. I needed a preservation system for the heirloom originals and a digitization plan. My intentions were noble, but clearly, I needed to stop, step back, and come up with a new, more practical strategy.

After a few more false starts, I finally came up with a scanning-and-preservation workflow that was simple, efficient, and met my needs. You may need more or fewer steps, or may be able to streamline some tasks, but I hope my workflow tips in this chapter will give you a basic outline for working with your own family photo collection.

PREPARE YOUR COMPUTER AND CHOOSE A STORAGE DEVICE

Before scanning your first photo, you need to know how you will organize your new digital files:

1. Decide where you will store your digital files, and purchase any necessary storage devices.
2. Decide on a file-naming scheme and create a file-naming cheat sheet for reference.
3. Decide on a folder structure and set up your folders.

Review Chapter 1 for strategies to set up your digital storage and folder system.

To help you decide which storage device may work best for your photo collection, use the Digital Storage Options chart.

Unsure what all the terms on the Digital Storage Options chart mean? I'll decode them.

�CD/DVD: Optical storage media such as CDs and DVDs typically offer the least expensive storage; however, a relatively short disc lifespan makes it necessary to migrate files regularly.

✱ M-DISC: Developed for long-term archival storage, the M-DISC DVD has been tested by the U.S. Department of Defense Naval Air Warfare Weapons Division facility at China Lake, California, and is rated to last one thousand years. Discs are available with two different storage capacities: 4GB and 25GB per disc. They cost about $3 and $5 per disc.

✱ SD (Secure Digital) media card: The standard SD card used in digital cameras and other portable devices has a capacity of 128MB up to 1TB of flash memory. SD cards are configured as original Standard Capacity (SD), High-Capacity (SDHC), and eXtended-Capacity (SDXC). They are available in full-size, mini, and micro formats. Not all devices accept all kinds of SD cards. Some SD cards, most notably the popular EyeFi Mobi SD card, include a built-in Wi-Fi transmitter that can wirelessly move files from card to computer or card to mobile device. Although there are no moving parts to store files on the SD card, the card should always be properly ejected from the device.

✱ USB flash drive: Similar to an SD media card in storing files in flash memory, a USB flash drive is a small memory "stick" with integrated USB connection. Capacity varies by model and manufacturer, with the highest terabyte storage costing more than a comparable external hard drive. Like SD cards, the lifespan of a flash drive is rated in read/write cycles. The fast write speed makes USB flash drives a good option for portable storage or transferring files between devices.

✱ External hard drive: Rapid price drops in digital storage have made external hard drives a popular option for archiving large digital collections. A USB, FireWire, or Thunderbolt

DIGITAL STORAGE OPTIONS

Before digitizing your heirloom photos, consider your digital storage options. Use this chart to help you compare your options—from recordable CDs and DVDs to external drives and online cloud storage.

STORAGE	CAPACITY	LONGEVITY	PROS	CONS
CD/DVD	CD: 650MB DVD: 4.7GB	2 to 5 years	inexpensive, handy, good for photo archive	requires burning software; large transfer may require multiple CDs/DVDs
M-DISC archival DVD	4GB to 25GB	1,000 years	longest rated archival disc media	requires special burning software
SD media card	varies	depends on read/write cycles	ultra-compact, high-speed transfer, portable, solid state storage	expensive, impractical for large amounts of data
USB 2.0/3.0 flash drive	4GB to 1TB	depends on read/write cycles	inexpensive, good for travel, quick backups, stores personal data	easy to lose, high cost per GB, limited storage capacity
external hard drive	500GB to 8TB	3 to 5 years	ultra-portable or desktop models, all sizes and prices, USB, FireWire, or Thunderbolt connection	can be dropped and damaged
cloud storage	infinite	indefinite	inexpensive, accessible from anywhere, good disaster backup	must maintain subscription; Internet security poses risks

Digital Storage Tips

- �֍ To determine the storage capacity needed, consider how many photos you plan to digitize, the number of digital images you already have, and the number of digital photos you take each year.
- ✖ Include any digital videos you currently have or plan to take in your estimates for the digital storage capacity needed.
- ✖ Consider your purpose for digital storage: What storage option do you need for items you want to access regularly vs. store off-site for archival purposes? You may need to use a combination of storage options for everyday, backup, and archival use.
- ✖ When considering cloud storage, read the terms and conditions and privacy policy. Beware any service that takes away your copyright to the images. Make sure you know how to remove your files in case you cancel your subscription or the business ceases operation.

connection is typically required to move files from computer to external hard drive. Most models are portable, inexpensive, and efficient solutions for digital storage.

⌘ **Cloud storage:** As Internet connections become faster and more widely available, cloud storage is a viable option for file backups and archiving. Many products offer free limited storage with annual subscription plans to handle more storage when needed. Prices and plans vary widely, so it's worth investigating several companies before deciding where to commit your files.

How Much Digital Storage Do You Need?

Is it possible to have too much digital storage? Possibly, yes. Not everyone needs a 1TB external hard drive for storing digital photos. But with the ever-decreasing cost of digital storage, it may not be efficient nor economical to purchase only what you need today.

Not long ago, consumers were advised to use mathematical calculations of projected digital storage needs when selecting new storage hardware. A series of questions helped determine how many gigabytes or terabytes they needed to store a collection of digital music, photos, videos, and documents. All of those calculations became obsolete when people discovered their smartphone cameras. If they weren't taking photos and videos of children and grandchildren, they were snapping pictures of old cars or restaurant meals, or scanning receipts. More digital files demanded more storage.

We can only anticipate our future storage needs, but if the recent past is a guide, whatever storage we have today won't be enough. My approach has been to purchase more storage than I need to hold my current digital collection. When migrating to new external hard drives, flash drives, or SD cards, I purchase the next size up from my present models. So far, I haven't run out of storage room.

My first external hard drive boasted a capacity of 256MB, and it seemed huge at the time. Those files were migrated to an "enormous" 500MB drive a few years later, and are now stored on my new 1TB drive. During those same years, I owned a series of digital cameras with higher and higher resolutions, including my first iPhone with an improved camera, and I continued scanning my family photo collection as high-resolution TIFF files.

Your digital storage needs may be different, of course, but when purchasing new hardware, be generous in anticipating future needs. Evaluate your present and future digital photo storage with the Digital Photo & Video Storage Worksheet in Chapter 1. And remember to include digital movie, video, or music collections that will also need storage and backup space.

DEVELOP A SCANNING PLAN

Once you've got your storage device chosen and equipment set up, it's time to put a plan in place for how you'll organize your files after you digitize them. You will want to create a SCANS folder where the photos will go when you first scan them. You will need to decide if you want to keep the working copies of your scanned images in the same Photo Library as your current family

photos or if you want to maintain a separate Genealogy Photo Library. (See Chapter 1 for tips on setting up your Photo Library system.) After you're done scanning a batch of photos, you'll want to move the scanned originals to your PHOTO LIBRARY folder (or to your GENEALOGY PHOTOS folder). As you move each item, rename it with a meaningful file name and add tags, keywords, and

✳ TIP ✳

Keep it Simple

Keep your Photo Library and Image Vault folder structures fairly simple and don't nest them too deeply. Use your computer's Search feature to locate files, if necessary.

other metadata as needed. You'll also need an Image Vault folder to hold master copies of your scanned images.

File Names and Metadata for Scanned Images

Scanned images are no different from photos snapped at a recent birthday party or family reunion. Undoubtedly, you'll want to include information with the file about who is in the picture, when it was taken, and what event was celebrated. These details are easily included in the metadata (described in Chapter 1), but they also can be included in an abbreviated form within the file name itself when naming files.

BE CONSISTENT: If you already use a file-naming structure, continue with the same structure for your new scanned image files. Use the same file-naming rules for all images and make your digital life easier by

- ✖ using a consistent file-naming system.
- ✖ avoiding special characters such as < > ? { } | ! @ # $ % ^ & * ().
- ✖ using underscores and dashes instead of periods, spaces, and slashes.
- ✖ keeping file names short.
- ✖ adding keyword tags and metadata.

USE MEANINGFUL FILE NAMES: After scanning your photos, you'll have a folder of digital images to be organized and renamed with meaningful file names. This will make your files easier to access and find again later. The file name set by the scanner or digital camera may be good for creating unique files, but it can make finding files difficult and confusing. Rename your files with descriptive or meaningful file names such as

- ✖ *104_3674.JPG* to *kinsel-arline_1890_baptism.jpg* (baby in baptism gown photo).
- ✖ *104_3675.JPG* to *kinsel-jacob_1872_house.jpg* (family home photo).
- ✖ *104_3676.JPG* to *kinsel-jacob_1885-ks-census_ks-atchison-grasshopper.jpg* (census image).
- ✖ *104_3677.JPG* to *AAK_P0076.tif* (for a numeric photo catalog).

You can save time and eliminate confusion by using batch file-naming shortcuts in your scanning, photo-editing, or photo-management software. These features are typically available

as customizable options in the Import menus as images are moved into the photo-management software or after importing by selecting several files and applying the Rename command.

Your Image Vault for Scanned Images

When preparing to start a digitization project, you'll want to create an Image Vault on an external storage device such as an external hard drive or a cloud storage service. Think of the Image Vault as your original backup—the place where valuable master files are stored. Unlike a bank vault, you can take out as many copies of your files as you wish, but the original master files should never leave the vault.

You might name your external hard drive IMAGE VAULT and then create digital file folders inside as needed to hold your master copies from different scanning projects. Keep files from specific scanning projects together, or group by kind of item digitized or by family surname. Use an organizational system that makes sense to you and fits with whatever folder-organizing scheme you use for your hard-copy genealogy files. You could organize by any of these methods:

* scanning date
* surname
* family line
* kinds of photos
* black-and-white snapshots
* record type (such as vital records, military records, diaries, correspondence, newspapers)

Working With Scanned TIFF and JPG Files

So far, I've talked about scanning files in archival TIFF format, but TIFF files are very large and aren't practical for e-mailing or everyday access. Consider TIFF files to be your master copies, your insurance; you can use these masters to make a very good replacement copy if the original is lost or damaged. For everyday use, you'll need JPG copies that take less storage space and are widely accepted for photo printing, Web projects, and sharing with family and friends.

TIFF VS. JPG COMPARISON CHART	
TIFF	**JPG**
* large, uncompressed files * best for archiving * will not degrade when saved repeatedly	* smaller, compressed or uncompressed files * best for working files, e-mailing, and photo sharing * will deteriorate when opened and saved repeatedly

Converting TIFF to JPG

You don't need special software to convert TIFF files to JPG files. This is a standard option available on Windows and Mac computers and in photo-editing programs such as Adobe Photoshop Elements. By digitizing heirloom original photos as TIFFs for archiving and then converting them to JPG format for printing and sharing, you will have the optimal strategy for long-term preservation and practical everyday access.

Here's how to convert your image files on a Mac, in Windows, or using Adobe Photoshop Elements.

- **MAC PREVIEW:** In the standard Mac OS Preview, click Export As (or Export) and then select JPG format from the drop-down menu.
- **WINDOWS EXPLORER:** In Windows 8, click to open the photo in the Edit window, choose Save a Copy, and then save as type: JPG.
- **PHOTOSHOP ELEMENTS:** Click on the File menu and then Save As. Select JPG format in the drop-down menu.

Storing JPG Images

Think of your newly compressed JPG images as your working files. Use them for editing, sharing (via e-mail or social media), creating photo projects (like photo books), and transcribing. You can store your new JPG image files in the same location as the original TIFF master images. JPG images will always be identified by the *.jpg* file extension. Or you may choose to keep your JPG images in a separate JPG file folder. Choose an organizational method that works best for you. Do not open the master file unless you need to create a new working JPG copy.

When You Only Have JPG Originals

It's not always possible to create a digital TIFF file, especially when working with digital cameras and scanning images with mobile devices. Some scanning software or devices do not support the TIFF archival format. If your master file is in the JPG format, it is a good idea to duplicate this original file and move it to your Image Vault so you always have one unchanged original image. Consider this JPG your master file.

Back It Up

Whenever you complete a scanning session, take time to back up your files. The best backup strategy is the 3-2-1 rule:

- 3 copies
- 2 different media
- 1 copy stored off-site

Many different combinations will provide a good backup solution, but the key to a great backup system is to spread out your copies across different media and different storage locations. When hurricanes and tornadoes wipe out a home and family photo collection, it's reassuring to know that digital copies are safe in the cloud or stashed at a relative's home in another state. Don't wait for a disaster to safeguard your precious family memories. Practice the 3-2-1 Backup rule regularly, especially after a major scanning session.

Cloud storage can get expensive for large image collections of TIFF and MOV files. Look for other ways to provide cost-effective off-site storage if needed, such as a duplicate external hard drive stored at a relative's home or at your place of business or in a safe-deposit box.

Establish a Scanning Workflow Plan

Now that you've got your storage device and a plan for organizing and backing up your digital files, you'll want to create a plan for how you'll do the digitizing—your scanning workflow. Here's an example:

STEP 1: CREATE A SCANS FOLDER. Create a desktop folder named SCANS to hold all your newly scanned files. Scan your files into the SCANS folder.

STEP 2: MOVE SCANNED IMAGES TO THE PHOTO LIBRARY. Import scanned images from the SCANS folder to your PHOTO LIBRARY folder. (See Chapter 1 for details on how to set this up.) If you use photo-management software, import and move files within the software. If possible, use the software to help you rename the files as they are moved. When you've finished transferring your scanned images to your Photo Library, the SCANS folder will be empty.

STEP 3: RENAME, TAG, AND ADD KEYWORDS. If you didn't rename files as you moved them, rename them now using a consistent file-naming structure. Also add metadata to the image, including tags and keywords.

STEP 4: BACK IT UP. Back up your Photo Library to your Image Vault, which can be on either an external hard drive, a cloud storage service, a DVD, or other media.

STEP 5: ARCHIVE. Create a Photo Archive by backing up your Image Vault of scanned images. Store this copy off-site. You will need to access it only if your Image Vault is damaged or destroyed, or if you need to transfer it to newer storage media. The Photo Archive could be stored on an external hard drive, on an archival DVD, or via an online backup service.

SUCCESSFUL SCANNING STRATEGIES

There's still one more thing you'll need before you start digitizing your family heritage photographs: a scanner, of course. In the next chapter, I'll introduce you to several options for at-home and mobile scanning and provide tips to streamline your scanning sessions and achieve the best possible images with different devices.

❖ Scanning Equipment ❖

My flatbed scanner has outlived all computers, printers, and hard drives in my home office, yet I use it for long digitizing sessions many times a week. It was definitely a good investment that delivers high-quality digital images ready for restoration, archiving, and sharing. My all-in-one printer offers scanning too, but the limited options and longer scanning times keep me going back to my Epson flatbed scanner whenever I need to scan a single photo or a box filled with snapshots.

Almost any scanner can perform wonderful digital tricks, but you need to know the secret word to unlock the door. That secret word is *Pro Mode*. You'll need to discover what's behind the preprogrammed Pro Mode to make full use of your scanner's software tricks. Once you know about these hidden features, you'll know what to look for when exploring new equipment for your home and travel.

In this chapter, I'll introduce you to a wide selection of scanners and scanning tools—from office desktop models to smartphone scanning apps to portable scanners to use on the go. I'll also walk you through the scanning options and features you'll want to look for when selecting a scanner to archive and digitize your heirloom family photos.

DIGITAL SCANNER TERMINOLOGY

When you first start looking for a scanner, the scanning jargon may sound like a foreign language. Here are some key scanning terms and features you should know.

- **Auto file naming:** Save time by using your scanner's file-naming features. This is usually available through the scanner's Preview window as an option for you to enter a custom name and a starting number. It uses the custom name you provide and automatically adds unique sequential numbers to each image.

- **Batch scanning:** This feature lets you scan multiple photos in one pass of the scanner. Some scanners will automatically detect each item; other scanners require manual selection. Each photo is saved and named individually. This feature saves time when scanning large collections.

- **Color:** Scanners typically offer 8-bit or 16-bit grayscale (aka black-and-white) or 24-bit or 48-bit color options for scanning. Color is the best choice for digitizing all photographs, whether the originals are black-and-white or color. The 24-bit color will give you a full range of photo-realistic color on your scanned images.

- **Color restoration:** This feature restores faded color to old snapshots.

- **Cropping:** Cropping allows you to cut out unwanted parts of an image. Some scanners will allow you to preview the image and crop the photo before you scan it, so you get only the photo (not the scanner background) in your scan. Portable devices typically scan the full scanning bed without a cropping option.

- **Descreening:** This eliminates the tiny dots used in the printing process and improves scans of newspaper and magazine photographs.

- **Digital ICE:** Use digital image correction and enhancement (ICE) to remove dust and scratches when dust removal is not sufficient. Digital ICE requires a longer scanning time and higher computer resources, but it gives a higher-quality result. Results are not visible when you preview the image. Digital ICE may not be available for all document types.

- **Dust removal:** This option automatically removes dust on the original item; the effects are not visible when you preview the image. You may need to select the level of correction: low, medium, or high. Dust removal may not be available if digital ICE is selected, and scanning time will be longer.

- **File format:** Most scanners scan documents and photos in many file formats. TIFF is the best choice for archival images, but it creates large image files. Most digital cameras and portable devices offer only JPG images, which is more efficient for files saved to removable storage such as an SD card or flash drive.

- **Max scanning size:** Popular office scanners accommodate letter and legal size paper; some models can handle items up to 11x17 inches and larger. Portable devices may be limited in scanning image size. Cameras can digitize items of any size and shape.

- **Negatives/film/slides:** A special film carrier for scanning film and negatives allows the scanner light to pass through the transparency. Software can convert the negative image to a positive image with far greater detail than is available by scanning a printed image. Not all scanners have this feature.
- **Resolution:** Resolution is measured in dots per inch (dpi) or pixels per inch (ppi). To achieve good print quality, digital images should be a minimum 200 dpi at the size you want printed. Because images are often enlarged or modified, it's safer to aim for a resolution of 600 dpi for your photo scans.

KEY FEATURES TO CONSIDER

When purchasing any new scanner—whether it's a flatbed, all-in-one, or mobile device—you'll want to consider the following features:
- overall dimensions of maximum scan area
- included scanning software, cables, film accessories, memory cards, and OCR software
- scanning speed
- flush-edge and removable (or adjustable) cover for scanning bound books and artifacts
- ability to scan color, text, and black-and-white, plus options for photos, documents, and film
- resolution options that range from 75 dpi through 2400 dpi or higher
- preview and cropping ability
- file format options (JPG, TIFF, PDF, PNG, GIF, BMP)
- file-saving options, such as scanning to a folder or an application for desktop devices, or built-in memory or removable SD card for mobile scanners
- file-naming options, including ability to add custom names and consecutive numbers
- image adjustment options for color restoration, descreening, dust removal, and digital ICE
- batch-scanning options
- ease of use
- overall footprint and size
- manual and help options

Once you narrow your options, check out reviews of scanners at CNET **<www.cnet.com>**, *PC Magazine* **<www.pcmag.com>**, and Imaging Resource **<www.imaging-resource.com>**.

✳ TIP ✳

Benefits of OCR Software

Optical Character Recognition (OCR) software is bundled with many scanners to provide searchable text from a digital image. This means that if you scan a document or image that has text, your text will become searchable. Accuracy of the searchable text varies, depending on the quality of the original image and scanning equipment.

DIGITAL SCANNING EQUIPMENT OPTIONS

	FLATBED SCANNER	ALL-IN-ONE SCANNER	FLIP-PAL MOBILE SCANNER
Best for ...	any photo or film that will fit on the flatbed	photo prints	4x6 or smaller prints or scanning on the go
Scan saved to ...	computer hard drive	computer hard drive	SD card
Portable	some models	no	yes
Permitted in many research archives	yes	not applicable	yes
File formats	TIFF, JPG, PDF,	TIFF, JPG, PDF	JPG
Maximum scanning size (in inches)	8.5x11 8.5x14	8.5x11 8.5x14	4x6*
Resolution (in pixels)	50 to 12,800	75, 100, 200, 300, 600, 1,200	300, 600
Speed	average	average	average
Photo prints	yes	yes	yes
Negatives/film/slides	with carrier	no	no
SOFTWARE FEATURES			
Auto file naming	yes	yes	no
Batch scanning	yes	yes	no
Color	yes	yes	yes
Color restoration	yes	yes	yes
Cropping	yes	yes	no
Descreening	yes	yes	no
Digital ICE	yes	no	no
Dust removal	yes	no	no

*Larger photos require multiple scans. The included software "stitches" the complete image together after the parts are scanned.

DIGITAL SCANNING EQUIPMENT OPTIONS

	WAND SCANNER	SMARTPHONE/ TABLET	DIGITAL CAMERA
Best for ...	scanning text; not recommended for photos	on-the-go digitizing of photos	oversize photos (use a tripod and shutter remote)
Scan saved to ...	internal memory or SD Card	internal memory or SD card	SD card
Portable	yes	yes	yes
Permitted in many research archives	some	yes	yes
File formats	JPG, PDF	JPG (PDF with apps)	JPG, RAW
Maximum scanning size (in inches)	varies	varies	varies
Resolution (in pixels)	300, 600, 900	varies	varies
Speed	average	fast	fast
Photo prints	yes	yes	yes
Negatives/film/slides	no	no	no
SOFTWARE FEATURES			
Auto file naming	no	yes, with app	no
Batch scanning	no	yes, with app	no
Color	yes	yes	yes
Color restoration	no	yes, with app	no
Cropping	no	yes, with app	no
Descreening	no	yes, with app	no
Digital ICE	no	no	no
Dust removal	no	no	no

DESKTOP SCANNERS

When it comes to scanning heirloom photographs, your digitizing equipment is only half of the solution. You also need digitizing software that will produce high-quality scans quickly and easily. All desktop flatbed scanners and all-in-one devices offer a variety of scanning resolutions, file formats, and other options. The key is to find a scanner and software to suit your work style, needs, and budget.

If you routinely digitize heirloom photos and documents or plan a large digitizing project, you will appreciate the speed and features of a dedicated flatbed scanner. If you only need to scan photos occasionally, you may find an all-in-one device is adequate for your needs. Either device is a safe option for digitizing heirloom photos and documents.

Flatbed Scanners

The best digitizing equipment for most family historians is simple, affordable, and efficient: a dedicated flatbed scanner, which usually costs under $200. Look for a scanner with user-friendly software offering batch scanning and file naming, along with a film carrier, a plastic accessory usually included for scanning color and black-and-white negatives, slides, and film. The resulting digital image from scanned film is sharper and more pristine than a scanned paper image and well worth the effort for special images. Even if you think you won't be scanning film or slides, the first time you do need to digitize an old black-and-white negative found tucked inside a photo envelope, you'll be glad you have the option to work with film on your flatbed scanner. Several Epson flatbed models have these features.

It can be tempting to try compact slide scanners, negative scanners, or digitizing gadgets that promise "fast, easy results," but I've found that a dedicated flatbed scanner with film carrier easily handles most of my digitizing needs. I recommend choosing a flatbed scanner when you want to digitize items that will easily fit on the glass of your scanner such as heirloom photographs, snapshots, color or black-and-white negatives, and slides.

FLATBED PROS	FLATBED CONS
✖ accommodates many kind of items	✖ limited to size of scanning bed
✖ affordable	✖ requires flat, stable surface
✖ faster than all-in-one devices	
✖ consistent, high-quality digitized images	
✖ included software offers advanced scanning options	
✖ time-saving features of batch scanning and file handling	
✖ separate film carrier can scan negatives, film, and slides	

All-in-One Devices

You may already use an all-in-one printer, scanner, and copier device in your home office and be reluctant to add another piece of equipment such as a dedicated flatbed scanner. An all-in-one device is a good option for occasional scanning, especially if workspace is limited. Depending on the manufacturer and model, you may have the same scanning software available on dedicated scanners; however, because film scanning requires both a special film carrier and a light source above the film, most all-in-one devices are unable to digitize negatives and slides. I was delighted to find that my new large-format Epson all-in-one included the same Epson scan software I used for years with my Epson V500 flatbed scanner. The only feature I missed was the film-scanning capability of my dedicated scanner.

Be sure to also consider an all-in-one device's features such as an optional sheet-feed mechanism and its ability to scan bound books. But keep in mind that the roller in a sheet-feed mechanism can mangle and damage fragile papers and photos. To avoid the risk of ruining your heirloom photos, use the all-in-one device's flatbed portion to scan your images.

ALL-IN-ONE PROS	ALL-IN-ONE CONS
✖ saves desktop space ✖ economical	✖ slower scanning speed than a flatbed scanner ✖ limited scanning format, resolution, and file-naming options ✖ few image adjustments ✖ usually cannot scan negatives, film, or slides

MOBILE DIGITIZING EQUIPMENT

You may have heard the old adage, "The best camera is the one you have with you." It's true for digitizing equipment like scanners, too. How many times have you wished you had your flatbed scanner handy to copy a stack of family photos cautiously shared by an elderly relative? You know this may be your only opportunity to view and copy those snapshots, and you need to get the best images possible. The room is warm and poorly lit by only a few table lamps. Your great-aunt is not eager to let the photos leave her home. Your options are simple: a smartphone camera, which will result in fairly good, but not great, copies, or nothing. But wait—there's another option: mobile scanners. Several models of portable devices offer yet another method for digitizing photographs on the go. These devices fall into two categories: portable flatbed scanners and handheld wand and mouse scanners.

Full-Size Portable Flatbed Scanners

The CanoScan LiDE portable scanner **<www.canon.com>** is popular with researchers who want to use their own scanning equipment at libraries and archives. The CanoScan LiDE offers a full-size scanning flatbed powered by a USB cable attached to your Windows or Mac laptop computer. The scanner is about the size of a small laptop computer and fits easily inside a computer bag with a laptop. Of course, the trade-off for lightweight portability is the scanner's overall plastic build, so be careful to protect the device from damage by transporting it in a padded computer bag with the lid closed and secured with a piece of plastic tape.

The CanoScan LiDE portable scanner delivers high-quality letter-size scans in a variety of resolutions and file formats, including TIFF, and the software included can stitch together multiple scans of oversize items. You can save images to the laptop hard drive or directly to an SD card or USB flash drive for later transfer to your photo collection.

The CanoScan LiDE can capture an 8.5x11-inch image in one scan as an archival TIFF, and it has the ability to add file names as you work. These features save considerable time when you return home and move your new digital images to your Photo Library. The main drawback of this scanner, however, is that its software is less user-friendly than other scanners. To work around this disadvantage, install and use Hamrick's VueScan software on your laptop with the CanoScan LiDE. At a price point under $100, this is a good portable scanner for researchers.

CANOSCAN LiDE PROS	CANOSCAN LiDE CONS
✖ portable, lightweight, fits in a laptop bag	✖ unintuitive scanner software
✖ inexpensive	✖ doesn't have film or negative carrier
✖ permitted in many archives and libraries	
✖ doesn't damage documents or photos	
✖ scans letter-size sheets in one operation	
✖ scans in multiple resolutions and file formats, including archival TIFF	
✖ offers batch scanning and file naming	
✖ crops images automatically	
✖ USB powered (no need for batteries)	
✖ saves images to computer/storage media	
✖ cover hinge allows for book scanning	

Small Portable Flatbed Scanners

The Flip-Pal portable flatbed scanner is popular with many family photo fans because of its unique "flip-and-scan" feature. This scanner was designed by family historians to easily scan

photos at family gatherings. The Flip-Pal offers high-quality JPG scanning comparable to a traditional larger scanner. Other manufacturers are now offering similar products, as well.

The 4x6-inch scanning bed and limited resolution (300 or 600 dpi) are adequate for most family snapshots and create good-quality images for restoration work. The scanner's small size allows it to be flipped upside-down to copy large photos or oversize documents in multiple images that can be "stitched" together using the included EasyStitch software.

The Flip-Pal is powered by four AA batteries; alkaline, photo lithium, or rechargeable batteries may be used, but rechargeable batteries will scan nearly three times more photos than alkaline batteries. If you're going to do a lot of scanning, you will save money in the long term by investing in a set of quality rechargeable batteries, such as the newest generation nickel-metal hydride (NiMH) rechargeable batteries, which recharge fast and can hold their charge for up to nine months. I recommend purchasing an extra set of rechargeable batteries, too, so you will be set for any scanning that comes along.

Images scanned with the Flip-Pal mobile scanner are saved to a standard SD card (included with the scanner) and can be transferred to your computer like any digital image. Many users automate transfer by using the Wi-Fi-enabled Eyefi Mobi SD card (see Chapter 2), which can send the scanned images directly from card to computer as you work.

The Flip-Pal is not really efficient for heavy office document scanning due to the small scanning bed, limited file formats, and battery-only operation, but these same features make it a terrific mobile digitizing tool.

FLIP-PAL PROS	FLIP-PAL CONS
✖ fun to use, lightweight, portable, affordable	✖ limited size of glass flatbed scanning area
✖ good for visits with relatives and on-site research at libraries and archives	✖ limited to JPG format
✖ EasyStitch software extends scan size options	✖ limited to two options for resolution
✖ quick scanning time with standard (300 dpi) and high (600 dpi) resolution	✖ limited image enhancements available
✖ has a removable cover to scan artifacts and oversize items	✖ number of scans limited by card storage
✖ permitted in many archives and libraries	✖ battery powered, so you must carry extras
✖ will not damage documents or photos	✖ doesn't scan negatives, film, or slides
✖ uses rechargeable batteries	
✖ accepts standard SD cards; also will accept wireless-enabled Eyefi Mobi SD card	
✖ everything is included: batteries, SD card, software	

A Note About Older Scanners

If you have an older scanner that no longer works with your computer or upgraded operating system, you might be able to use it with third-party scanning software such as VueScan from Hamrick Software **<www.hamrick.com>** or SilverFast by LaserSoft **<www.lasersoft.com>**. I've used VueScan successfully with several scanners, including an HP All-in-One, Epson flatbed, and Canon CanoScan LiDE flatbed.

VueScan for Windows, Mac OS X, and Linux offers features similar to the Epson scanner software for batch scanning, renaming, and editing, and it's compatible with more than 2,500 scanners. SilverFast is sold in Beginner and Professional editions for specific scanner models, including more than 350 different scanners for Windows and Mac computers.

Wand and Mouse Scanners

Many genealogists regularly use a portable wand or mouse scanner to digitize research material, especially pages from books, magazines, or other documents. The low cost and portability of wand and mouse scanners are attractive features, and you can achieve good-quality scans with a little practice and a steady hand. Like the Flip-Pal mobile scanner, wand and mouse scanners capture JPG images only, but they offer cordless, battery powered mobility in a handheld device.

The scanning mechanism in wand and mouse scanners is located inside the device facing the open underside. Small rollers on the underside of the mouse or wand scanner help the device glide over the paper, scanning the image as it passes. Some archives and libraries, including the National Archives in Washington, D.C., do not permit the use of scanning devices with moving parts such as wand or mouse scanners. If you plan to use a wand or mouse scanner to copy research on-site, it's a good idea to check the library or archive scanning policy before you go.

When considering a wand or mouse scanner, you'll want to be sure to look at four key features:

- length of the wand, because it determines the width of material that can be scanned
- power source, such as battery power or AC adapter
- number of scans per battery charge
- number of scans stored on the device or SD card

Wand Scanners

Sometimes called "Magic Wand" scanners, these portable stick-type scanners require the user to move the wand over the item. Typical scanner settings vary by model and offer scanning resolution from 300 dpi up to 900 dpi. Files are saved in JPG or PDF format to internal memory or to a microSD card (the tiny version of the standard SD card), depending on the model. You can

transfer the images to your Photo Library via a USB cable. Wand scanners are battery powered with AA or rechargeable lithium batteries.

Wand scanners are popular with researchers who need to copy pages from books or other printed material, but most users find the results are less satisfactory with photographs and images where you may want a high-quality digital file for restoration, reproduction, and archiving.

Mouse Scanners

Small handheld mouse scanners resemble a computer mouse but include a multidirectional scanning mechanism that can copy a document or photo in any direction when the Scan feature is activated. The scan is made by sweeping the mouse back and forth over the item until the entire surface has been copied. Users report that it works well for small receipts and documents, but photos are best digitized with another method.

WAND AND MOUSE PROS	WAND AND MOUSE CONS
✖ affordable	✖ requires a flat, stable surface
✖ small, lightweight, portable	✖ may be difficult to achieve good results
✖ good scans for text and bound books	✖ scans only flat items
	✖ number of scans is limited by device or SD card storage
	✖ limited file formats and resolution options
	✖ not permitted in all libraries and archives
	✖ battery powered, so you must carry extras
	✖ can't scan negatives, film, or slides

DIGITAL CAMERAS AS SCANNERS

If I could only have one digitizing device, it would be hard to choose between a flatbed scanner and a digital camera. The scanner is better for capturing high-resolution detail and nuances of color in heirloom photographs, but it's hard to fit a large antique print on the standard-size glass bed of a scanner. That's when I bring out my digital camera, set the resolution to maximum megapixels, turn off the flash, and snap multiple photos from different angles. When paired with a tripod and automatic shutter release, a digital camera can become a do-it-yourself copy station that speeds up digitizing scrapbooks, photo albums, and oversize photographs.

Look for a digital camera with a minimum 5 megapixel (MP) resolution. Learn to turn off the Auto Flash so your images aren't ruined by a flash burst or overexposed with too much light. If you have a choice between a smartphone, digital point-and-shoot camera, digital Single Lens

Reflex (SLR) camera, or Mirrorless Four-Thirds (M4/3) camera, always select the one with the largest image sensor. The larger the sensor, the more light will be available to the camera lens to record the image, resulting in a better picture. Learn more about digital image sensors and find the image sensor size of your own gear at Camera Image Sensor **<cameraimagesensor.com>**.

DIGITAL CAMERA PROS	DIGITAL CAMERA CONS
✖ versatile, affordable	✖ requires good light
✖ good for almost any item	✖ needs a tripod for best results
✖ best device to digitize oversize and 3-D objects	✖ most consumer cameras offer JPG-only file format
✖ expandable storage with removable SD storage cards	✖ number of scans is limited by device or storage card
✖ fast for creating digital images	✖ battery powered, so you may need extras
	✖ can't scan negatives, film, or slides

DOCUMENT CAMERAS

Document cameras aren't well-known outside of schools where they have largely replaced the overhead projector of past classrooms. New technology has made these cameras a viable alternative for fast, high-quality scans of photos and documents. The tiny camera is positioned on an adjustable arm connected by USB cable to a computer. Software included with the device captures anything within view of the camera in photos and videos for screen display or as a digital file.

Historians can use document cameras to quickly digitize documents and photos in JPG, TIFF, or PDF format. Because the item rests on the table or desk, there's no need to manipulate a bound book or fragile oversize photo onto a scanning bed. And the weighted document camera arm acts like a tripod to hold the camera steady for a shake-free shot. It may be necessary to extend the camera arm height to digitize larger items. The integrated light aids image capture in low-light situations common to libraries and archives.

Document cameras are powered through a USB cable connection to your Windows or Mac computer, and scanned images can be saved to the computer, an SD card, USB flash drive, or other storage device.

Fast, high-quality scans make them good portable devices for digitizing many items quickly, especially for research documents or photo album pages.

Look for the highest resolution document cameras, such as the new Solo 8 models from HoverCam **<www.thehovercam.com>**.

DOCUMENT CAMERA PROS	DOCUMENT CAMERA CONS
�֍ creates fast digital scans	✖ more expensive than a typical scanner or digital camera
✖ permitted in many archives and libraries	✖ heavier and bulkier than a digital camera
✖ doesn't damage documents or photos	✖ may need to extend camera height for large items
✖ compact and sturdy	✖ no option for scanning negatives, film, or slides
✖ offers multiple resolutions and file formats, including TIFF	
✖ integrated light is helpful in dark libraries	
✖ video options are useful for demonstrations	
✖ automated scanning functions speed large scanning projects	
✖ USB powered (no need for batteries)	
✖ multiple file storage options	

SMARTPHONES AS SCANNERS

It doesn't take any special skill or equipment to capture acceptable images of a recipe or restaurant receipt using your smartphone camera. Most mobile phones include a camera lens and built-in software that rival dedicated point-and-shoot cameras for outdoor shooting and do a good job indoors with adequate light.

Smartphone cameras take terrific photos, but capturing a good scanned image is not the same as snapping a vacation scene, so smartphones aren't always the best choice for digitizing photographs. The small image sensor limits the amount of light that the camera lens can take in, making it harder to capture a sharp image in low-light situations. Because genealogists typically digitize photos and documents indoors, this limitation can result in fuzzy images.

Enter scanning apps. Scanning apps are designed specifically to address the challenges of low-light document capture. Scanning apps offer features such as cropping, deskewing, light correction, and various file format options. Some of the most popular scan apps:

- ✖ CamScanner (Android, iOS) **<www.camscanner.com>**
- ✖ DocScan (iOS) **<ifunplay.com/docscanapp.html>**
- ✖ Genius Scan (Android, iOS, Win Phone) **<www.thegrizzlylabs.com>**
- ✖ Handy Scanner (Android) **<www.halfmobile.net>**
- ✖ Prizmo (Mac, iOS) **<www.creaceed.com/prizmo>**
- ✖ Scanner Pro (iOS) **<readdle.com>**
- ✖ TurboScan (iOS, Android) **<turboscanapp.com>**

Take time to investigate apps available for your Android or iOS device and learn to use their features. If you're considering using your smartphone as your scanner, you may want to get some additional gear, including a scanning app, a camera grip, and a tripod. It's also good to be mindful of the limited battery life and storage options for most smartphones. See the Appendix for a complete list of scanning resources.

SMARTPHONE PROS	SMARTPHONE CONS
✖ convenient (you may already have one)	✖ requires good light
✖ small and portable	✖ scans may be better with a tripod
✖ can digitize items of nearly any size or format	✖ JPG-only file format
✖ safe for fragile and old items	✖ can be expensive to purchase
✖ permitted in many archives and libraries	✖ number of scans is limited by device or storage card
	✖ may drain your device's battery
	✖ can't scan negatives, film, or slides

ESSENTIAL SCANNING ACCESSORIES

High-quality digital images are easier to achieve with a few simple accessories, such as:

- ✖ a microfiber glass cleaning cloth
- ✖ a soft artist's or photo lens brush

Helpful accessories for scanning with a digital camera or smartphone:

- ✖ a standard rigid-leg tripod
- ✖ a flexible-leg tripod (such as the Joby GorillaPod **<www.joby.com>**)
- ✖ a microfiber lens cloth
- ✖ wired or wireless shutter remote
- ✖ a scanning app for smartphone scanning
- ✖ extra batteries and memory cards

WHEN TO CALL IN THE PROS

Although digitizing is easy and affordable using home equipment, there are times when it makes sense to use a professional digitizing service, especially when you need to scan any kind of film. Because negatives, slides, and movie film hold more detail than printed photographs, each frame needs to be scanned at a higher resolution, which takes more time per scan. For example, a full-color 600 dpi scan of a printed 3x5.5-inch black-and-white snapshot takes about twenty-five seconds. In contrast, scanning the 2.5x4.5-inch Brownie negative of the same image in the recommended 2400 dpi resolution takes about two minutes. If you need to scan one hundred negatives, the scanning time alone—not including setup—will require nearly three and a half hours. Do you have the time available for this project?

You may have a different situation and want to digitize only a few slides or movies, but lack the proper equipment. Sending your work to a professional service will be more economical and efficient than purchasing and learning to operate a new scanner for only one project.

Professional digitizing services vary from high-quality professionals who do all work on-site to automated scanning by "big-box" stores who send crate-loads of photos overseas for cheap turnaround. Don't let this scare you away from seeking out a reputable company to help you digitize your family photos, negatives, slides, and movies. Here are the key features to look for.

- **Local business, on-site work:** Call ahead and ask if you can deliver your photos. Take a small order and then ask for a tour, or look around and observe the equipment and process. If you need to ship your photos, ask what the intake and tracking procedure involves.
- **Equipment:** Some automated equipment is acceptable for modern photos, but ask: How does the company work with fragile photos, negatives, and slides?
- **File formats:** Make sure they deliver your scans back to you in a format you can use, such as JPG or TIFF.
- **Image adjustment:** Is this available? Can you request untouched images?
- **File delivery:** Some companies offer Internet downloads, flash drives, or external hard drives. Be sure you know how your digital copies (and the hard copies you drop off) will be returned to you.
- **Cost:** Be careful about selecting a service based on price alone. Test a new firm with a small job before committing to a bigger project. Look for online and local discount coupons, and ask about discounts for return customers.

❂ Scanning Tactics ❂

The first time I scanned a photograph of my grandmother and zoomed in to view the digital image on my computer screen, I felt a shift in attitude toward my photo inheritance. Instead of feeling like a family member viewing an old snapshot, I became a research historian, scrutinizing the photo for clues in my grandmother's jewelry, clothing, and surroundings. The digital image allowed me a close examination of the image, and when I looked at my scan of the photo's reverse side, I discovered faint handwriting. With a few adjustments in my photo-editing software, I was able to reclaim the faded handwriting and read the caption identifying the date and place the photo was taken. After I finished working with photo clues, I touched up a digital copy to use in a photo book to share with my sister and extended family.

Digitizing family photos with a scanner or camera does much more than preserve image copies. A single digital image can be shared, restored, reprinted, and used in countless creative family history projects—all you need is a scanner or digital camera.

BEFORE YOU BEGIN

Before you begin any digitizing project, take time to learn about your equipment and how to access the full range of its available features. When using a flatbed scanner, turn on its Pro Mode to view all options for your scanning project. This will allow you to access the full range of fea-

tures offered by your scanner and its scanning software. You'll likely need to turn off Auto Mode to access the custom or professional features. When using a digital camera or smartphone camera, take time to understand how to turn the flash on and off, how to set the camera resolution, and how to confirm the date and time are correct.

Working With File Formats

Most family photographers and genealogists capture images in JPG format. This is the default file format for consumer digital cameras, smartphones, and tablets. You may have heard that JPG files lose some data every time the file is opened, edited, and saved. This is part of the compression feature that keeps JPG files small enough to be effective for e-mailing and online use. Each time you edit and save a JPG, a new edited version overwrites and compresses the old version. A few edits and saves don't appreciably alter the image for most of us, but many edits, tweaks, crops, and adjustments can leave you with a virtually unusable, pixelated image.

> ❊**TIP**❊
>
> ### JPG vs. TIFF
>
> JPG is a file format that uses compression when saving files and is called a lossy file format because repeated opening and saving of JPG files deteriorates the image quality over time. TIFF is a file format that does not use compression when saving files and is considered a lossless format because it maintains its quality over time.

When you use a scanner to capture images, you have many more file format options including TIFF, a lossless uncompressed image format. TIFF files do not use file compression, and your original file does not degrade in quality with each edit and save. If you crop and adjust the color of an original and save your edits, however, the original file will be overwritten by the changes, and you will be unable to revert to the original.

The open-standard Portable Document Format (PDF) is a third common file format often used by family historians. PDF is useful for creating a document to hold multiple pages of scanned research materials, but the adjustment tools are limited and may not give you enough options to enhance color and adjust contrast when you need to read and transcribe old documents and faded handwriting. It's better to stick with TIFF or JPG formats for scanned photos and documents and then combine the files into a PDF document for archiving. For photographs, scan using TIFF format when possible.

HOW TO SCAN AN HEIRLOOM PHOTO

When you're ready to start digitizing your family photos, prepare a sturdy surface to hold your scanner and photographs. I like to work with two folders or small boxes to hold photos, labeled To Be Scanned and Scanned. This helps me avoid losing my place if I'm interrupted during the

SCANNING GUIDELINES

What's the best scanner type for each type of family keepsake you want to digitize? What resolution is optimal when scanning photographs? Use this chart as a guide to help you optimize the scanning quality for digitizing your heirloom photos and other keepsakes.

ITEM TO SCAN	RECOMMENDED SCANNER TYPE	RESOLUTION	FORMAT	COLOR
Album pages	flatbed or digital camera	600 dpi	TIFF	24-bit color
Letters, documents	flatbed or digital camera	300 dpi	TIFF or JPG	24-bit color
Maps, large documents	digital camera	maximum dpi	JPG*	
Negatives, slides	flatbed with carrier or special scanner	2400 to 3200 dpi	TIFF	Transparency
Photographs	flatbed	600 dpi	TIFF	24-bit color
Quilts, other textiles	digital camera	maximum dpi	JPG*	
Small books	flatbed or digital camera	600 dpi	TIFF	24-bit color
3-D artifacts	digital camera	maximum dpi	JPG*	
Tintypes, daguerreotypes	flatbed	1200 dpi	TIFF	24-bit color
Working document, research receipts, etc.	digital camera, mobile device camera, or scanner	300 dpi for printing, 72 dpi for display	JPG	24-bit color

*Convert and save images made by a digital camera in JPG format to TIFF copies. Place the TIFF copies in your Photo Library and back them up in your Image Vault.

Scanning Tips

�֍ Start each scanning session by cleaning the scanner glass.
✖ Wash your hands before handling photos.
✖ Handle photos on edges or wear white cotton gloves.
✖ Remove light dust or dirt from photographs by lightly using a soft artist's brush.

scanning session. Use this checklist to guide you through each step in preparing your equipment, your photos, and your scanner settings.

STEP 1: WASH HANDS AND CLEAN SCANNER GLASS. Start each scanning session by cleaning the glass bed of the scanner with a soft microfiber cloth lightly dampened with water or glass cleaner. Avoid spraying directly on the glass. Repeat this step frequently during long scanning sessions. Old photos often leave dust and bits of crumbling paper on the glass bed after handling. Clean the glass often. Also, wash your hands or wear white cotton gloves before handling photos.

STEP 2: CLEAN PHOTOS. Use a soft artist's brush to lightly dust off any loose dirt from your photograph prints. Do not use an eraser to remove marks or smudges; instead, rely on photo-editing software to touch up and restore.

STEP 3: SET FORMAT TYPE (REFLECTIVE OR FILM). Photographs printed on paper are "reflective" documents; that is, the light emitted by the scanner is reflected back into the device. Negatives, slides, and movie film are transparent and allow the light to go through the item. Choose the appropriate setting for your photo or film.

STEP 4: SET RESOLUTION. Scanner resolution is set in dots per inch (dpi), a reference to the ratio at which the original image is converted from printed dots to digital pixels. When I started scanning my photo collection, I followed advice to "use the highest resolution possible" and soon discovered that the resulting files were enormous and far larger than necessary. I now follow a protocol adopted by museums and archives that need to process material efficiently and effectively, and scan most photos at 600 dpi.

I've found that a 600 dpi scan of a 4x6-inch print will provide a good-quality 8x10-inch enlargement or excellent same-size reproduction of the original. When my original is extremely small—for example, a single face in a large group photo or a tiny school picture—I set the scanner resolution to 1200 dpi and make an additional scan focusing on the individual. Film, slides, and negatives hold more information than printed photos and should be scanned at a higher resolution as well, typically 2400 to 3200 dpi. Refer to the Scanning Guidelines chart to see recommended settings for various photo types.

STEP 5: SET COLOR CHOICE. Select 24-bit color. As family historians and archivists, our goal is to preserve photographs and documents in a near-original form. You can easily accomplish restoration and enhancement in photo-editing software working from a full-color image of the original photograph or document. Scan everything in full color, including black-and-white photographs and handwritten documents.

Your scanner may have several different color choices used by graphic artists for design and printing, along with options for 8 or 16 bits/channel. I typically use the standard sRGB (Red, Green, Blue) at 8 bits/channel (24 bits total); this allows later manipulation of the color channels in my photo-editing software.

STEP 6: TURN ON ADJUSTMENT OPTIONS, IF DESIRED. If you want to apply image adjustments to the original scan and save editing time, you can do so in the scanning setup. The most com-

HEIRLOOM PHOTO SCANNING CHECKLIST

- ☐ STEP 1: Wash your hands. Clean the scanner glass.
- ☐ STEP 2: Lightly dust the photo.
- ☐ STEP 3: Set format to PHOTOGRAPH (or REFLECTIVE).
- ☐ STEP 4: Set resolution to 600 dpi.
- ☐ STEP 5: Set color to 24-bit color.
- ☐ STEP 6: Set adjustments (optional): Color Restoration, Descreening, etc.
- ☐ STEP 7: Set file-saving and file-naming to TIFF. Save to desktop SCANS folder.
- ☐ STEP 8: Preview and crop.
- ☐ STEP 9: Scan the photo's front and back.

mon adjustments include color restoration to automatically adjust for faded color prints and dust removal, and digital ICE to remove dust and scratches.

STEP 7: SET FILE-NAMING AND FILE-SAVING PREFERENCES. On an Epson scanner, these options are found in a second window accessed with the Folder button. For archive-quality digital copies, select TIFF format whenever possible. Save new scans to your SCANS folder.

STEP 8: PREVIEW AND CROP IMAGE. Place your photo on the glass scanning bed and click the Preview button. If you don't see the Preview button, you may be operating in the auto scanning mode. Click the Mode drop-down menu and select Home, Office, or Professional Mode. I recommend Professional Mode for full access to all features. To crop the image, click the Marquee selection button and note the dotted line. This defines the area that will be scanned. Click and drag the dotted line to select the entire photo. I like to include the border.

STEP 9: SCAN FRONT AND BACK. Always scan the front and back of the photo to capture any handwritten remarks or photographer's information that could help identify and date the image. Use the same file name with the suffix R for Recto (right side, or front) and V for Verso (reverse side). Or use sequential numbers in batch file naming with odd numbers indicating the right side and even numbers indicating the reverse.

HOW TO SCAN MULTIPLE SNAPSHOTS AT ONE TIME

If you have scanned slides or a strip of negatives, you may have noticed options to scan multiple images. You can save time by scanning multiple photos or documents as well. For best results when scanning more than one item at a time:

- Leave a clearly defined space between the images to help the scanner identify each item.
- Group items of the same type: all black-and-white photos with good contrast, all color portraits, all color snapshots, etc.
- Group items of the same size.
- Leave room at the edge of the glass document bed so the scan captures the edges.

The following steps are for using an Epson flatbed scanner. Other brands of scanners should have similar software options.

STEP 1: PLACE PHOTOS. Wash your hands (or wear white cotton gloves) and clean the scanner glass. Place your photos or documents on the glass document bed leaving about a half inch between each photo.

STEP 2: CHOOSE SCANNER SETTINGS. For photos, use 600 dpi, 24-bit color. Always scan in Color Mode to capture the full range of color. (See the Scanning Guidelines chart for details.)

STEP 3: SELECT FILE NAMES, FILE FORMAT, AND SCAN FOLDER. Choose the location of the folder to hold your scanned images. (I use a desktop folder labeled SCANS.) Enter the file name

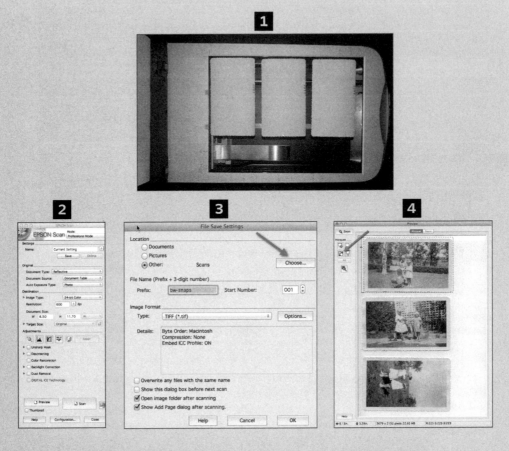

prefix for the images and set the start number for your individual photo files; choose the folder where you want the scans to go. Select the TIFF file format and click OK.

STEP 4: PREVIEW THE SCAN. In the main scanning window, click Preview. You will see a preview of all the items on the document bed. You should see a selection marquee (dotted-line rectangle) around one item or around the entire group. If you do not see the selection, click the Marquee tool button (indicated by the arrow). Using your mouse, grab any of the dotted lines and adjust to completely enclose the photo. It's okay to have white edges showing outside the border of the photo. If you prefer to have a wider or thinner border on your photo, make the marquee larger or smaller. Everything you see inside the dotted lines will be included in the scan.

STEP 5: SELECT IMAGES TO SCAN AND DUPLICATE SELECTION MARQUEE. Copy the first selection rectangle and use it to select another image on the document bed by clicking the Duplicate Marquee tool. The dotted line around your first image will become a solid line and a new dotted-line marquee will appear, and the number of images will change from one to two.

Use your mouse and click anywhere inside this dotted-line marquee. Hold down the mouse button and the pointer will turn to a hand; drag the dotted-line marquee to the next photo. If all the photos are the same size, you should be able to enclose the next image without adjustments.

STEP 6: SELECT ADDITIONAL IMAGES. Repeat as many times as needed to select each individual item on the page. Click the Duplicate Marquee button and drag the new dotted-line rectangle to select each image. Notice that the image count changes as you make additional selections. The active photo will have the dotted lines.

STEP 7: COMPLETE IMAGE SELECTION. Click the All button to indicate you want to scan all selections. Each image will be enclosed by a dotted line showing that it is selected for scanning.

STEP 8: SCAN IMAGES. In the main scanning window, click the Scan button. When finished, your folder will include the individual scanned images automatically named and numbered according to your settings in the File Save window.

HOW TO SCAN A PORTION OF A PHOTO

Most of the time I scan an entire photo, including any borders or edging on the print. Early twentieth-century snapshots were often printed with the date in the white margin, and my ancestors often added handwritten comments in the margin as well. When photos are pasted on an album page, I want to keep the context and any comments with the pictures, so I always scan or photograph the entire page as a reference. This information can help identify mystery people, locate ancestral homes, and provide clues to family groups. But to work with an individual photo for restoration or another project, I need a high-resolution file of an individual print.

A photo scanned at 300 or 600 dpi may be blocky and pixelated when a portion is enlarged for a printed pedigree chart or large family tree. But scanning a large photo or album page at a higher resolution creates a huge image file and requires measurably longer scanning time. I can achieve the best result with a smaller size file by using the scanner to crop the image and scan only the selection. This technique is useful when you need to

�֍ create individual mug shots for a family tree chart.

✖ focus on an individual in a group photo.

✖ scan individual photos displayed as part of a group on an album page.

✖ delete damaged areas of a photo.

✖ eliminate unnecessary and distracting backgrounds.

In this example, I am going to crop and enlarge individual faces for a printed chart. The original snapshot is 3.5 inches square. At the standard setting of 600 dpi, the headshots will print at about 1 inch square. Setting the Target Size will confirm the final size.

STEP 1: PLACE PHOTO. Wash your hands (or wear white cotton gloves) and clean the scanner glass. Place your photo on the glass document bed.

STEP 2: CHOOSE PORTION TO SCAN. With the photo on the scanner and the image displayed in the Preview window, adjust the Marquee tool to include only the selected face.

STEP 3: SELECT RESOLUTION. Adjust the scanner settings to scan at 600 dpi. Create a 1x1-inch square target template: In the main scanning window next to Target Size (see **A**), click on the drop-down menu and select Customize (see **B**). Enter a new user-defined Target Size Name: 1x1 and set the width and height at 1.00 inches (see **C**). Click Save and OK when finished (see **D**).

STEP 4: MAKE FINAL CHANGES. Click on the Zoom button and adjust your selection. The marquee will retain the 1x1 shape set as the target. If you want to change it, go back to the main scanning window to select a different Target Size.

STEP 5: SCAN PHOTO. When you are pleased with the selection, press Scan.

HOW TO SCAN NEGATIVES AND SLIDES

If you are fortunate to own old slides or negatives, you will achieve the best results by scanning the film instead of the printed photograph for your digital image copies. Clean, well-preserved film retains crisp, sharp detail that is often lost in older prints.

To scan negatives or slides, you will need a "film/slide carrier." This is a plastic accessory that holds the film above the glass scanning bed. Many flatbed scanners are bundled with these accessories; all-in-one printing, scanning, and copying devices typically do not offer slide and film scanning or the software to support the option.

Negatives and slides should be handled much the same way as for scanning. Only touch the film on the edges; avoid touching the surface of the image. Refer to your scanner's user guide for installation instructions for the film carrier and recommended settings.

Achieving good results with film scanning requires patience and a bit of trial and error. Be prepared to experiment. In addition, scanning film requires a higher resolution, 1800 dpi or more, which adds time to the scanning process.

If you are digitizing many slides or negatives, you may want to consider using a scanning service. Search locally to find a company where you can drop off your items; ask for recommendations from friends. Avoid shipping negatives, film, or slides, if possible, to minimize the chance of loss or damage.

To scan filmstrips or slides, you will need to remove the document mat on the inside cover of the scanner lid to allow the light to pass through the transparent film. Consult your user guide for instructions on removing the document mat and correctly installing the film carrier.

Follow this process for scanning film with the Epson V500 or a similar scanner.

STEP 1: CONNECT COVER CABLE. Confirm that the cover cable is connected to the scanner.

STEP 2: REMOVE DOCUMENT MAT. Remove the document mat on the underside of the cover.

STEP 3: CLEAN SCANNING WINDOW. Clean the scanner film transparency window by wiping gently with a clean microfiber cloth.

STEP 4: ATTACH FILM CARRIER. Place the film carrier on the glass flatbed scanning surface.

STEP 5: INSERT SLIDES OR FILM. Put slides or film into the carrier with the shiny side down. Close scanner cover.

STEP 6: SELECT SCANNING OPTIONS. Set the scanning selections in the software window:

- Document Type: FILM
- Film Type: select Color Positive Film, Color Negative Film, or B&W Negative Film
- Resolution: 2400 dpi

Use the same resolution for black-and-white or color originals. Due to the high-resolution and TIFF file format, scanning will take some time. Be patient.

STEP 7: PREVIEW SCAN. Preview the scan; select the image using the selection Marquee tool.

STEP 8: SCAN. After scanning, remove film or slides. Replace the document mat when finished with your film-scanning session.

HOW TO DIGITIZE WITH YOUR CAMERA

When you need to digitize fragile or oversize photographs that could be damaged when maneuvered on the glass scanner flatbed, use your digital camera as your scanner. A digital camera may also be good to digitize

* ✖ photos in albums or scrapbooks.
* ✖ images in bound books.
* ✖ photos in bulky cardboard mats.
* ✖ framed photographs.
* ✖ a collected group of photos.

Prepare Your Camera

Use your camera to capture the original photograph in its present condition. Resist the urge to add in-camera filters for black-and-white, sepia, or other creative effects. You always can make these adjustments later in photo-editing software. When digitizing for preservation and possible future restoration, it's best to capture the full photo in color in its present condition. Check that you have the following settings selected on your camera:

* ✖ Maximum megapixels (at least 5MP)
* ✖ Flash: OFF
* ✖ Filters: NONE
* ✖ Format: JPG
* ✖ Auto White Balance: ON
* ✖ Date and Time Stamp: OFF
* ✖ Image Stabilization (if available): ON

If you are digitizing many photos away from home, take along extra batteries, a battery charger, and extra memory cards.

Prepare Your Camera Gear

Successful digitizing with a digital camera depends on a well-exposed, sharp image. You will have the best success shooting in natural light using a tripod to stabilize the camera and a remote shutter release to eliminate camera shake from pressing the shutter with your finger. Helpful gear for digitizing photographs with a camera:

* ✖ a sturdy, adjustable tripod
* ✖ a small flexible-leg tripod, such as the Joby Gorrillapod **<www.joby.com>**
* ✖ a smartphone grip and tripod (if you shoot with your phone)
* ✖ a remote shutter release (wired or wireless)

1

2

3

4

HOW TO DIGITIZE FRAMED PHOTOS

To photograph items hanging on a wall, place the camera on a sturdy tripod with the camera lens aimed directly at the item. Turn off the flash and use the self-timer or remote shutter to snap the photo. If reflection from the glass causes difficulty, try a Circular Polarizing Filter available from camera shops to minimize the glare. Alternatively, you could remove the glass from the frame, if possible, to minimize glare.

HOW TO DIGITIZE OVERSIZE PHOTOS AND ALBUMS

To photograph oversize items such as individual large photographs or photo album pages, mount your camera to hang upside down on the tripod with the camera lens aimed directly down at the item. Turn off the flash and use the self-timer or remote shutter to snap the photo.

Some camera tripods feature a reversible center mount pole that can be used to position your camera directly over the subject. When this isn't available, I've used a second, small tripod with flexible legs to hold the camera in place. Flexible tripods from Joby GorillaPod are available for most camera sizes and models.

HOW TO DIGITIZE USING A MOBILE DEVICE SCANNING APP

A smartphone or tablet camera is a great mobile scanning tool, especially when used with a scanning app such as TurboScan, Genius Scan, or DocScan. These specialty device applications locate the edges of your photo to "deskew" (straighten) any warped shapes and crop out unwanted background. In addition, scanning apps allow you to add a file name to each scan and adjust brightness.

Follow these steps to see how TurboScan makes smartphone scanning even smarter.

STEP 1: OPEN APP AND SELECT CAMERA. When the camera view opens, position your device to view the photo you want to scan and press the shutter button to capture the scan.

STEP 2: PREVIEW AND ADJUST IMAGE. In the Preview window, adjust brightness with the gray buttons along the bottom of the image. Rotate using the left or right arrows. Toggle between black-and-white or color by tapping the Photo-B/W-Color option.

STEP 3: ADJUST FRAME. Tap Frame to adjust the edges of your captured image. Tap on the corners of your image to adjust the frame, if needed. Tap Done when finished adjusting the frame or to move to the next window.

STEP 4: ADD FILE NAME, SHARE, AND SAVE SCAN. Tap the Pen icon to add a file name. Tap the Page+ icon to add a second page to your scan. Tap the Share icon (the bracket and arrow) to e-mail, print, or save to your Camera Roll. Tap Close when finished.

❖ Heirloom Photo Storage ❖

My family photo collection includes a motley assortment of beautiful cased daguerreotypes, fading cabinet cards, black-and-white scalloped-edge snapshots, and borderless 4x6-inch prints. While all photos should be stored in archival containers, each different kind of print requires a slightly different preservation method. Most photo collectors find it efficient to organize their collection for long-term archival preservation; family historians also will want to save clues that might reveal the stories behind the photographs.

In this chapter, I'll share practical tips for organizing your photo originals and discuss basic archival techniques to help you select appropriate storage containers to house your collection.

ORGANIZE YOUR PHOTOS FOR PRESERVATION

When you gather your family photos, film, and albums for digitizing, maintain the original order of any smaller photo groupings to aid in learning more about the photos. As much as possible, organize and store photos of the same style, format, and size together in one container. Make a copy of the Heirloom Photo Inventory Form and store a copy with each photo storage container.

To make the best use of storage containers and available space, I've adopted this strategy for my own collection. Here's how I organize my heirloom images:

�֍ Cased images (daguerreotypes, ambrotypes, and tintypes) are wrapped individually in four-flap enclosures and stored vertically in a small archival box with a computer printout inventory of the box contents.

✖ Oversize photos are stored in archival-quality plastic sleeves inside a large shallow archival drop-front box. I attach an Heirloom Photo Inventory Form to describe the box contents.

✖ Loose black-and-white snapshots are grouped by event and/or subject in archival photo envelopes with a handwritten label identifying the contents. These envelopes are stored vertically in an archival "shoebox" that holds all envelopes firmly upright without slouching.

✖ Negatives benefit from cooler storage temperatures. Negatives are placed inside archival negative envelopes and stored inside an archival box. This box is stored in the coolest area of my home.

✖ Old Polaroid prints tend to stick together when stacked; prints are interleaved with archival tissue and stored vertically inside an archival box.

Ultimately, how you sort and organize your photo collection within each archival storage container depends on your personal preference. Some historians like to organize by date, while others organize by subject. I organize my own twentieth-century photos chronologically by year and event, but I sort my older family photos by subject.

Tips for Handling Photos

When you handle your heirloom family photos, be sure to

✖ wear white cotton gloves or wash your hands before handling photos or film.

✖ avoid touching the surface of the photo; handle by the edges.

✖ avoid light and heat near photos and film.

✖ work on a flat, stable surface. A large table covered with a clean sheet or large piece of clean paper is a good option.

✖ use a soft artist's brush to gently remove dust or dirt.

✖ avoid writing directly on the print. Use only a soft lead pencil to jot down notes on the reverse side.

CHOOSING ARCHIVAL STORAGE CONTAINERS

Your storage needs will vary depending on the quantity and format of your photos. The variety of archival photo-storage options can sometimes be confusing. Manufacturers use the term

HEIRLOOM PHOTO INVENTORY FORM

1. Use as an individual box or folder catalog. Print a copy of the blank form on acid-free paper, fill it out, and place it inside an archival box with your photos.

2. If you use individual folders within the box, include the number of photos in each folder. Identify the photo by subject, event, or date. Add a brief description. Add notes on condition or original location with other photos.

3. Keep a master copy on your computer for reference or print out copies for a complete inventory of all your family photos and keepsakes.

ARCHIVE BOX #		DATE CATALOGED	
SUMMARY OF CONTENTS			
TOTAL NUMBER OF PHOTOS/ FOLDERS IN BOX		STORAGE LOCATION	

FOLDER # OR NAME	SUBJECT/EVENT	DESCRIPTION	NOTES

archival to indicate any kind of storage container, whether or not it is true "archival quality" by museum standards. Look for containers that are acid-free and lignin-free. These products have been manufactured specifically to prolong the life of paper-based items by avoiding acidic wood-pulp materials.

If you've ever seen a newspaper that turned yellow because it was left in the sun too long, you can recognize the damage of acidic paper. Your photos can suffer permanent stains if stored inside or adjacent to newsprint or news clippings. Photos stored inside a typical high-acid content cardboard shoebox will deteriorate faster than photos stored in a true archival container.

The Archival Storage Guide chart in this chapter gives specific ideas for storing different kinds of photographs.

The Problem With Plastic

Plastic containers offering waterproof or water-resistant storage may be appealing for photo preservation, but they are not recommended. Moisture can easily become trapped inside the container, allowing mold and mildew to take hold. Museum-quality archival boxes are a better choice. The heavy coated cardboard is a "breathable" natural material that allows small amounts of accumulated moisture to evaporate.

Not all plastic is necessarily a bad choice, however. If you want to share heirloom photos at a reunion or with other family members, you may want to place individual images inside a protective plastic sleeve or enclosure. Look for archival plastic that has passed the Photographic Activity Test (PAT), a laboratory test that measures how well the storage enclosure interacts with photos and film.

Check out archival storage containers from these companies:

* Aaron Brothers **<www.aaronbrothers.com>**
* Brodart **<www.shopbrodart.com>**
* Gaylord **<www.gaylord.com>**
* Hollinger Metal Edge **<www.hollingermetaledge.com>**

Always use archival sleeves, folders, and boxes that have passed the PAT test to store photos and film, and keep them in a cool, dry location. Store most prints vertically, rather than stacked horizontally where pressure can cause abrasion and scratches.

Layered Storage Solutions

The ancient Egyptians were masters of archival storage. They created layers of storage that survived centuries by placing treasures inside rooms within rooms within rooms. In handling our home archives, we can borrow a few lessons from the past by using layers to protect our family photos and keepsakes.

✷ **Archival Layer 1: Enclosure.** The first enclosure for any item should be archival quality. This is the first line of defense against light, acid, and other environmental hazards. For photographs, albums, and film, choose acid-free, lignin-free paper or PAT-approved plastic envelopes or sleeves.

✷ **Archival Layer 2: Container.** Organize and support these enclosures by placing them inside a larger archival box or binder. Label the box clearly on the outside with the collection name and contents.

ARCHIVAL STORAGE GUIDE

After scanning, place each photo inside the appropriate archival enclosure.

✷ **Layer 1:** Enclosure protects the photo.

✷ **Layer 2:** Container preserves and organizes the enclosure.

✷ **Layer 3:** Your home archive is where you store the container.

ITEMS TO STORE	HOW TO ORGANIZE	ARCHIVAL ENCLOSURE	ARCHIVAL CONTAINER
Color or black-and-white snapshots (loose)	Sort by size and type of snapshot; further sort by person, event, or date, as desired.	Store vertically in archival paper or plastic envelopes or sleeves. Place rare prints in individual sleeves.	Store envelopes or sleeves vertically in box or binders; place in home archive.
Photo albums	Interleave pages with interleaving tissue.	Store flat or vertically in archival box; support fragile albums with four-flap enclosures.	Store box in home archive.
Scrapbooks	Interleave pages with tissue; isolate photos from newspaper or artifacts by protecting with archival plastic.	Store flat or vertically in archival box.	Store box in home archive.
Large photographs (up to 8.5x11 inches)	Sort by person or date, as desired.	Store in large flat file folders or archival box.	Store folders in metal file cabinet or archival document case in home archive.

1. **Archival Layer 3: Home archive.** Store the boxes and binders together in a suitable home archive located inside your home. Avoid storing images in basements, attics, garages, or sheds where fluctuating temperature and humidity can hasten deterioration.

The Archival Storage Guide lists recommended best practices for safely storing your photos, albums, film, and slides. For more information on organizing and preserving photos, consult *How to Archive Family Keepsakes*.

ARCHIVAL STORAGE GUIDE

ITEMS TO STORE	HOW TO ORGANIZE	ARCHIVAL ENCLOSURE	ARCHIVAL CONTAINER
Oversize photographs (larger than 8.5x11 inches)	Place archival tissue between photos and between photo and folder.	Place individual images in custom-made or purchased enclosure.	Store in home archive.
Cased photographs (daguerreotypes, tintypes, ambrotypes, etc.)	Sort by size and type of image.	Place individual images in custom-made or purchased enclosure.	Store vertically in archival box; place in home archive.
Cabinet cards, *cartes de visite*	Sort by size, type, photographer, or subject.	Place individual images inside plastic sleeves or protect from abrasion with interleaving tissue.	Store photos vertically in archival box; place in home archive.
Stereograph cards	Sort by theme or subject, decade, and type.	Place inside plastic sleeves.	Store vertically in specially sized stereoscope card box; place in home archive.
Slides	Sort by subject, place, event, date, or photographer.	Store vertically in archival slide boxes.	Store in home archive or cool, dry archival location.
Negatives	Sort by subject, place, event, date, or photographer.	Store in paper or plastic negative sleeves.	Store sleeves in archival binder, boxes, or metal file cabinet; place in home archive or cool, dry archival location.
Movie film and video	Sort by date and family, then film type and size.	Store vertically in archival boxes.	Store in home archive or cool, dry archival location.

Create

Do you remember Uncle Joe's vacation slideshows? Endless photos of desert long-shots and folks who were almost, but not quite, in the picture. Family photo collections are meant to be shared, but sitting around a computer looking at disorganized, unedited photos can be unbearable.

Genealogists spend a lot of time walking through cemeteries and studying death records. But sometimes we're working so diligently to break through a brick wall problem or complete a branch of the family tree that we put off sharing and publishing our family history until the day that the story is "finished."

Instead of reaching for the finish line, think of your family tree as a living, breathing organism that continues to grow with each passing season. Select a single branch to shape with well-crafted stories, or handpick the perfect ancestor to feature in a special tribute, and then share those stories and photos in a book or digital publication.

In this section, you'll discover how to take your photo projects (and your genealogy research) from frumpy to fabulous with step-by-step instructions and ideas. Our twenty-five projects feature print and online photo creations to make on your computer or your smartphone or tablet.

Although you can read and use the individual projects in any order, the card and collage projects present fundamental skills that will be useful for more-complex creations. In addition, Chapter 11 introduces you to core project skills for limitless digital photo creations. Project boards to help you plan your calendar and photo-book projects are also included.

Before you start any photo project, you'll want to

1. select project photos and place copies in a desktop folder for easy uploading. Use full-resolution copies or refer to photo service websites for recommended image resolution.
2. read the step-by-step instructions and plan your project using the project boards provided.

All projects are rated based on the time to complete (not including time spent selecting and preparing photos and working with the project board):

�֎ less than an hour (quickie)
✖ less than three hours (good for a weeknight)
✖ three to six hours (complete over a weekend)

Allow more time for big projects where you need to write text or compile family tree information.

Project Time Ratings

<1 hour <3 hours 3–6 hours

You can view each project in full color and find additional ideas and inspiration on the *How to Archive Family Photos* website **<www.thefamilycurator.com/archivephotos>**. The following is a list of projects in Part 3 of this book.

Card, Collage, and Scrapbooking Projects

Calendar Projects

Smartphone and Tablet Projects

Fabric and Home Décor Craft Projects

Photo-Book Projects

❖ Core Photo-Project Skills ❖

Successful photo projects begin with a plan and advance preparation. I learned the hard way that homework pays off when I couldn't find the full-bleed option for the photo calendar page I was designing. I didn't know this option was unavailable on the website I was using. I'd already uploaded and adjusted my images, but the only solution was to start over with a different service that did offer full-bleed photo templates. You can be sure I double-checked the other features I wanted for my next project.

In this chapter, I'll introduce you to using a project board as well as to some key terms you'll need to know in order to plan and execute your photo projects. Plus, I'll give you tips for features to consider when selecting an online photo service for your project.

LEARN THE LINGO

When working with digital photos and online photo services, there are lots of features and jargon to learn. Before starting a photo book, calendar, or other project, or working with your digital family photos, learn these essential photo terms. Some terms refer to the physical photo project, while others refer to design features and specifications.

- ❖ **aspect ratio:** refers to the shape of the image and whether it is horizontal or vertical in orientation; a picture that is 2x2 inches is a square; 4x6 inches is horizontal; aspect also can be expressed in pixels, such as 4000:6000 (4,000 pixels by 6,000 pixels)

- **auto adjust/color correct:** a tool to correct basic contrast, balance, and exposure in an image
- **background:** the color, texture, or design of the overall project page or item
- **binding:** how calendar and book pages are bound together, either by glue (perfect binding), stitching, staples, spiral, or comb binding
- **bleed:** describes a page layout where the image runs off the edge of the page; a full bleed covers the entire page extending to all four edges of the page without any border or background showing
- **borders:** the design element that frames your photo; it can be anything from a simple line to a fancy graphic frame
- **collage:** a multi-photo layout
- **cover:** the outside jacket enclosing the book pages; includes front, back, and spine
- **crop:** cutting out unwanted elements in an image to focus on the subject; some photo services instruct users to upload *uncropped* images and crop within the project to allow for borders and layout design
- **digital scrapbooking:** using a computer, software, and digital images to create a digital page layout of background designs, photos, text, and embellishments that can be printed on a home printer or a commercial site
- **dpi (also ppi):** dots per inch (or pixels per inch) is a measure of the image resolution; high-resolution images are usually 300 dpi or higher; low-resolution images (such as for Web use) may be 72 dpi
- **embellishment:** this term is borrowed from scrapbookers who often add charms, ribbons, and ephemera to page designs; digital photo-book and scrapbook embellishments may look three-dimensional, but they will print like clip art on the page
- **fill flash:** a photo-editing feature used to improve dark, underexposed areas in an image without affecting the other parts of the photo
- **filter/effect:** allows you to change an image's color image to black and white or sepia, or any number of other colors; can give your photos an artistic, creative flair with filters and creative effects
- **flip:** turning over a photo or page layout as if it were a page so that everything on the page or image is reversed; sometimes called *mirror*
- **JPG:** a compressed digital file format widely accepted for digital photo projects
- **landscape:** horizontal orientation for your images and project page; popular for most projects
- **layout:** the individual page design or template that includes the page background, images, text, clip art, and embellishments
- **matte finish paper:** slightly textured matte finish produces a softer image

- **paper weight:** expressed in pounds (such as 80# or 100#), this indicates the quality or thickness of the paper; premium paper is heavier than standard paper
- **portrait:** vertical orientation for your images and project pages
- **red-eye removal:** a tool that eliminates the red-eye appearance caused by a camera flash reflecting in a subject's eyes
- **resolution:** a measurement of image quality expressed in dpi or ppi; check your photo service for recommended photo resolution for your project; the dreaded "resolution too low" warning indicates your image will not print well (see *dpi* for more details)
- **rotate:** turning an image clockwise or counterclockwise
- **satin finish paper:** smooth semigloss paper that produces a sharp, colorful image
- **size:** the overall dimensions of the photo book, card, calendar, or other project
- **spine:** the edge that covers the glue or other binding and attaches the pages to the cover of a book; the spine usually shows the title and author of a book
- **square:** all four sides of your image or project are equal; a popular option for Instagram or books created with mobile apps
- **text box:** the place where you type your text
- **theme:** the overall design or style of your photo project
- **TIFF:** an uncompressed image format good for archival-quality preservation images; TIFF files are generally large and not accepted by most online photo services

USING A PHOTO-PROJECT BOARD

A project board helps to organize your ideas and remind you of specific features offered by different services. A project board is also useful if you are planning ahead and need more photos for a project. Pin a copy of the project board to your bulletin board noting the images needed.

When you've completed the project, the project board sheet can help you remember what online service you used and how much you paid if you want to order more copies. Scan and save the sheets to your computer or file the hard copies for later reference.

Project boards are available for two specific project types: calendars (see Chapter 13) and photo books (see Chapter 16). Each project board includes three sections:

- **Project Snapshot** with notes on overall design, size, and style
- **Project Services** with notes on website features and cost
- **Project Layout/Design** with your ideas for page-by-page layouts, design sketches, or other notes

Use the project board planning sheets in whatever way works best for you. Here are a few suggestions for using them.

- **If you have a clear idea for your project but aren't sure what service to use,** start with the Layout/Design or Snapshot sections and use your notes to evaluate websites.
- **If you are looking for inspiration,** browse photo services for ideas, noting themes or styles you like.
- **If you aren't sure you have enough photos for your project,** use the Layout/Design section to outline the project. Identify gaps and list new photos you might need to locate or shoot. If you don't have enough pictures for a photo book, consider making a calendar or collage.
- **If you have found a project you'd like to customize,** list the specific features or elements you need in the Layout/Design and Snapshot sections and compare services to find one that offers most of these features.

Selecting Photos

When it comes to family photo projects, it's okay to play favorites. Choose only the best photographs for your project. If a less-than-best image is the only photo available, use adjustments and special effects to make it work seamlessly with the other photos in your project. Try to choose images that work well together. Play with cropping and Auto Adjust features offered on most online photo-project websites to see your photos improve instantly.

When selecting images for your photo projects, look for images that

- are in focus and have good contrast and lighting.
- have good composition, such as tight cropping or framing that eliminates distracting backgrounds and extra people.
- work well together in terms of style (such as similar clothing, color, setting, or theme).

Selecting an Overall Theme

Whether you are designing a photo book, a calendar, or a holiday card collage, most projects will benefit from a unifying theme that sets the overall tone and mood. A theme also can help pull together images that don't quite seem to go together. For example, a hodgepodge of snapshots works better together under the heading "Family Milestones" than in a random display.

PHOTO SERVICE FEATURES

You don't need to be a graphic artist to make a great photo book, but it helps to understand some of the options and features you'll find on photo-project websites. Come back to this section for a refresher at any time and look for projects highlighting features you'd like to explore. (For a complete list of photo services, see the Appendix.)

Project Styles, Sizes, and Materials

An online photo service is only as good as the projects it offers. Want to print a tiny photo book measuring 3.5x2.75 inches? The only option is MyPublisher **<www.mypublisher.com>**. Looking for a medium-size 8-inch-square book? Take your pick from several book publishers. Some services offer premium papers, matte or glossy printing, slipcases, dust jackets, and cutout covers. All of these options can be confusing if you just want to make a simple photo book.

One way to help narrow your choices when getting started is to list any special requirements on your project board. Not all services offer premium paper, leather covers, lay-flat binding, or other deluxe options, so look for these features when exploring options. Photo sites add new products frequently, so it's a good idea to revisit sites when starting a new project.

Design Themes and Styles

In photo creation jargon, the theme (also known as "style" or "design" on some sites) is the overall design for your project. A design theme applies to the entire project, including cover, pages, fonts, and colors. Featured projects will often show a theme name such as "Kids Quotes" or "Summer Party." The project will include a coordinated set of designed background pages, fonts, stickers, or other clip art and photo templates. This makes it easy to quickly create a professionally designed book or other project by simply dropping in your own photos and captions. Most sites offer the option to customize some or all of the theme elements.

Some services allow you to change the theme after you have already started a project; with others you may have to start over. It's a good idea to check this feature before you spend too much time working on your project, because it can be frustrating to find out you can't switch to a different design when something isn't working out.

Photo services use different terms for the same feature:

❖ **Book style:** MyPublisher
❖ **Design:** Mixbook
❖ **Theme:** Blurb, Snapfish
❖ **Style:** Blurb, Bookify, Shutterfly
❖ **Template:** Blurb, Bookify

Layout Options

All services use the term *layout* to refer to the individual design for book pages, cards, prints, posters, and gifts. The layout helps convey the overall tone and mood for your project:

❖ Full-page images, also called full-bleed, present a clean, modern look.

> ✼ **TIP** ✼
>
> ### Test First
>
> It's good to play around with a test project before committing too much time with any one service. You want to make sure that you will be able to change page backgrounds, delete photo frames, and add text blocks if these features are essential to your project.

�֎ Framed or bordered photos are traditional or classic.

✖ Tilted images convey a fun and whimsical mood.

✖ Captions and text overlay appear modern.

✖ Large blocks of text lend a book feel to your project.

When you change a page layout, you may need to adjust photo placement or re-crop some images. Choose layouts with image blocks in the same aspect ratio as your photographs: A vertical portrait needs a vertical photo layout. Take advantage of special features offered by some services such as using a two-page spread to show off a great horizontal photograph.

Auto Create

Photo books can be time-consuming projects, so to save time, most services offer a tool that "automagically" places photos into your book design. You can then go back and customize text and page layouts. You may not want to use this feature if you'd like to maintain complete control, but if you're in a hurry or have a large pool of images, auto create can save time. Each service has its own version of the auto-create feature:

✖ **Autofill:** Snapfish

✖ **Auto Fill:** Mixbook

✖ **Autoflow:** Blurb, BookSmart

✖ **SimplePath:** Shutterfly

✖ **Simple Publisher:** MyPublisher

Borders and Backgrounds

Borders, frames, and page backgrounds go a long way in setting the tone, mood, and style for your project. Use a faint full-page image as the page background for a modern look, and overlay a cropped color version of the same image to create a stunning design element. Experiment with different photo borders to find line widths, shapes, and colors that enhance your project's theme.

To change an image border, click on the image to select it and then apply the change. Some sites will have the frame preset as part of the page layout, but you may be able to select the frame and delete it if you'd like to try something different.

Text

How and where you can add and modify text is important if you want your photo projects to include long captions or journaling, or formatted text blocks like a cookbook. Most photo services offer layout options with assorted text blocks, but you may need more customization than the simple designs offered for photo-intensive projects. Instead, if you're creating a photo book, you may want to explore publishing sites favored by authors and professional photographers such as Blurb **<www.blurb.com>** and myPhotoPipe **<www.myphotopipe.com>**.

Stickers, Clip Art, and Embellishments

Scrapbookers will find a wealth of theme "stickers," clip art, and other embellishments to use in page design. Snapfish **<www.snapfish.com>** and Mixbook **<www.mixbook.com>** are favorites for designing embellished pages. To use stickers, drag and drop from the design window to your page. Rotate and resize as you would any photo.

Collaboration

Some photo services make it easy to invite contributions to your photo project. This is helpful if you are coordinating a school or organization yearbook that will include members' photos and snapshots of activities from throughout the year. Special yearbook themes can guide your design and make it easy to create an attractive book for your organization. Collaboration features are also important if you're working with other family members on a photo project.

SELECTING A PHOTO-PROJECT SERVICE

To manage your photo service choices, use one main service for photo uploads, sharing, and print orders. This allows you to consolidate your images in one location. Upload photos as needed for specific projects at secondary sites. To choose which site is best for managing your photos or for creating the photo projects you want, use the Online Photo Service Comparison Worksheet.

Tips

- ✖ Online photo sites change every day. To keep up with new features, templates, and specials, subscribe to the site's e-newsletters.
- ✖ Save money by planning ahead. Don't wait to check out several photo services until you need a quick photo book for a reunion or want to print your holiday collage card. Spend a few hours playing around with a test project on different photo-project sites. When you register as a user, the sites will send you e-mails with special discount offers that can save you a lot of cash.

ONLINE PHOTO SERVICE COMPARISON WORKSHEET			
	SITE #1	**SITE #2**	**SITE #3**
Website			
Username			
Password			
Overall ease of use (1=difficult 5=easy)	1 2 3 4 5	1 2 3 4 5	1 2 3 4 5
IMAGE STORAGE OPTIONS			
Project-based or upload anytime?			
Length of time images are stored			
PROJECT TYPES AVAILABLE			
Calendars	Y N	Y N	Y N
Cards	Y N	Y N	Y N
Digital scrapbooks	Y N	Y N	Y N
Gifts	Y N	Y N	Y N
Lay-flat books	Y N	Y N	Y N
Photo books	Y N	Y N	Y N
Prints	Y N	Y N	Y N
SPECIAL FEATURES AVAILABLE			
Creative filters	Y N	Y N	Y N
Cropping	Y N	Y N	Y N
E-mail sharing	Y N	Y N	Y N
Full-bleed option	Y N	Y N	Y N
Image adjustments	Y N	Y N	Y N
Image rotating	Y N	Y N	Y N
Mobile app	Y N	Y N	Y N
Print at home	Y N	Y N	Y N
Private Web page	Y N	Y N	Y N
Social media sharing	Y N	Y N	Y N

ONLINE PHOTO SERVICE COMPARISON WORKSHEET

	SITE #1	SITE #2	SITE #3
Book sizes available			
Types of book covers available			
Pricing			
Likes			
Dislikes			

ADDITIONAL NOTES

❖ Card, Collage, and ❖ Scrapbooking Projects

Notecards, holiday cards, invitations, and announcements are among the most popular first-time projects for many photo lovers. Photo websites make it easy to create great personal stationery for any occasion, and creative effects let you showcase one image by making your own pop-art collage.

The photo-card projects in this chapter are a good place to begin if you're new to using online photo services or if you'd like to create a personalized greeting card. You'll learn what to look for when selecting a suitable image and how to upload your digital files. Plus, step-by-step instructions will guide you in customizing your project for printing and sharing.

The collage projects will introduce you to using free online editing tools useful for all kinds of photo tasks. A digital collage is an artist's canvas just waiting to showcase your favorite photos in unusual and artistic ways. Look beyond the old-school collage technique that assembles many different photos on one canvas. Try using variations of one photo to create a pop-art-style collage. Include color and text blocks to add interest and focus a story line to your project.

You can create a collage for almost any photo project—prints, notecards, mouse pads, pillows, or tablet cases. Generally, you'll want to choose a project that shows off medium to large photos. A collage of twelve images sized for a 3x5 notecard will have tiny pictures.

Explore your favorite project websites before you upload your images.

In addition, if you love scrapbooking with paper and stickers, you might be surprised to discover how fast and fun it can be to create digital scrapbook layouts using an online photo service. You can select a scrapbook-style theme and add digital stickers, ribbons, and other embellishments. Experiment with color, texture, and fonts. And if you don't like something, the Undo button makes it easy to start over again.

❋ TIP ❋

Collage Uses

Use the techniques in these collage projects for any creation featuring multiple photographs. Most photo services offer collage-style prints and posters, as well as collage page templates for photo books and calendars.

Digital scrapbooking, also known as "digi scrapping" or online scrapbooking, is popular with photo crafters who want to use computer graphics to create page layouts with digital photographs. Scrapbookers use stand-alone software such as Adobe Photoshop Elements **<www.adobe.com>** and MyMemories Suite **<www. mymemories.com>** to work offline designing books, layouts, and other projects. Photo-book services such as AdoramaPix **<www.adoramapix.com>**, Shutterfly **<www.shutterfly.com>**, and Snapfish **<www.snapfish.com>** have adapted this technique to their featured layouts.

BEFORE YOU BEGIN

For all photo projects, place a copy of your JPG images in a desktop folder labeled PHOTO PROJECTS. Here, they will be easy to locate and upload to the photo service, and you'll avoid accidentally changing the originals. For a photo greeting card or collage, choose an image that has all the elements of a great photograph and that conveys the overall tone of your project.

❖ **For greeting cards:** Look for a 300-dpi image that's the same size or larger than your intended card. For instance, any full-size photo shot with your digital camera should be fine, but avoid using a small, cropped portion of the image. If you scan a photo for this project, set the Target Size at the same size or slightly larger than your intended greeting card. Most scanned prints have acceptable resolution, but again, avoid using a small, cropped portion of the image.

❖ **For collages:** Use a theme or design idea to tie together the different photos. Throughout the year, collect good photos of family members you may want to use. Look for similarities in the images you choose—like clothing, color, setting, theme, or creative filter. Remember, each photo is part of the larger overall collage design. When it comes to a collage, less is more. Use the fewest photos needed to tell your story in the largest size available for the design.

STEP-BY-STEP PROJECT
PHOTO THANK-YOU CARD WITH SHUTTERFLY

Time	less than 3 hours
You will need ...	1 photo
Good for ...	yourself or a gift
Design ideas	incorporate a social media profile picture, a favorite photo, pet, landscape, or hobby

Project Overview

Creating a custom notecard is a good introduction to online photo creations. Most websites use a similar card-creation process, so check out several different services before deciding which one to use for this project. Consider these questions:

* **Where are your digital images stored?** If they are already hosted on a website such as Shutterfly or Snapfish, it might be easiest to use the same site for your project.
* **What card designs are available?** Styles and templates vary widely. You may find exactly what you want on a different service than you usually use.
* **What's the cost?** Frequent special offers for hefty discounts or free shipping make it worthwhile to compare pricing.

For this project, I'm designing a thank-you notecard to use with my blog, The Family Curator **<www.thefamilycurator.com>**.

Instructions

STEP 1: SELECT CARD DESIGN. Log in to Shutterfly **<www.shutterfly.com>** and select Cards & Stationery, Linen Snapshot Thank You card. Click the orange Personalize button to customize the card. When you select a card, be sure it has the same aspect as your image, or be prepared to crop out significant parts of the photo. Some cards are offered either in vertical or horizontal format, and you can change the aspect after selecting the design. You can resize and crop in the design phase of your online project. I've selected a horizontal flat card.

✳ TIP ✳
Save Money

Photo-project websites run frequent sales, especially around holidays. Look around for discounts on shipping and different project types before starting your project. Sign up to receive e-mails and download a photo service's mobile app (if available) to learn about additional deals.

STEP 2: IMPORT PHOTO. Click the Get Photos button to import a JPG image from your computer or Shutterfly account.

STEP 3: EDIT, CROP, AND ADD TEXT. Click the photo to edit and adjust cropping. Adjust the color; if you wish, add a different special effect to each photo. Click Done to save your changes. Click on the text box to type any text and adjust line placement, font, or font size.

STEP 4: PREVIEW AND ORDER. Click the Preview button to review your work. Click Add to Cart, or click Save and give it a name so you can order later. When you purchase cards, you will be able to select cardstock and other special features. Some sites offer premium lined envelopes or specialty papers that can be fun for a special occasion.

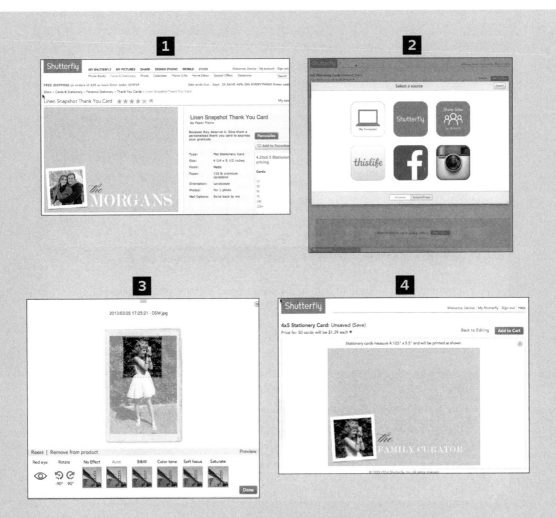

STEP-BY-STEP PROJECT
CREATIVE EFFECTS COLLAGE MOUSE PAD WITH SHUTTERFLY

Time	less than 3 hours
You will need ...	1 photo with good contrast
Good for ...	gifts for grandparents, executives, computer users
Design ideas	use images of a child, pet, or anything else important to the recipient

Project Overview

A collage project doesn't have to use several different images. It's also a great way to showcase a single photo by applying special filters and adjustments. Most photo-project sites offer these creative filters as photo-editing options, or you can apply filters in your own photo-editing software.

Special-effects adjustments work best with a high-contrast image. Something with a simple subject and uncluttered background will work well, although interesting textures and designs can work, too. Try several photos to find one that will give you the look you prefer. Don't worry about cropping the image for now; you'll see why as we work through the project.

This project shows you how to make a fun and unusual creative collage mouse pad. You can adapt the same techniques for almost any project that offers a collage template, including holiday cards, greeting cards, photo books, prints, or posters.

For this project, I selected a photo with sharp contrast and a crisp geometric image. It's fun to play with rotating the image so the baby appears to be looking at himself. When you choose an image for your project

* look for an image in your collection with a strong focal subject, like a close-up portrait or an interesting object.
* avoid busy, cluttered images with too much detail.
* consider images with stripes, bold textures, or strong lines—they add interest to the design.
* disregard color, but look for strong contrast. View potential images through different filters to see possible adjustments.
* import the full-size image and crop as needed in the online program so you can adjust for the collage border and shape.

Instructions

STEP 1: SELECT MOUSE PAD DESIGN. Sign in to Shutterfly **<www.shutterfly.com>** and select the Mouse Pad option under the Product menu. Select the Gallery of Nine theme and click the Personalize button. Click the Layout tab to see different options. Choose the eight photos layout.

1

2

3

4

5

STEP 2: IMPORT AND PLACE PHOTO. Click the Get Photo button and follow the prompts to import a photo from your computer photo project folder or other location. The green check mark confirms your selection. Place the image in the layout by clicking on the photo in the photo tray and dragging it to the appropriate square. Repeat to place the image in all eight photo blocks.

STEP 3: CROP, EDIT, AND APPLY EFFECTS. Open the Edit window by clicking once on the image after it's placed on the template. The mouse pad's curved edges cause some of the photo to be cut off, so crop the image to fit the space. Choose a different creative effect for each image: B&W, Color Tone, Soft Focus, Saturate. Use the slider tools to make each image look different. Try different colors, blur, and intensity. Rotate the photo for variety. Experiment and have fun.

STEP 4: ADD TEXT. Click the center text block below the Layouts tab in the side panel to open the Text Edit window. Type your desired text using the Return (or Enter) key to force a new line. Change the background color of the center text square by clicking on the Backgrounds tab.

STEP 5: PREVIEW AND ORDER. Click on the Preview button to preview your project. Save your design for later or order the product now by placing it in your Shopping Cart.

STEP-BY-STEP PROJECT
HOLIDAY GREETING CARD COLLAGE WITH SNAPFISH

Time	less than 3 hours
You will need …	assorted family photos
Good for …	families with college students or distant family members
Design ideas	choose a unifying theme for your photos: clothing, season, or activity

Project Overview

We don't always have the luxury of selecting one perfect photo for our family holiday greeting cards. Sometimes you have to work with whatever images you manage to beg, borrow, or steal from busy or reluctant family members. What can you do when you have no control over the photo shoot or even the photo selection? How can you design a great holiday card that includes separate family groups or children when everyone lives far apart?

This project accepts the annual challenge of creating a holiday greeting card when the family members can't all be in the same picture. It shows how you can adjust five very different images to create a unified look. Careful cropping and converting to black-and-white, plus a few other creative techniques, can transform a holiday collage card from dull to dynamite.

Instructions

STEP 1: SELECT CARD DESIGN. Log in to Snapfish <**www.snapfish.com**> and choose a collage-style holiday card for four or more images. I have six photos to work with for this project. Assemble your photo images in a folder on your computer desktop.

STEP 2: IMPORT AND PLACE PHOTOS. Import the photos and drag them into suitable placeholders in the template.

STEP 3: EDIT, CROP, AND CHANGE COLOR. Click on each photo to crop. Eliminate distracting details. Change photos from color to black and white to give a unifying appearance.

STEP 4: ADD TEXT. Add text in the greeting box.

STEP 5: PREVIEW AND ORDER. Preview the card and then order or save until later.

More Holiday Photo Collage Ideas

Holiday collage cards aren't just for sharing new babies and children. There are many different options for creating collages for use on holiday cards. Here are a few ideas:

- **Your year in review:** Use photos of your personal hobbies or projects, or select your favorite images from travel snapshots.
- **Then and now:** Use photos from your own childhood holidays.
- **Vacation:** Summer vacation snapshots can be a good choice for a holiday collage card.
- **Family milestones:** Sometimes the only photos available are those you've collected throughout the year at various family gatherings. You may have photos of graduates, new brides, and a young family in front of their first home.
- **Single theme:** Choose a subject that most family members enjoy and tell your family photographers that you're collecting high-resolution digital images for the annual card. No formal photo shoot required. Parents love to show off kids in soccer and Little League uniforms. Team fans can send snapshots from a ballpark or wearing a favorite jersey. Grandkids can send a selfie from their smartphone.
- ***The Brady Bunch* style:** Use individual portraits to create a collage similar to the one in the opening credits of *The Brady Bunch*. If clothing colors are too distracting, use image adjustments to create black-and-white images or add a retro image tone.
- **Outtakes:** Movie bloopers, or outtakes, have always been a fun surprise at the end of a feature film. Family photo shoots often end up with a similar set of images. After a long and boring photo session, you may find you have one son crossing his eyes, another knuckling his brother, someone sticking out her tongue, and absolutely not one single good shot of everyone in the group. Don't fight it. Pick a template for multiple images and choose a few to showcase the spunk and spirit of your group.

1

2

3

4

5

STEP-BY-STEP PROJECT
ANCESTOR COLLAGE WITH PICMONKEY

Time	less than 3 hours
You will need …	assorted ancestral portraits (clear with good contrast) digitized in JPG format
Good for …	greeting cards, posters, book covers, timelines, family history books
Design ideas	showcase photos of different ancestors in the same original format, or several photos of one ancestor

Project Overview

Showcase a family line or pivotal events in your ancestral history with an easy-to-make photo collage using scanned images. The free online photo editor PicMonkey **<www.picmonkey. com>** will do the basic editing chores; all you have to do is gather an assortment of photos in JPG format. You can save the resulting collage to your desktop for printing later or use it on a greeting card, small poster, or book cover.

Instructions

STEP 1: UPLOAD PHOTOS TO PICMONKEY. Go to PicMonkey. Hover over the Collage icon at the top of the screen and choose Upload From Computer. Navigate to your photos, select, and upload. Your photos will display in the photo selection tray.

STEP 2: SELECT LAYOUT AND PLACE IMAGES. Click on the Layouts icon. Select a layout with a suitable number of images (you can change this later). Drag and drop images into the layout.

STEP 3: EDIT AND CROP. Click the Edit icon to fine-tune image cropping and placement.

STEP 4: SAVE. When you're finished, click Save, and you will be prompted for file size and format. I want to use my collage for a book cover, so I am saving it at the highest setting (Pic-Monkey calls this "Sean").

STEP-BY-STEP PROJECT
FACEBOOK COVER PHOTO COLLAGE WITH PICMONKEY

Time	less than 3 hours	
You will need ...	2 to 5 photos	
Good for ...	updating Facebook timeline cover/header	
Design ideas	feature a seasonal design, special occasion, or your favorite photos	

Project Overview

Digital images and online photo services make it easy to create custom headers for your social media pages and profile pictures. You can create custom profile pictures and headers for Twitter **<www.twitter.com>**, Pinterest **<www.pinterest.com>**, Facebook **<www.facebook.com>**, and other sites.

Bloggers, Pinterest pinners, and social media fans use PicMonkey **<www.picmonkey.com>** to design these creations. PicMonkey makes it easy to customize images with text, add special effects, crop photos, and add seasonal embellishments. Basic features are free and offer enough variety for most users. The Royale subscription offers ad-free designing and more design options.

Instructions

STEP 1: GO TO THE PICMONKEY WEBSITE. Note that you don't need to register or log in to use the basic design features, but you can't save your design to PicMonkey without registering for an account.

STEP 2: CHOOSE COLLAGE OPTION. Hover the cursor over the Collage icon; select Facebook.

STEP 3: CONNECT TO FACEBOOK ACCOUNT. Click the Connect to Facebook button. When the Facebook Connect window pops up, click Okay. When you see a second window with the message "PicMonkey would like to post to Facebook for you," click Okay to permit PicMonkey to post your new timeline cover.

STEP 4: SELECT PHOTOS. You will see a window of photos posted to your Facebook account. Click to select individual photos; a check mark will appear on the photo. Click Open to open the photos in PicMonkey.

STEP 5: ADD MORE PHOTOS (IF DESIRED). The photos you selected in Facebook will appear in the PicMonkey window. To add more photos from your computer or other location, click Open Photos and then navigate to your computer files and choose the photos you want.

STEP 6: PLACE PHOTOS IN COLLAGE LAYOUT. Click the Layouts icon and choose FB Cover. Click on the Photo icon (top icon) to make the photos visible again and drag photos into the collage layout.

STEP 7: ADJUST BORDERS AND BACKGROUND. Click on the Background tab (Palette icon) to adjust the border width. Click on the Swatches tab (Tag icon) to adjust background pattern.

STEP 8: ADD TEXT AND EDIT. Select a font and click the Add Text box to bring up the text box. Type your text, and then select color and alignment. Drag the text box and place it in your design. Drag the edges to adjust font size.

STEP 9: SAVE AND SHARE. Click Save to bring up the PicMonkey Save window. Select the middle Pierce size option in JPG format. Save it to your computer. Click the Share button to share to Facebook or other social media sites.

STEP 10: SAVE AS FACEBOOK TIMELINE COVER. To set your collage as your Facebook cover, click the cover image to Change Cover and navigate to the new image. Drag into position and save.

❋ TIP ❋

Shutterfly App For Facebook

Shutterfly's **<www.shutterfly.com>** Facebook app is another alternative for changing and customizing your Facebook header (aka cover photo). To use the app, simply sign into Facebook and type *Shutterfly Cover Photo* in the Facebook Search box. Click the Get Started box. Then, add photos from your Facebook Photos or your computer. Drag and drop each photo to the design. Click once on the photo to crop and position. Save your cover photo to your Facebook timeline by clicking the button to Set Cover.

1

2

3

4

5

6

7

8

9

10

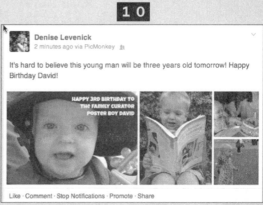

STEP-BY-STEP PROJECT
DIGITAL SCRAPBOOKING TRIBUTE PAGE WITH SNAPFISH

Time	less than 3 hours
You will need ...	2 (or more) photos
Good for ...	a single customized page for a tribute book or special occasion
Design ideas	share a special memory, tell a joke or humorous story, use letters of the person's name to describe his/her personality

Thank goodness, some things never change.

Happy Birthday to my Forever Sister.

Project Overview

Milestone events such as birthdays, anniversaries, and retirements typically generate requests for cards, photos, and sharing memories. If you have a few great images in your photo collection, you can create a beautiful tribute page in under an hour using an online digital scrapbook tool. Some online photo services also offer the option to print individual pages on your home printer. Before you begin your digital scrapbook project, you'll want to decide whether you will print at home using Snapfish **<www.snapfish.com>** or opt for professional printing with Shutterfly **<www.shutterfly.com>** or Mixbook **<www.mixbook.com>**.

For this project, I used Snapfish so I could print the project on my home printer. Not all photo service companies offer digital scrapbooking or the option to print pages at home (Snapfish is one of the few online services that offers a print-at-home option), so be sure the service you use has the features you need before you begin your project. To find digital scrapbooking options on photo-project websites, try using the Search box to search for *scrapbook* or look under options for prints or print-at-home projects.

If you are a paper or digital scrapbooker interested in exploring the world of online digital scrapbooking, take time to look for a service that offers your favorite features, including

- ✳ the availability of traditional scrapbook size pages, especially 12x12-inch.
- ✳ the availability and variety of embellishments.
- ✳ scrapbook-style titles, quotations, and headers.
- ✳ layered-look frames.
- ✳ customizable background pages and textures.
- ✳ 3-D looking embellishments.
- ✳ templates designed by professional scrapbookers.
- ✳ the option to print individual pages on a home printer.
- ✳ the option to order professionally printed individual pages.

Some photo services offer the option to print your layout at home or order individual professional prints of full 8x8-inch or 12x12-inch pages. This is a great option if you want to build a scrapbook a few pages at a time or contribute a special layout to a group project. If you already use digital scrapbooking software on your computer, you can upload completed layouts to online services without using their design program.

As you're working on your digital scrapbooking project, you may want to

- create your own layered frames for photos by adding color blocks and using the layer button to Send Back or Send Forward.
- create special quotes or headers in Adobe Photoshop Elements using your own computer fonts. Select and save as a JPG image. Import the text and place in your layout.
- use images as background to create your own unique background paper.
- purchase downloadable digital scrapbook papers and embellishments from digital scrapbooking sites to use in your own creations in Photoshop Elements or digital scrapbooking software.

Instructions

STEP 1: SELECT PAGE DESIGN. Sign in to your selected photo service and navigate to the digital scrapbook creation page. On Snapfish, this is Projects>Print at Home>8.5x11-inch Photo Book.

STEP 2: UPLOAD PHOTOS. Upload your images and drag the selected photos to the selection box.

STEP 3: SELECT A THEME. Choose Landscape or Portrait orientation for your page. Select a theme. I'm using the Family: Storytelling theme. (This theme is also available for a full photo book, but you will be presented with a single page for your digital scrapbook page.)

STEP 4: PLACE PHOTOS AND EDIT TEXT. Select the Page Layout tab and choose two photos with text. Drag and drop the layout onto the page. Drag and drop your photos into the image boxes. Click in the text boxes to edit text.

STEP 5: REVIEW AND PRINT PAGE. Click the Review button to move to the next step. You may see a warning that some photo-book pages are empty. Don't worry. The final step should give you the option to Print or Save your page. Load cover stock or photo paper in your home printer and print.

1

2

3

4

5

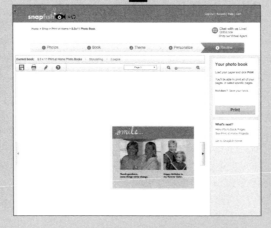

❖ Calendar Projects ❖

For many years, my sister-in-law presented each family with a wall calendar showcasing the best photos of the previous year. It was always great fun to see how much the cousins had grown and how everyone's hairstyles and hairlines had changed. Now that my daughter-in-law has continued this annual tradition, she's added my favorite feature—birth dates and anniversaries printed right on the calendar grid so we never miss a date.

We've all seen family photo calendars that are more "fun" than fabulous. You know the calendars I'm talking about: lots of pictures, some good, some not-so-good, and some that leave you wondering, "What were they thinking?" Why spend your time and money creating a calendar that's just ho-hum when you can make a photo calendar so great that everyone hates to turn over the last page? Custom photo calendars are a great project to stretch your photo-project skills and create unique mementos that everyone in the family can enjoy. The best part about a custom calendar is that it's self-limiting—you have a cover and twelve pages to tell your story.

BEFORE YOU BEGIN

The calendar projects in this chapter will give you ideas to showcase your family and their favorite events, hobbies, or places in a monthly calendar that begins with any month and is as simple or complex as you wish. You can use one photo per month or ten. Some of the most effective photo calendars use a single standout photo per month, each selected to portray a theme or

special subject. If you want to create a monthly collage or display multiple images on one page, check out the photo selection tips in Chapter 12 for suggestions on how to help images play well together. And if you don't have quite enough photos for all the calendar pages, plan to shoot new images to fill in the gaps.

The estimated time listed for each project in this chapter doesn't include the time spent planning your ideas with the Calendar Project Board and selecting photos. Do all planning with the Calendar Project Board and photo preparation before you start your project.

Using the Calendar Project Board

Creating a fabulous photo calendar will be faster and easier if you take time to plan ahead using the Calendar Project Board. To get started, print a copy of the Calendar Project Board and work through the various options, thinking about the theme, colors, and photos you'd like to use. You may change your mind later, but time spent organizing your ideas with the Calendar Project Board will make it much faster and easier to create the actual calendar.

SNAPSHOT: Start by writing down a working title for your calendar, and then make notes of the fonts, colors, and other design elements that will help convey this idea. Note that if you want to include special events on the calendar grid or use full-bleed images, you'll want to select a photo service that offers these features. If you're including special dates or holidays, create a separate list of those dates so you have it ready when you begin the project.

SERVICE: Explore photo websites to select a service with the features you like. You may have a favorite photo-project website, but I encourage you to explore other sites for unique features and inspiration. Use the Calendar Project Board to make notes comparing design and printing options, prices, and shipping times that work best for this particular project, your budget, and time frame.

Depending on your vision for your calendar project, you'll want to know:

* Can you include full-bleed images?
* What's the maximum number of photos for calendar layouts?
* Can you add custom events, such as birthdays and anniversaries, to the calendar grid?
* Can you add photos to the calendar grid?
* Can you add and delete background images, clip art, and embellishments?

LAYOUT: Sketch individual page layouts and make a list of the photos needed for each page. This will help you discover if you need to select a Collage or Multi-Photo Layout for the page.

Selecting a Calendar Theme

An effective photo calendar needs more than good or even great photos. A successful photo calendar is like a photo book: It should tell a story in photos. But unlike a photo book that can have many pages, your calendar is limited to twelve pages plus a cover. Think of it as a short story or vignette instead of a novel.

Selecting Calendar Photos

After deciding on a theme and overall style for your calendar, it's time to make your final image selections. Prepare any print images you plan to use by scanning them at a minimum of 300 dpi in full color. Gather all your images in a folder on your computer desktop, including a few extra images just in case you don't like some photos when they are placed into the project template.

- Select only photos with sharp focus and good contrast. Avoid grainy, blurry, poorly exposed images.
- Use different photo styles such as portraits, group shots, and scenes to add interest and avoid repetition.
- Choose a few close-ups of people, pets, and theme items like birthday cake or Christmas tree ornaments.
- Select long views that set the scene: a lush, green backyard or a room filled with party decorations.
- Include photos snapped at different times of day: early morning, twilight, and night, as well as during the day.
- Consider the colors of clothing, furnishings, and food. Balance brights with darker tones to avoid a cluttered, hodgepodge look.
- Think about the photos in your collection and check out calendar projects on Shutterfly **<www.shutterfly.com>**, Mixbook **<www.mixbook.com>**, Snapfish **<www.snapfish. com>**, and other popular photo-project websites. Find more inspiration on Pinterest **<www.pinterest.com>** boards by searching for *photo calendar.*

Preparing Calendar Photos

Create a desktop folder for your current project, and add copies of your selected images, text, clip art, or other graphics. All photos should be in JPG format at full resolution. Check the photo-project service for recommended photo sizes to ensure your photos aren't too large or too small.

Should you crop, edit, and enhance your photos before importing to your calendar project? There's no right answer to the question. Some services make it easy to crop and enhance photos as you are building each page. Other services suggest uploading camera-ready images. I generally try one or two images before uploading my entire project image file and placing them on the page to see if they will need further adjusting. Sometimes the service recommends cropping after placement.

CALENDAR PROJECT BOARD

» HOW TO USE THIS PROJECT BOARD

1. Think about what you want to include in your calendar and what you want it to look like. Jot down your ideas in the Snapshot section.

2. Explore photo-service websites to find one that has the features you want. Make notes on what you find in the Service section to compare your options.

3. Sketch individual page layout ideas (photos and text) in the Layout section.

SNAPSHOT	
Calendar theme/ working title	
Style (monthly, weekly, appointment)	
Size	
Tone (classic, lively, modern)	
Colors	
Photo style (framed, full-bleed)	
Fonts (script, fun, traditional)	
Include special dates	
Include holidays	
Quantity to print	

SERVICE	
Possible Websites	**Design and Cost**
1.	
2.	
3.	

CALENDAR PROJECT BOARD

LAYOUT: IMAGES AND DESIGN IDEAS

Cover	January	February

March	April	May

June	July	August

CALENDAR PROJECT BOARD		
LAYOUT: IMAGES AND DESIGN IDEAS		
September	**October**	**November**
December		

What story will you tell?

Your calendar's story can be as simple as "Family Birthdays" or "A Year in the Garden." Begin with an overall calendar theme and then gather together suitable images or start with photographs that shout the perfect message. I find it easiest if I actually give my calendar a working title that sets a theme and helps me maintain the overall focus throughout the twelve-month design. With a little tweaking, my working title often becomes the cover headline. A working title of "Family Birthdays" might become "Miller Family Celebrations" or "The Millers Celebrate."

SAMPLE CALENDAR PROJECT BOARD

SNAPSHOT	
Calendar theme/working title	*A Year at the Lake (Wall Calendar)*
Style (monthly, weekly, appointment)	*monthly, full-bleed and large image collage, narrow white border between photos*
Size	*wall calendar with squares*
Tone (classic, lively, modern)	*simple, modern*
Colors	*color images, black/white text*
Photo style (framed, full-bleed)	*full-bleed*
Fonts (script, fun, traditional)	*bold, modern font*
Include special dates	*family birthdays and anniversaries*
Include holidays	*yes*
Quantity to print	*4*

SERVICE	
Possible Websites	**Design and Cost**
1. *Shutterfly.com*	*8x11-inch or 12x12-inch options, Photo Gallery style, starts at $21.99 for 8x11 size*
2. *Snapfish.com*	*Simply Elegant, photo framed on black, no full-bleed designs, $19.99*
3. *Mixbook.com*	*11x8.5-inch calendar, Classic Photos, Landscape Calendar option, starts at $19.99*

SAMPLE CALENDAR PROJECT BOARD

LAYOUT: IMAGES AND DESIGN IDEAS

Cover	January	February
full-bleed image: view of house sign	*SNOW!*	*collage: indoor cabin fun*

March	April	May
late winter	*Easter party*	*summer cabin decorations*

June	July	August
collage: lake views	*quilt and flag; July 4 party*	*on the lake: sailboats, canoes*

SAMPLE CALENDAR PROJECT BOARD

LAYOUT: IMAGES AND DESIGN IDEAS

September	October	November
before and after: remodeling	*collage: birdfeeders and birds*	*Thanksgiving on the deck*

December		
cozy pictures		

Calendar Project Tips

�౫ Let your calendar tell a story—the story of your family's annual celebrations, family and ancestor birthdays, or another theme important to you or the recipient of the calendar.

✭ Choose images that complement one another and vary choices—from close-ups of individuals to group shots to more casual or formal images.

✭ Scan any images you plan to use in your calendar at a minimum of 300-dpi resolution. (This way they'll print nicely and won't be blurry.)

✭ Before you begin, gather all your images and place them in a folder on your computer desktop for easy access and uploading.

✭ Some online photo services accept only JPG images, so convert your images to JPG format if needed.

✭ Consider cropping images after you upload them so you can see how they fit first.

STEP-BY-STEP PROJECT
WALL CALENDAR WITH MIXBOOK

Time	less than 3 hours
You will need ...	12 photos or more
Good for ...	families, singles, couples, clubs, groups, anyone
Design ideas	highlight the year in review, celebrations, recipes, or seasonal and holiday favorites

Project Overview

This step-by-step guide will walk you through creating a twelve-month photo wall calendar using Mixbook **<www.mixbook.com>**. This project will demonstrate some of the unique features offered by this service, including full-bleed images and customized calendar notations to mark birthdays and anniversaries.

Instructions

After you've organized your ideas on the Calendar Project Board (refer to the sample project board to see how this is done) and placed copies of your images in a desktop project folder, you're ready to start creating your calendar.

STEP 1: SELECT A CALENDAR DESIGN. Sign in to Mixbook and select the Calendar option. Click on the Classic Photos image to select this theme. On the Ordering Options page, use the drop-down menus to select the format, size, and start month. I have selected the Landscape Calendar, 11x8.5 inches, Starting January 2016. Click the Start Calendar button to begin customizing your calendar.

STEP 2: ADD EVENTS AND HOLIDAYS. The Mixbook Editor will open in a full-page mode and display the Event Calendar. You can enter personal birthdays or anniversaries now or later. Click on the Add New Event button to add birthdays and anniversaries. Click on the Holidays tab to select the holidays you would like displayed on the calendar grid. Close the Event. Click the Update Calendar button.

STEP 3: UPLOAD PHOTOS. Click the Add Photos button and upload your pictures from your computer or from Instagram, Facebook, or another website. Thumbnail images of your photos will appear in the photo tray. The Mixbook Editor automatically saves your work every few minutes and when you exit the Editor.

STEP 4: PLACE AND EDIT PHOTOS. To place a photo into the layout, drag and drop it onto the page, or use the Add Photos button. Adjust the photo using the Photo Editing Toolbar. To easily fill the entire page with the photo, click the Fill Background With Image icon on the Toolbar. To

1

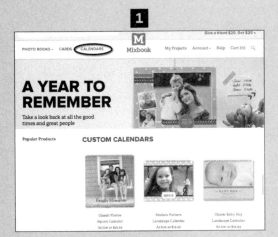

2

3

4

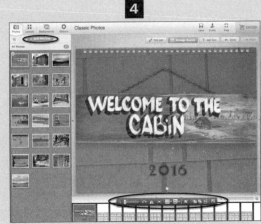

5

6

edit the title, double-click the text block and replace sample/placeholder title with your own title and year (in this example, *Welcome to the Cabin*). Navigate to the next month's page by clicking the page icons at the bottom of the Design window.

*** TIP ***

Using the Toolbar

Click twice on the image to open the Toolbar if it's not visible. Hover your mouse over each icon to see a description of the tool.

STEP 5: CUSTOMIZE THE DESIGN. Click the Layouts tab to find alternate layouts to fit the number of photos and text blocks on each individual page, and add photos for each page. Use the Backgrounds tab to change paper background colors and textures if desired. Click the Stickers tab to add decorative images or text blocks. Click the Manage Events button to customize the date blocks with birthdays, anniversaries, and holidays.

STEP 6: PREVIEW AND ORDER. Click the Order button to preview and order your calendar; your calendar will open in the Mixbook website window. Preview the completed calendar, checking carefully to be sure you have no typos or errors. Use the Edit option to go back and make any changes. When you're ready, click the Add to Cart button to purchase the calendar. Your calendar design will be available in the My Projects section of Mixbook.

STEP-BY-STEP PROJECT

PERPETUAL CELEBRATION CALENDAR WITH ADORAMAPIX

Time	3 to 6 hours, depending on the number of custom events entered
You will need ...	12 photos or more
Good for ...	holiday, wedding, shower, or birthday gift
Design ideas	use your best photos to be enjoyed for many years; highlight favorite people and places

CELEBRATE!

Project Overview

If you'd like to try creating a calendar without the expectation for an encore, consider making a calendar that never goes out of date. This perpetual calendar is a handy reminder of annual celebrations such as birthdays and anniversaries, and provides a place to add notes for new babies and newlyweds. Instead of the typical calendar grid with year and month, a Perpetual Celebration Calendar includes dates and space to mark birthdays, anniversaries, and other annual events, and it remains current year after year.

Although several photo-project services offer custom photo calendars, the dated calendar grid itself is usually an integral part of the overall design that can't be edited or deleted. At AdoramaPix, however, the calendar is a moveable element you can edit, delete, or move. Follow the step-by-step instructions to create your own perpetual celebration calendar.

Instructions

Organize your ideas and photos using the Calendar Project Board. You'll want to feature your very best images because it's likely this calendar will be displayed for many years. Make a list, by month, of the birthdays, anniversaries, and events you'd like to include on your calendar.

STEP 1: SELECT A CALENDAR DESIGN. Log in to AdoramaPix <**www.adoramapix.com**> and navigate to the Calendar projects. Name your calendar, select your preferred size, and choose the twelve-month style. Select your paper. Select the Basic Calendar Theme (you can change this later). Click the Start Editing button.

STEP 2: UPLOAD PHOTOS. AdoramaPix can upload images from your computer or from your photo-management software. Follow the prompts provided for uploading. Click OK to exit the Upload window.

STEP 3: PLACE PHOTOS. The Edit window will show your images on the left with your project in the main panel. The tabs along the left side of the window allow you to change options for

3

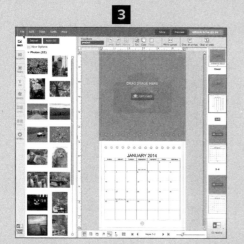

4

5

6

7

8

Images, Backdrops, Frames, Text, Stickers, Layouts, Cover, and Settings. The scrolling window at the right indicates the project pages. Click 1-2 to edit the first spread. You should see the spread for January. Select and drag a photo from your photo tray to the January spread.

STEP 4: REPLACE THE CALENDAR GRID WITH TEXT. Delete the calendar grid by clicking once on the calendar. The grid will be highlighted in orange, and a selection box will appear around the calendar with a floating toolbox. Click Delete on the Toolbox. Add a text box for the name of the month. Click the Text tab. Drag it to the top of the calendar page. Type *January Celebrations* in the box and select your font, size, and color.

To create the monthly dates, click the Text tab and drag a text box to the page. Select a plain font, about 10-point size in a dark gray color. Type a space and then numbers for 1 through 16. Add underscores after each number. After the first line, use copy/paste to add the lines after the remaining numbers.

Use the Line Spacing button to expand the spacing between each line to about 185. Pull the handles of the text box close to the row of numbers, and with the box selected, click the Copy button in the Toolbox. Click next to the first column of numbers and click the Paste button. Change the numbers to 17 through 31. Adjust the boxes to align.

STEP 5: REPLACE MONTH GRIDS WITH TEXT. Next we'll take a shortcut to completing the rest of the calendar pages. When you've finished editing the date boxes, click the month header. Then click the Add Item icon at the bottom of the window and select the first column of numbers. Click the Add Item icon again and select the second column. With all three elements selected, click the Copy Spread button on the Toolbox. The three text boxes should be highlighted in red.

Navigate to the next monthly spread by clicking the arrows at the bottom of the window. Click the Paste Spread button in the Toolbox. The month name and dates will be pasted to the new page spread. Click in the text boxes to edit the monthly titles and the dates as needed and add names for birthdays and anniversaries.

STEP 6: PLACE MONTHLY PHOTOS. Place photos on each calendar spread by dragging and dropping a new photo from the Images tab to the page. To adjust the image placement, click twice for the photo edit toolbar and move the image within the frame.

STEP 7: SELECT A COVER IMAGE. Select your favorite image for the cover and edit the text for your title.

STEP 8: PREVIEW AND ORDER. Preview your calendar and order.

❋ TIP ❋

Days Per Month

28	February
30	April, June, September, November
31	January, March, May, July, August, October, December

PROJECT IDEA
IT'S A PARTY! CALENDAR

Time	less than 3 hours
You will need ...	12 photos or more
Good for ...	families, grandparents, clubs, teams, groups
Design ideas	use a modern design for full-bleed page templates; select a template with frames

Project Overview

Celebrate family birthdays or special occasions with a twelve-month calendar that makes each birthday person the star of the month. Begin by listing all the family members with their birth dates or special events and sort the list by month. Using the Calendar Project Board, list the names or events next to each month. Sketch possible page template ideas for each month, and make notes about the fonts, colors, and other design elements you would like to use.

Tips and Techniques

* Find photos from past birthday celebrations to feature on the birthday person's special month. Fill in with more photos for a montage or collage effect, or just pick one fabulous image and run it from edge to edge.
* Feature the birthday person with a snapshot from his school days, sports events, or hobbies.
* The calendar cover sets the theme and tone for your entire project. Pick the one best photo and run it full-bleed, from edge to edge. Overlay a headline announcing the year and theme, such as 2016 Celebrations.
* If you have a month that's short on family birthdays, look to your family pets, ancestors, or special occasions for dates and photos to include.
* Look beyond your current photo collection if you have months without family birthdays. Scan Mom's recipe of everyone's favorite birthday cake. Bake the cake, take a photo, and include it on the page.
* Fill the gaps of a no-celebration month with birthday bloopers or post-party photos.
* If you have too many photos, include pictures along with the event information right on the calendar grid (a feature offered at some websites).

PROJECT IDEA
A YEAR IN THE LIFE CALENDAR

Time	less than 3 hours
You will need ...	12 photos or more
Good for ...	anyone with a camera
Design ideas	try a modern look with full-bleed images; use a frame with a colored background

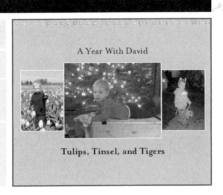

Project Overview

If you've ever wanted to join a Photo-a-Day Project but felt it was too big of a commitment, you might like to try a Year-in-the-Life or Photo-a-Month calendar. This is also a good project if you don't have many images available—one good photo per month is all you need to create an attractive wall calendar you will enjoy displaying in your home.

Tips and Techniques

Plan ahead and shoot photos throughout the year for next year's edition:

* **Your garden or yard through the seasons:** Vary the images with close-ups, long views, and portraits.
* **Seasons and holidays:** Photograph decorations, parties, food, or objects that convey the spirit of the season.
* **New family member:** Babies, kittens, and puppies change so fast from month to month that they make great subjects for photos to enjoy long after the newborn stage.

Bonus Calendar Ideas

* **Home Sweet Home:** Design a calendar that highlights your family home throughout the year or your childhood home over time. Use photos of the front of the house, a close-up of the front door or porch, the mailbox, the backyard garden, and interior photos of the family gathered in the kitchen or dining room, or around the Christmas tree in the living room.

* **Play Ball:** Feature your family all-stars or create a tribute to your favorite college or pro team with a monthly sports wall calendar. Use team colors and logos to set the theme and include photos of uniforms, printed programs, and souvenirs. Include favorite family games such as croquet, ping-pong, darts, or bocce ball.

PROJECT IDEA
KITCHEN DUTY CALENDAR

Time	less than 3 hours
You will need ...	12 photos or more
Good for ...	anyone who likes food, cooking, or grandma's baking
Design ideas	use bright colors for trendy dishes or vintage colors for old recipes

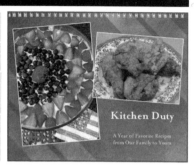

Kitchen Duty

A Year of Favorite Recipes
from Our Family to Yours

Project Overview

Food blogging has become a hot new career, but food calendars have been around for a long time. And why not? Everyone loves seeing their favorite dishes in crisp, beautiful color.

Tips and Techniques

� Create a calendar that shows off your family food heritage with photos of special dishes from every month of the year: Grandma's stuffing in November, Easter ham in April, and a special birthday ice-cream cake in your birthday month.

✖ Take a photo of the original recipe in Grandma's handwriting and use it like a photo along with a snapshot of the prepared dish.

✖ Consider including photos of the cook, her kitchen, or even her favorite apron and spoon.

✖ Each month, feature a seasonal recipe and photo of the prepared dish. Add the cook's photo for family heirloom recipes.

✖ Don't feel limited to family cooking. Create a calendar to share favorite restaurants, souvenir menus, and meals enjoyed in your hometown and on your travels.

✖ **Commemorative Calendar:** Create a wall calendar to showcase the history of a local organization celebrating a milestone anniversary (tenth, thirtieth, fiftieth, etc.). The organization might be a church, a Little League club, or a nonprofit group you support. Include then-and-now photos of the organization's activities, members, and buildings. Design the calendar as a gift for each member or as a fund-raiser. Work with other members of the organization to gather photos and historical information.

❖ Smartphone ❖ and Tablet Projects

Mobile apps for Apple iOS and Android devices have made photo editing into a game. With a few taps of your finger on your tablet or smartphone screen you can add or remove color, turn photographs into cartoons, or create a fast-and-easy photo book. There are so many apps to choose from that it can be hard to know where to start!

This chapter highlights mobile apps that are especially helpful to family historians looking for new ways to share stories and engage family members in understanding their ancestry. If you enjoy using an iPad, Kindle Fire, or Android tablet, you'll like designing your next family history project from your favorite chair instead of your home office desk.

BEFORE YOU BEGIN

Photo apps for mobile devices are among the most popular apps in the iTunes App Store **<itunes.apple.com>** and on Google Play **<play.google.com>**. Check for a free app edition before purchasing the full version. Many times the free version will give you a good idea if the program suits your needs. Look at the Version History to note when the app was last updated and if the developer appears to be actively working on the program to keep it running smoothly. I tend to avoid apps that are still in 1.0 version status after months of availability. Read reviews. Visit the developer website for more information.

Most photo-sharing and shopping websites also have mobile versions. If your photos are on a site such as Shutterfly or Snapfish, be sure to check out their photo-creation apps for your device. Here are some of my favorite mobile apps for editing, special effects, and photo products:

- ❋ Photogene (iOS)
- ❋ Moldiv Collage Photo Editor (iOS, Android)
- ❋ Snapseed (iOS, Android)

You can even create photo books right on your smartphone or tablet. These are my favorite apps for creating photo books:

- ❋ KeepShot (iOS, Android)
- ❋ Kodak Moments HD Tablet App (iOS)
- ❋ Mosaic (iOS, Android)
- ❋ Shutterfly Photo Story for iPad (iOS)

STEP-BY-STEP PROJECT
PHOTO LABELING WITH MOLDIV COLLAGE PHOTO EDITOR APP

Time	less than 1 hour	
You will need ...	1 or more photos	
Good for ...	adding text blocks to multiple images	
Design ideas	add a caption to a photo; scan a signature image to import for a collage; add source documents	

Project Overview

The Moldiv Collage Photo Editor app is easy to learn. Swipe from the left side of the app to reveal the menu bar with a link to YouTube tutorials and inspiration. The tutorial gives a quick overview to get started. The free version has enough features for most users: You can make collages, add special effects, or label photos with the app. This project shows how to add labels or captions to a photo.

You'll need to have copies on your tablet or smartphone of the photos you want to use in the project. Move photos from your computer to mobile device using a cloud storage service such as Dropbox or Google Drive, a USB connection between your computer and mobile device, or via Wi-Fi transfer. Open the photos on your device and save them to your Camera Roll or Picture Gallery for access by the app.

Instructions

STEP 1: DOWNLOAD AND INSTALL MOLDIV. Download and install the free Moldiv Collage Photo Editor app from the iTunes App Store or Google Play. (I created this project on my iPad.)

STEP 2: SELECT STITCH TO ADD A LABEL. When Moldiv opens, you'll see a selection of collage layouts. Choose Stitch.

STEP 3: SELECT PHOTOS. Your Camera Roll/Photo Stream/Gallery will open; choose the photos you want to use by tapping to select. Tap the check mark when finished selecting.

STEP 4: ADJUST THE FRAME. Tap Frame Adjust to increase the margins or to add a shadow or border. Tap the photo when you're finished adjusting. Change the background if desired.

STEP 5: ADD TEXT. Tap T to bring up the Text Tool and type your caption. Tap the Label icon to format the text box with a background and border. When finished, tap OK. Move the text boxes to label people or place them in the margin area.

STEP 6: SAVE AND SHARE. When you're finished, tap the Share icon to save your work to your Camera Roll or share.

STEP-BY-STEP PROJECT
TOMBSTONE ENHANCEMENT WITH SNAPSEED APP

Time	less than 1 hour
You will need ...	tombstone photos
Good for ...	enhancing hard-to-read engraving or handwriting; viewing details
Design ideas	improve readability of inscriptions or documents

Project Overview

When you only have one hour in a cemetery, the resulting tombstone photographs might be a little less than perfect. I was disappointed when a headstone photo I took one late afternoon was difficult to read, but enhancing the sharpness and zooming in with the Loupe tool in the Snapseed app made it easy to confirm my best guess of the inscription.

Snapseed is owned by Google and available for both iOS and Android mobile devices. Its features will look familiar to Google+ Photos users because Google has integrated Snapseed's editing functions for desktop users.

1

2

3

4

5

6

Instructions

STEP 1: DOWNLOAD AND INSTALL SNAPSEED. Download and install the free Snapseed app from the iTunes App Store or Google Play.

STEP 2: OPEN A PHOTO. Click Open Photo and navigate to your Camera Roll or Album to select a photo. The left side of the window shows available editing options.

STEP 3: ENHANCE DETAILS. Select Details for your photo to open in full window view. (Note: The commands may be slightly different on iOS and Android devices.) Rub your finger over the portion of the photo you want to sharpen. Notice that the numbers increase in the Sharpening indicator at the bottom of the window.

STEP 4: USE THE LOUPE. Tap the Loupe (the Magnifying Glass icon) and drag it around the image to zoom in and enhance details.

STEP 5: GET HELP. Tap the Question Mark in the upper right corner at any time for help. Use the back arrow to Undo any action.

STEP 6: COMPARE AND SAVE. To view the original, press the Compare icon. When you lift your finger, the edited version will appear. Edits are not saved until you check Apply.

STEP-BY-STEP PROJECT
PHOTO BOOK WITH MOSAIC MOBILE APP

Time	less than 1 hour
You will need ...	20 photos
Good for ...	a thank-you gift, vacation souvenir, or just a fun surprise
Design ideas	remember a vacation, fun weekend, reunion, or visit with friends or grandkids

Project Overview

In the mobile app world of photo-book creation, Mosaic **<heymosaic.com>** stands out for its unique photo tile cover, beautiful interface, and quick turnaround time. If you order a Mosaic book today, you can get it in four days. This isn't the book for fancy backgrounds, text, and embellishments. It's all about creating a sharp, attractive photo book quickly, without much fuss.

Instructions

STEP 1: DOWNLOAD AND INSTALL MOSAIC. Download and install the free Mosaic app from the app store for your device.

STEP 2: REGISTER AND START CREATING. Click the Create a New Mosaic button and your Camera Roll and Albums will appear.

STEP 3: SELECT PHOTOS. Your Camera Roll will open; choose the photos you want to use by tapping to select. Choose from Facebook or Camera Roll, or import photos from another location. Selected photos appear in the tray at the bottom of the screen. Drag to rearrange. Tap the original photo in your Camera Roll to deselect. Exactly twenty photos must be selected. Click Next when you are finished.

STEP 4: PREVIEW AND ORDER. Tap the book to view the pages. Your photos will autofill the twenty-page book with photos. Shuffle cover photos if desired. When ready, place your order.

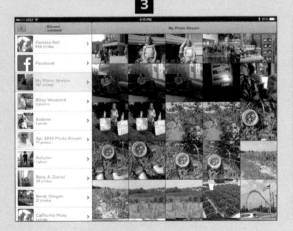

STEP-BY-STEP PROJECT
FAMILY HISTORY TIMELINE WITH TREELINES

Time	3 to 6 hours
You will need ...	photos of an heirloom, research images, map images, or newspaper clipping images
Good for ...	documenting the stories behind heirlooms; creating a timeline of an ancestor or family line
Design ideas	illustrate the timeline with your digitized research documents and memorabilia

Project Overview

Treelines **<www.treelines.com>** gives genealogists a new online tool for creating illustrated timelines to share family stories, memoirs, and histories. Created in 2013 by New York genealogist Tammy Hepps, Treelines is an award-winning and popular tool for documenting family stories. This Web-based program, which you can use in a Web browser on your computer or tablet, guides you to build a timeline with short text blocks and photos that you can share privately via e-mail or publicly on the Treelines Community page. Everything you do on Treelines is private by default until you decide you are ready to share your story with others.

Each individual page in a Treelines story can hold text, a photo with caption, and page decorations. A timeline running across the bottom of the Story window highlights dates featured in the story. Two or more people can work together to fill in stories and events about a family.

You can upload a GEDCOM (the universal family tree computer file format) to Treelines to speed up story building and give you a framework for adding stories one family branch at a time. Names, places, dates, and events help build searchable keywords for your story. Find inspiration for your story and Treelines tutorials in the Getting Started section of the Treelines website. If you don't have a family photograph to use in your timeline, use a census image or your ancestor's signature from a document. Think about images that will make your story come alive: news clippings, maps, county histories, and historical images from digital archives.

Instructions

STEP 1: SET UP YOUR FAMILY TREE. Sign up for a free account or log in with your Facebook account at Treelines. By default, anything you add is private until you change your account settings. You'll be prompted to set up your family tree. Select "I Don't Have a Tree Yet" to enter a few names at a time for your first story. You can add a GEDCOM tree later.

STEP 2: CONFIRM YOUR ACCOUNT SETTINGS. Click your username in the menu bar and click Public Profile to edit your username, upload a profile picture, and add your social media links. Click Settings to adjust privacy. Click Stories to begin creating a new story.

STEP 3: UPLOAD A TREE OR ADD NAMES. For your first story, use names you added at sign-in and add more names for your story manually.

STEP 4: CREATE YOUR STORY. The Tree Wizard will build your first tree from any information you've entered, or click the Jump Right In link to get started.

STEP 5: ADD PHOTOS WITH CAPTIONS, TEXT, PAGE DECORATIONS, AND EVENT DETAILS. Prompts will guide you through adding text, photos, and page decorations. Treelines works best with only a few lines of text on each page. If you start to write a long narrative, you'll get a warning to keep it short. Think of it like a story on index cards where you try to build suspense

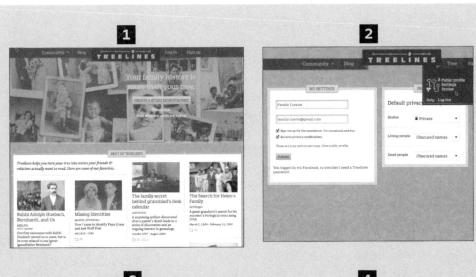

so your reader flips to the next page. Format text with bold or italics, increase font size, and add page links. Remember to add name, place, date, and other details in the right panel. The date is used to build the timeline across the bottom of the page.

STEP 6: INSERT AND MOVE PAGES. Reorder pages in the story by dragging a page to a new location. Click the green plus (+) sign to insert or add new pages.

STEP 7: PREVIEW AND PUBLISH YOUR STORY. Toggle between the Write and Preview buttons to work on your story. Click the Publish button when you're finished.

STEP 8: SHARE AND PRINT. Confirm your privacy settings and share your story with friends and relatives. Download a PDF copy to your computer with the Download link under your Account Settings.

More Ideas for Treelines Stories

�֎ Use Treelines to help untangle family relationships. Each person will have his or her own line on the story timeline—making it easy to see where dates overlap and relationships intersect. Remember to enter date, place, and name information with each page to use this feature.

✖ Treelines can document the history and milestone events of your genealogy society. Use it to create a slideshow to share your group's growth, changing membership, and past officers.

✖ Create an illustrated timeline of a family business, past or present. Include digital images of photos, maps, and business documents.

✖ Create a memorial tribute to honor an ancestor.

✖ Record the provenance of a family heirloom or make an album of family keepsakes and their chain of ownership.

PROJECT IDEA
AUDIO PHOTO BOOK WITH SHUTTERFLY PHOTO STORY APP

Time	less than 3 hours
You will need ...	assorted family photos, photos of heirlooms, research images
Good for ...	interviewing relatives, identifying unknown people in images, and recording family heirloom info
Design ideas	try a modern magazine design for a documentary-style project with audio interview, or a heritage theme

Project Overview

One of my greatest treasures is an audio recording of my mother and her sister talking about the places they lived as children. I love the idea of leafing through a photo album and listening to their voices as they talk about the pictures on the page. With the Shutterfly Photo Story app for iPad **<www.shutterfly.com/photo-book-ipad-app>**, you can make a digital photo book with audio clips to share via e-mail or Facebook, as well as a printed book for your coffee table.

The "doodle" feature in Photo Story lets you draw directly on the iPad screen to point out features of a photo or identify people in a group picture. Combine the annotated page with a thirty-second audio clip for a personalized commentary. The print version of the book includes QR codes that you can scan with your smartphone so you can hear the recordings.

Tips and Techniques

❈ Get started by selecting a style and size book; you can switch to another style or change layouts later.

❈ Import photos from your Shutterfly or iPad photo albums or from Facebook or Instagram. To use photos from your computer, it's easiest to upload them to your Shutterfly account first, then select the album and photos you want to use.

❈ Photos are automatically placed in your book, but you can rearrange images and pages later.

❈ To annotate photos during an interview, you will need to have the photos on your iPad and select Doodle on a Photo from the Doodle menu in the Photo Story app.

❈ Prepare an album of unidentified photos to share with relatives and record their comments as audio files. Use the Doodle feature to label pictures as they talk.

❈ Create an heirloom album and record stories about your favorite family keepsakes.

❈ Record short audio clips with each relative at your next family gathering.

❈ If you have schoolchildren in your family, they may have already created family stories as part of Shutterfly's special school project. See lesson plans and learn more at Photo Story for the Classroom **<www.shutterfly.com/photostoryclassroom>**.

❈ Fabric and Home Décor ❈ Craft Projects

In the earliest days of photography, images were printed directly on assorted materials including cloth, metal, glass, and paper. Today's popular photo-printing and transfer techniques and technology also can print to a specially prepared surface such as burlap, canvas, or glass. Projects in this chapter will show you how to create a photo keepsake by printing your favorite family photos on fabric via professional printing services and at-home printing.

Professional services use screen printing or other methods to copy the design on fabric or paper with permanent ink. The custom fabric service Spoonflower **<www. spoonflower.com>** offers professional design services to home fabric designers. Spoonflower custom printing works much like a photobook service: Upload your photo to a design template, select fabric and quantity, and wait for your order to arrive at your home.

> ❈ **TIP** ❈
>
> ### Embrace Fabric
>
> Spoonflower lets you print your own custom images on fabrics such as cotton, silk, knit, suede, and linen, so get creative! Print an image of Grandma's handwritten recipe on fabric to create a tea towel. Create a canvas tote bag with a meaningful image on it. Get more ideas for fabric projects on Spoonflower's blog **<blog.spoonflower.com>** and on Pinterest **<www.pinterest.com/spoonflower>**.

Home office printing is a good solution if the material you're using is small enough to fit in an ink-jet or laser printer, making it possible to print directly on a fabric or plastic surface. Some materials are specifically designed for either ink-jet or laser printing, so make sure you purchase the correct format for your home printer.

BEFORE YOU BEGIN

Think beyond paper for ways to share your family history photos throughout your home. I'm always inspired by unique projects posted on the Web and social media, especially Pinterest **<www.pinterest.com/FamilyCurator>** and Houzz **<www.houzz.com>**.

You don't have to be an expert sewer to enjoy photo prints on fabric. Spoonflower offers custom-print linen towels reminiscent of the old-fashioned annual calendar towels my grandmother displayed in her kitchen. Spoonflower also prints on silk or polyester crepe, which can make an easy silk scarf that needs only a simple hand-sewn hem.

When choosing photos for fabric projects, consider not only traditional photographs of family, but also parts of or entire family history research document images such as a census image or a newspaper article clipping. For best results, you'll want to edit your images in photo-editing software before uploading them to Spoonflower.

STEP-BY-STEP PROJECT
VINTAGE HOLIDAY PHOTO PILLOW WITH SPOONFLOWER AND PICMONKEY

Time	3 hours plus sewing time	
You will need ...	1 photo, printable fabric	
Good for ...	holiday decorating, custom gifts	
Design ideas	put then-and-now photos on the front and back, or make a multiple-photo collage	

Project Overview

Home decorating catalogs and glossy holiday magazines are filled with elegant fabric projects that you can duplicate with your own photos and scanned art custom-printed on the fabric of your choice. While ink-jet printing limits your projects to letter-size fabric sheets, custom-printed silk, linen, cotton, and canvas are available by the yard in full bolt-widths. You can use these larger printed fabrics to make totes, pillows, quilts, clothing, or drapery, or as upholstery.

This project is designed with the online photo-editing program PicMonkey. I scanned a vintage holiday photo and uploaded it to PicMonkey for cropping and embellishing. You can save

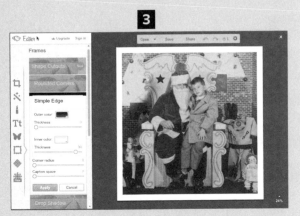

the completed image to your computer and upload it to Spoonflower to print as a 16x16-inch decorator pillow.

Instructions

STEP 1: PREPARE THE IMAGE IN PICMONKEY. Open PicMonkey **<www.picmonkey.com>** and select the Design icon at the top of the page.

STEP 2: UPLOAD THE IMAGE. Click the Open button to upload your image.

STEP 3: ADD A FRAME OR BORDER. In the Edit window to the left of your image, select the Frames (picture frame) icon. Choose Simple Edge and change the outer color to black 0 thickness and the inner color to white 90 thickness to add an old-fashioned photo-print border.

7

8

9

10

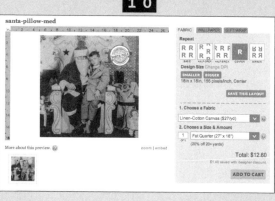

STEP 4: ADD BACKGROUND FOR CLIP ART. In the Edit window, select the Overlays (butterfly) icon and then choose Geometrics/Circle and drag the circle to your photo. Change the Overlay Color 1 to red and Color 2 to white; close the Overlay window.

STEP 5: ADD CLIP ART. Scroll down to Overlay/Postal and find the globe postmark. Drag the postmark to the circle you placed earlier. Change the color to red; close the Overlay window.

STEP 6: ADD TEXT. In the Edit window, select the Type (Tt) icon, select the Special Elite font, and drag the text box to your photo. Type *NORTH POLE* in the text box and change the font size to 75.

STEP 7: ADJUST THE TEXT AND SAVE YOUR DESIGN. Click the right-hand border of the text box and drag it left to make the box smaller; drag the text box to the postmark and place it in the opening, rotating if needed. Click the Save button in the top toolbar to save your image to your computer as a high-quality JPG file.

STEP 8: CREATE YOUR FABRIC IN SPOONFLOWER. Log in to Spoonflower **<www.spoon-flower.com>** and choose Create Fabric from the Create menu.

STEP 9: UPLOAD DESIGN. Select your saved image on your computer, confirm your copyright, and upload your file.

Bonus Idea: Create Custom Gift Wrap

In addition to printing on fabric, several online photo services, including Spoonflower **<www.spoonflower.com>**, Shutterfly **<www.shutterfly.com>**, and Zazzle **<www.zazzle.com>,** let you print your own custom gift wrap. Here are a few ideas for creating custom wrapping paper.

- ✂ *Holiday Collage:* Use a gift-wrap template on Shutterfly such as Holiday Stamps or From Santa Gift Tags. Personalize it by adding family photos and adding the family name. Change any color photos to black-and-white format for a cohesive feel or a vintage look.

- ✂ *Single Photo Tile:* Choose a single photo to create tile-pattern wrapping paper at Zazzle. A simple image, without a lot of detail, works best. You can add text after uploading your image.

- ✂ *Your Own Design:* To create one-of-a-kind gift wrap for any occasion, use the online photo editor PicMonkey **<www.picmonkey.com>** along with Spoonflower. You'll create a design from scratch, then order it through Spoonflower. Include any text on the image before you upload it. After you upload your image, you can select whether you want it to be repeated.

STEP 10: SELECT FABRIC AND ORDER. In the Design window, select the Repeat: Center, Design Size: Bigger. Under the Choose a Fabric drop-down menu, select a desired fabric. Under Choose a Size & Amount, select Fat Quarter. Add to the shopping cart and complete your payment and shipping information.

STEP 11: SEW THE PILLOW. After you receive the fabric from Spoonflower, cut the fabric and sew the pillow as desired.

PROJECT IDEA
PHOTO QUILT BLOCK

Time	1 hour	
You will need ...	1 photo, printable fabric, such as burlap or canvas sheet (available at craft stores)	
Good for ...	transferring an image to printer-size fabric	
Design ideas	print quilt blocks; small pillow tops; quotations; other small fabric items	

Project Overview

When you need a quilt label or photo printed to fabric, look no further than your ink-jet printer. Pretreated fabric sheets are a good option if you need only a few copies. You'll want the final product to be washable and colorfast. Commercial printable fabric sheets are available from Avery, Dritz, Electric Quilt Company, and Printed Treasures. Many quilters make their own printable fabric sheets with freezer paper and chemical products to make fabric colorfast. Remember to reverse any images that have wording.

Tips and Techniques

* Select and scan your photograph at 300 dpi. Set the target size for your intended print dimensions or larger.
* Remember to include a seam allowance when calculating print size.
* Open your photo in your photo-editing software or place the image in a word processing document. Size the photo for your print.
* Choose the correct fabric for your printer, either ink-jet or laser ink.
* Follow the fabric manufacturer's directions to print or copy your photo to the special fabric. Gently guide the fabric through the paper tray if needed.
* Set the print aside and let the ink dry completely before sewing or cutting.

16

❖ Photo-Book Projects ❖

Everyone loves stories, especially stories told in pictures. If you have inherited a family photo collection, your family story may be waiting to be shared with a family history photo book. And if you're busy snapping photos of everyday family life, you can easily turn digital bytes into digital books.

The step-by-step projects in this chapter will help you plan and design a family photo book or a family history photo book using an online book service. If you've made similar books before, you may have found the process time-consuming or confusing, or thought the results were more of a hodgepodge of pictures than a meaningful family story. In this chapter, you'll find ideas to streamline the process and create a book you will be proud to share.

BEFORE YOU BEGIN

You'll find the entire photo-book creation process will be much faster and smoother if you take time to use the Photo-Book Project Board to organize your ideas and your photos before starting to create your book. In addition, you'll need to focus the story you want your photo book to tell.

A single photo book can't cover everything, so it's important to narrow your focus to a specific theme or topic. Think carefully about your purpose for this photo book and try to state

your book's theme in a sentence or two. If that's not possible, the topic may be too big for a single photo book. A theme or topic will help you stay focused so you're not tempted to add photos that don't really fit with your overall objectives. Browse photo-book websites for ideas and think about the theme and story line. Note what makes some books better than others, and incorporate those ideas into your project.

Keep in mind that family history projects can be more complex than a typical vacation or annual family photo book. Genealogists must try to faithfully share ancestral stories using illustrations and images such as heirloom photos and old documents, and draw on historical context and social ephemera to make the story interesting and compelling.

Writing a family history photo book doesn't have to be a huge, complicated project. Instead of preparing a monumental six-hundred-page document, focus on a specific individual or couple, or on one branch of the family tree. This will establish the main subject for your book and help you narrow your choices when selecting photos and illustrations and making design choices. Depending on the online photo-book service you choose, you may need to stay within a maximum page limit. This is probably a good thing. Less is definitely more desirable when it comes to creating a family photo book that your family will enjoy.

If you're creating a family history photo book, allow extra pages for

* a title page with author, date, and publication place.
* contact information, which may be added to the title page or back page and should include your name, e-mail, and/or phone number.
* credits or acknowledgements, which might include a note of appreciation to family members who shared photos or research material.
* a dedication to thoughtfully convey your personal remarks and future intentions for your family history.
* footnotes or endnotes. These add credibility to your family stories and give future researchers confidence in your conclusions. Use a consistent citation style and include all pertinent details to help the reader evaluate and locate your sources. *Evidence Explained* by Elizabeth Shown Mills provides a comprehensive guide to citing print and digital sources.

Using the Photo-Book Project Board

Make a copy of the blank Photo-Book Project Board. Each section of the project board will help focus decisions for your photo-book project.

SNAPSHOT: In this section of the Photo-Book Project Board, start by writing down a working title for your book and making notes of the theme as well as design elements (colors, etc.) you'd like to use. Consider fonts and other elements you want to use. For example, a tribute to your family athletes, past or present, will look great with college letterman-style fonts and team colors. A book honoring your mom might feature clip art with her favorite flowers and colors.

PHOTO-BOOK PROJECT BOARD

» **HOW TO USE THIS PROJECT BOARD**

1. Decide what type of photo book you want to create. Fill in the Snapshot and and Audience sections of the project board.

2. Explore the types of photo books and designs offered on photo service websites. Make notes in the Services section.

3. Sketch plans for text and images in the Storyboard Layout section.

SNAPSHOT	
Photo-book theme/working title	
Orientation/style (landscape, portrait, square)	
Size	
Tone (classic, lively, modern)	
Colors	
Photo style (framed, full-bleed)	
Fonts (script, fun, traditional)	
Print options (lay-flat, specialty paper)	
Book-cover features (photo window, full-bleed image, text on spine)	
Quantity to print	
Family history design features (pedigree chart, family tree, record images)	

SERVICE	
POSSIBLE WEBSITES	**DESIGN AND COST**
1.	
2.	
3.	

AUDIENCE	
Details about your audience	

PHOTO-BOOK PROJECT BOARD

STORYBOARD LAYOUT: IMAGES AND DESIGN IDEAS

Spine			
Front Cover and Page 1			
Pages 2–3			
Pages 4–5			
Pages 6–7			
Pages 8–9			
Pages 10–11			
Pages 12–13			

PHOTO-BOOK PROJECT BOARD

STORYBOARD LAYOUT: IMAGES AND DESIGN IDEAS			
Pages 14–15			_____ _____ _____ _____
Pages 16–17			_____ _____ _____ _____
Pages 18–19			_____ _____ _____ _____
Page 20 and Back Cover			_____ _____ _____ _____

Photo-Book Tips

✖ As you evaluate online photo-book services, consider your ideas from the Snapshot section. Consider the design/theme styles, book styles, and number of pages allowed.

✖ Keep in mind your audience's age, gender, interests, personality, and any known likes and dislikes. This will help you choose the appropriate design, photos, and text for your book.

✖ Before you begin your project, save JPG copies of the images in a folder on your computer desktop for easy access and uploading.

SAMPLE PHOTO-BOOK PROJECT BOARD	
SNAPSHOT	
Photo-book theme/working title	*Sisters*
Orientation/style (landscape, portrait, square)	*landscape*
Size	*8.5x11 inches*
Tone (classic, lively, modern)	*classic with modern twist*
Colors	*color images, black/white text*
Photo style (framed, full-bleed)	*framed; full-bleed background images*
Fonts (script, fun, traditional)	*serif for old fonts, sans serif for new photos*
Print options (lay-flat, specialty paper)	*lay-flat*
Book-cover features (photo window, full-bleed image, text on spine)	*montage of all sisters, text on spine*
Quantity to print	*6*
Family history design features (pedigree chart, family tree, record images)	*pedigree chart*

SERVICES	
POSSIBLE WEBSITES	**DESIGN AND COST**
1. *Shutterfly.com*	*good design themes for this project; family tree chart*
2. *Snapfish.com*	*can mix themes; photos already on Snapfish*
3. *Mixbook.com*	*nice themes; great family tree*

AUDIENCE	
Details about your audience	*nieces and daughters (ages 22–32)*

SAMPLE PHOTO-BOOK PROJECT BOARD

STORYBOARD LAYOUT: IMAGES AND DESIGN IDEAS

Spine			*book title*
Front Cover and Page 1			*cover: collage photo of sisters* *page 1: Title page, author, date*
Pages 2–3			*intro with text and photo of oldest sisters*
Pages 4–5			*youngest sisters*
Pages 6–7			*girls with their moms*
Pages 8–9			*nieces with their sisters*
Pages 10–11			*nieces with their mom*
Pages 12–13			*me and Sis*

SAMPLE PHOTO-BOOK PROJECT BOARD

STORYBOARD LAYOUT: IMAGES AND DESIGN IDEAS

Pages 14–15			*Mom and Aunt Frances*
Pages 16–17			*Grandma and Great-aunt Mercy*
Pages 18–19			*Great-grandmother Minnie with sister Maud*
Page 20–21			*Great-great-grandmother Mercy with sisters*
Pages 22–23			*pedigree chart showing all generations*
Page 24 and Back Cover			*page 24: thanks and dedication back cover: photo of oldest sisters (great-grandma, Minnie & Maud)*

Also think about the overall design style: modern, traditional, or playful. Consider how you will feature your images and whether or not it's important to use full-bleed or two-page spread photos. Note any essential print features, including lay-flat pages, printing on the spine, cover windows, dust jackets or leather covers, and slipcases. Your notes will help you compare book services to find the best fit for your project.

SERVICES: You may have a favorite photo-project website, but I encourage you to explore other sites for unique features and inspiration to find one you like for photo-book projects. Make notes on your Photo-Book Project Board to compare design options, printing options, prices, and shipping times. Ask yourself these questions as you evaluate your options:

* What's the minimum and maximum number of pages?
* Can I create the cover style I want?
* Does this service offer text on the spine?
* Can I choose lay-flat pages, if desired?
* Do built-in design styles complement my own book theme?
* Can I include full-bleed images?
* Can photos extend across two pages?
* Can I add and delete background images, clip art, or embellishments?
* Is the design software intuitive and easy to use?

AUDIENCE: Every photo book has an intended audience—even if the audience is only you. It's more likely, however, that you're creating a family photo book to share vacation memories, birthday celebrations, or family history with others. We've come a long way from family slideshows that left everyone yawning in the dark after the fourth carousel of color images flashed on the screen. Today's custom photo books make it easy to target audiences of any age or interest level.

To identify your audience, ask these questions:

* What is their age?
* Where do they live? Where have they lived in the past?
* What activities does your audience enjoy doing?
* What makes them smile or laugh?
* Do they share funny stories?
* Will any topics make them uncomfortable or sad?

To create a book that your audience wants to read, consider which stories and photos would interest them most. Include the photos you feel are important to share. And use the proper tone (perhaps humorous or conversational) to help your reader connect to the people and stories you share in the book.

LAYOUT: In the Storyboard Layout section of the Photo-Book Project Board, sketch individual page layouts and make a list of the photos you'll need for each spread. Think about viewing your book as two-page spreads instead of individual pages. You'll have more layout space and

story options when working with two facing pages, including extended pedigree charts and large photos that run across both pages. Also, remember that odd-numbered pages are always on the right side and even-numbered pages are on the left. Always include a title page with your photo book's title, your name, and the publication date.

❋ **TIP** ❋

Don't Go Font Wild

Many family history books include generous amounts of text and photo captions. Select no more than three fonts to use throughout your book: one large font for headlines, one font for text and captions, and one for accents.

Tips for Selecting and Preparing Photo-Book Images

Photo books are great projects if you have a digital photo collection you'd like to showcase: snapshots from your last vacation, scanned images from an heirloom photo collection, or smartphone photos taken at a birthday party. Before you begin, take a deep breath, pull out your Photo-Book Project Board, and start looking through your photos for images that tell the story you want to share. Consider these tips as you select photos to include.

- �֍ Look for photos that are well-composed, well-exposed, focused, and have good contrast.
- ✖ If you absolutely must include a poor image because it's the only photo of a specific person, work around the photo's limitations by using the image in the best size for the photo. Don't force a small, low-resolution photo into a large image layout. You'll be disappointed with the result.
- ✖ Create a folder on your computer desktop to hold JPG versions of photos for your project. This is not a permanent archive. You can move this to a folder for Past Projects when you're finished.
- ✖ Examine each photo closely in your photo-editing software. The best photo-book images will have a high enough resolution that they can be placed in a book of any size. Choose images with a minimum 300 dpi resolution if you can. If you have lower resolution photos you want to use, consider using them in multi-photo layouts or as a design element rather than a feature photo.
- ✖ Select photos that tell a story, show a person's personality, spark a memory, or evoke a strong emotional response.
- ✖ Be aware that most online photo services accept JPG files only.
- ✖ Edit images as much or as little as you like. In most cases, simply adjust the color and repair damage in your photo-editing software before uploading to your photo-book project.
- ✖ Photo-book services can correct red-eye, crop, and auto-adjust an image, but they can't erase water spots or repair torn edges. Do advanced editing with photo-editing software before uploading the image to a photo service.
- ✖ Save cropping for later. Many times it is better to crop after placing the photo in the page template so you can adjust it to fit a curved or decorative frame. If you crop too tightly in

your photo-editing software before placing the image in your project, your subject may lose his head or feet to the frame.

� Sort photos based on the order you would like them to appear in your photo book. This can save considerable time when you're ready to create your photo book. Most sites offer an autofill option that automatically populates pages with your photos. You can make adjustments and rearrange photos to finalize the design. If you use photo-management software such as iPhoto, Picasa, or Adobe Lightroom, you can make an album or collection to hold the images you want to use for a specific photo-book project. Use the Batch Edit function in your software to create a new copy of each image in the recommended JPG format and rename the files sequentially for easy importing to your photo book. After you create an album or collection, export it to your computer desktop at the original size and image quality.

Photo-Book Terms to Know

✘ **cover stamping:** photo-book option for adding text imprinted on a book cover

✘ **die-cut cover:** a book cover that features a cutout window to showcase the photo on the first page; the cover itself can be softcover, hardcover, fabric, leather, or other specialty material

✘ **dust jacket:** a paper cover with flaps that wraps around and protects the cover of your book

✘ **endpapers:** paper covering the inside of the front and back covers of a book

✘ **flush-mount book:** a premium lay-flat book typically has each page printed on high-quality photo paper mounted to an inner core, making the finished page thicker and stiffer than an average book page

✘ **gutter:** the inner edge of a book page where the pages meet at the binding; if you like to use two-page spreads, be aware that portions of your image (or text) can get lost in the gutter

✘ **hardcover:** this cover is produced as a hard cover with a smudge-resistant finish

✘ **image wrap cover:** this feature allows a photo to literally wrap around the entire cover over the front, spine, and back of your book or dust jacket

✘ **lay-flat book:** pages lay flat without a center seam; often features premium paper

✘ **memorabilia envelope:** a special envelope affixed to the inside cover of a photo book for your ticket stubs, cards, and other keepsakes

✘ **padded cover:** a book cover with a layer of padding added between the printed cover and the inner board to create a soft-cushioned cover

✘ **page count:** the number of pages in your book; most photo books require a minimum of twenty pages with options to add pages for an extra per-page cost

✘ **slipcase:** a protective box with one open side that protects the pages of your book from dust and light

- ✼ **softcover:** the cover is printed on thick paper or cardstock (like a paperback book), often with a matte or shiny finish
- ✼ **two-page spread:** refers to extending an image across the binding/gutter to cover all or part of two pages

STEP-BY-STEP PROJECT

CUSTOM PHOTO BOOK WITH SNAPFISH

Time	3 to 6 hours (depending on your photo-book-making experience)
You will need ...	15 photos or more
Good for ...	holiday and birthday gifts, as well as family reunions
Design ideas	focus on brothers and sisters, cousins, or multiple generations

Sisters : A Family Tradition

Project Overview

Some family trees are well-balanced with fairly equal numbers of men and women listed along the twigs and branches; others lean more heavily toward a single gender. In my own family, I come from a long line of sister siblings without any brothers. Although my family is now filled with sons and grandsons, my sister has continued the female tradition with four daughters and three granddaughters (plus one adorable grandson). This photo-book project celebrates our female family heritage with photos and stories about the sisters in our family tree.

Follow along with this project, beginning with the sample Photo-Book Project Board earlier in this chapter.

Instructions

Use the Photo-Book Project Board to organize your ideas and plan your project. Select photos and place JPG copies of your images in a folder on your computer desktop.

STEP 1: SELECT A BOOK DESIGN. Sign in to Snapfish **<www.snapfish.com>** and select Photo Books and the size and style desired. For this project, I'm trying out the new Lay-flat Book. Notice that the toolbar across the top of the page has options for Photos, Book, Theme, Personalize, and Review. Work from left to right, beginning with Photos.

✼ TIP ✼

Mixing Page Themes

To mix theme pages in a Snapfish photo-book project, drag and drop the individual theme page from the Theme tray to your page spread.

STEP 2: UPLOAD PHOTOS. Click the Upload Photos button to open the Upload window. Enter a name for the album to hold your photo-book pictures. Choose the recommended Fast upload speed and click the Select Photos button. Navigate to the folder you created earlier containing your project photos and select photos to upload. Click Done.

❋ **TIP** ❋

Rearrange Images

To quickly rearrange photos in a multi-photo layout, click the Shuffle icon in the page tab.

STEP 3: CREATE COVERS. Place photos in the cover layout by dragging them from the left photo tab to the page spread.

STEP 4: ADJUST AND EDIT YOUR COVER PHOTOS. Click the Hand icon in the center of the photo to open the mini editing toolbar; for more editing options, click the Edit icon to access tools for red-eye correction, photo effects, and zoom. I applied the black-and-white effect to each color photo and zoomed to crop excess background.

STEP 5: ADD A TITLE AND SPINE TEXT TO COVER. Click in the Title text box and type your book title. Select font, size, and color. Click in the Spine text box and type your title again; select the same font and color. The size will need be smaller to fit on a narrow spine.

STEP 6: DESIGN THE TITLE PAGE. Click the right arrow button to move to the first page spread. Select Page Layouts in the left-hand tools panel and drag a text-only page to the spread. Click the Add Text box and type the book name, your name, and the year. Adjust the font style, size, and color as desired.

STEP 7: ADD PHOTOS AND TEXT TO PAGE SPREADS. Click the right arrow to move to the next page spread for pages 2 and 3. Drag a photo from the left Photos tab to the layout. To adjust effects, cropping, and size, click twice on the photo to open the Edit window. Click once in the text box to add text.

STEP 8: CUSTOMIZE PAGE LAYOUTS. Customize each page by clicking the design tabs on the left: Page Layouts, Themes, and Embellishments. Alternately, customize by clicking the design icons in the page tab: Shuffle, Gallery, and Text. Drag and drop selections to your page spread.

STEP 9: ADD TEXT BOXES AND ADJUST SIZE. Add a text box to any page by clicking the Text icon in the Page tab. Drag the corner handles to adjust the size and position of the text box.

STEP 10: VIEW PAGE SPREADS AND THE COMPLETE BOOK. Click the page view icons to view all spreads. Continue adding page spreads, photos, and text until you complete all pages.

STEP 11: REVIEW AND ORDER. Click the Review button on the toolbar to open a flipbook preview of your book. Carefully proofread each page. Print a draft and order prints if desired. Place your order.

STEP 12: SHARE. Click the Share button to e-mail a link of your new book to family and friends, or click the tab to share your project on Facebook.

1

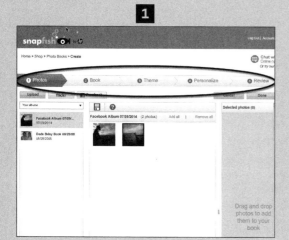

2

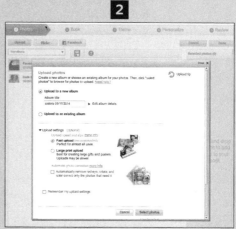

3

4

5

6

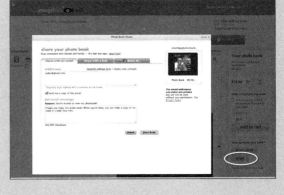

STEP-BY-STEP PROJECT
AUTO-FILL BIRTHDAY BOOK WITH MIXBOOK

Time	3 hours (depending on your photo-book-making experience)
You will need ...	20 photos or more
Good for ...	souvenir of a celebration, event, or vacation
Design ideas	choose a relevant theme, organize photos with consecutive numbers for easy autofill uploading

Project Overview

Creating a photo book doesn't have to be a huge chore. I used a designer template at Mixbook **<www.mixbook.com>** to assemble this fast little birthday souvenir in a few hours using the Auto Fill feature. It took as long to upload all my images as it did to place the photos and finalize the design. The hardest part was finding my credit card to order the book.

Instructions

Mixbook's Auto Fill option will import images to the book layout using the file-name order. Use photo-editing software to organize photos in a collection in the order you want them to appear in the book. (Note: Some photo-editing programs use Albums to organize a subset of photos.) In my photo-editing program Adobe Lightroom, I used Batch Renaming to give each file a new name and consecutive number. I saved a JPG copy of the files to a project folder on my desktop.

STEP 1: SELECT BOOK DESIGN. Log in to Mixbook; select a suitable book design. I chose Birthday Brights. Click the Create Now button to open the Design window.

STEP 2: IMPORT PHOTOS. Choose all photos to import.

STEP 3: PERSONALIZE COVER TEXT. Click on text blocks to change the name and resize to fit. To change the number 8 to 3, I clicked on the Stickers tab in the top left menu and replaced the 8 with the correct number.

STEP 4: PLACE COVER PHOTO. Drag and drop a photo to the cover. Click on the image to change cropping and enlarge.

STEP 5: AUTO FILL PHOTOS. To automatically place all photos in your book, click the Auto Fill button and wait for the magic. Fine-tune placement by moving around photos as desired.

STEP 6: PREVIEW AND ORDER. Preview your book, refine the photo placement, and add any text you'd like. When you're ready to order, click the Order button.

1

2

3

4

5

6

PROJECT IDEA
FAMILY YEARBOOK

Time	3 to 6 hours	
You will need ...	assorted family snapshots, team pictures, scanned images (memorabilia) from one year	
Good for ...	featuring any person, couple, family, or ancestors	
Design ideas	make it classic, trendy, serious, or fun—whatever you wish	

THE BEST
YEAR
— Ever —

2016

Project Overview

Families drowning in digital photos might want to take a practical step toward preserving the best of the best with an annual yearbook-style photo-book design. Instead of printing out individual snapshots and stuffing them into an album, pick only the best shots to showcase in an annual photo book modeled after a high school yearbook.

Tips and Techniques

�֍ Use the Photo-Book Project Board to plan an outline of the book, with attention to the colors and design you'd like to use. You can save time and skip ahead by using one of the professional family yearbook themes featured at popular photo-book websites.

✖ Every yearbook needs a title page with publication date and place.

✖ Organize your photos chronologically, beginning in January.

✖ Break up the months with page spreads on the season's sports, activities, or celebrations.

✖ Include all family members.

✖ Remember to give space to the family pets. It's fun to add vital statistics such as weight and height, too.

✖ Scan or snap photos of tickets, programs, birthday gifts, schoolwork, and other memorabilia you'd like to keep.

✖ Check out photo website yearbook designs for great ideas such as page spreads listing favorite foods, sayings, or people.

✖ Leave a page for everyone in the family to add his or her signature, handprint, or paw print.

PROJECT IDEA
HEIRLOOM REPRODUCTION BOOK

Time	less than 3 hours
You will need ...	scanned images of an heirloom book's pages
Good for ...	short personal books or collections of family correspondence
Design ideas	select a print book the same size and shape as the original

Project Overview

All too often, one-of-a-kind family heirlooms remain in the homes and hands of the owner and are difficult to share with other family members. If your ancestor left behind a journal, diary, or a bundle of correspondence, you don't have to be a biographer or a book designer to preserve and share it with others. You can create a digital reproduction of the heirloom so everyone in the family can own a personal copy of your family legacy.

This project creates an heirloom reproduction book you can make using an online publishing service and then share with your relatives at the next family gathering or reunion. Heirlooms that are good for this kind of project include small autograph books, travel diaries, recipe card collections, and small diaries. I've had success with reproduction editions of a 1940s home economics notebook, a wartime photo book, and a little autograph book. Aim to find a book that is twenty to thirty pages in length. View online versions of my projects at **<www.thefamilycurator. com/heirloom-books>**.

Tips and Techniques

- �֍ Measure your original book and choose an online photo-book or publishing service that offers a book size close to the original book or slightly larger.
- ✖ Scan the front and back covers and each page in order. Number each file name consecutively like this: *book-01, book-02, book-03*.
- ✖ Save master digital copies in TIFF format and upload JPG versions for your project.
- ✖ Use the Auto Fill feature to quickly place your digital images in your project.
- ✖ Add a few pages with explanatory information about the author and book creation at the end of the book. Include your contact information as the owner of the original copy.
- ✖ If your images don't completely fill the page, select a background that is similar in color and texture to the original and apply to the book.

- Create and share your book on Shutterfly **<www.shutterfly.com>** or Snapfish **<www.snapfish.com>** and let relatives order their own copies, or publish it with Blurb **<www.blurb.com>** or Lulu **<www.lulu.com>** to open sales to a wider audience (make sure you don't violate copyright laws if you plan to sell it).
- A lengthy book may be costly to print. Consider sharing it as an online digital book on Scribd **<www.scribd.com>** or as an e-book publication.

PROJECT IDEA
PHOTO BOOK FOR BUSY PEOPLE

Time	less than 3 hours
You will need ...	20 to 40 photos
Good for ...	annual Facebook or Instagram yearbook
Design ideas	compile a book of photos from your social media account or a vacation book

Project Overview

Don't put off sharing your photos with family and friends. A simple auto-generated photo book is better than photos locked in your computer where no one can enjoy them. Use these time-saving tricks to get your photos out of digital storage and into the hands of the people you love.

Tips and Techniques

- Create a folder on your computer desktop and start collecting images for your next photo-book project today.
- Surf the photo-book websites for ideas and inspiration. Save time later by opening accounts and subscribing to newsletters for special deals and coupons.
- All book services allow you to create and save your projects. Take advantage of a free weekend to start a book and then go back and finish it when you have more photos and more time.
- Browse Pinterest **<www.pinterest.com>** and Etsy **<www.etsy.com>** for design trends and layout theme ideas. Start a Pinterest board to save your favorites and follow my Easy Photo Book boards at **<www.pinterest.com/familycurator>** for more tips and inspiration.

PROJECT IDEA
GRANDPARENT AND GRANDCHILD MEMORY BOOK

Time	3 to 6 hours
You will need ...	assorted snapshots from your childhood or your grandchild's life
Good for ...	gifts for grandparents or aunts/uncles
Design ideas	use bright colors, clip art, and fun fonts

I Remember When

Project Overview

This project blends a grandparent journal with a photo album to create a one-of-a-kind book that any grandparent and grandchild will cherish. The book includes places for handwriting and lots of doodles to capture special times with photos and handwritten captions, like our grandparents did with old-fashioned photo albums.

Tips and Techniques

- ✖ Use the Photo-Book Project Board to plan page spreads and topics you want to include.
- ✖ Create the book with your grandchild.
- ✖ Choose a simple book design. For the best effect, use a white or light-colored background.
- ✖ Create a title page as Page 1 that includes your own title for the book, your name, your grandchild's name, and the date. Use a font point size of 12 or 14. Leave room under each name for your signatures.
- ✖ Forget about making a perfect book with computer-generated type and clip-art. Instead, encourage personal expression and fun with colored archival pens, real stickers, and playful photos.
- ✖ Use photos you already have on your computer to personalize the pages.
- ✖ Keep in touch with grandchildren living far away by adding a few captions and sending the book with an invitation to add more notes and drawings. Or make it a challenge: You can add notes for the first half of the book and send it along for your grandchild's contribution before adding the next set of captions.
- ✖ Consider using topics for a two-page spread (such as baby pictures, your first birthday, your parents, your pet, your favorite toy), and place a photo of the grandparent on the left page and a photo of the grandchild on the right page. Add appropriate text. For example, a spread with baby pictures might says "I was born ... "

PROJECT IDEA
REMEMBERING AND CELEBRATING BOOK

Time	3 to 6 hours
You will need ...	photos of family members; scanned news clippings, maps, and ephemera; photos of friends, homes, community
Good for ...	book of remembrance at memorial service; gift for family members; ancestor stories
Design ideas	choose a classic or traditional theme; pick a bold, colorful, and joyous Book of Life design

The Bama Years

Project Overview

Remembering is part of healing, and photos are a powerful aid in grieving the loss of someone we love. For the person who creates the book, the process of selecting photos and writing captions and stories can provide a place to celebrate and remember the loved one. For those who view the book, the photos help keep memories alive for a new generation.

A memorial book doesn't have to be somber and dry. Colorful pages and lively design can celebrate a person's life and convey his or her personality. Jokes and funny stories will make the book more appealing, and recipes or repair tips will instruct and entertain readers.

Tips and Techniques

* Use the Photo-Book Project Board to plan an outline of the book. Arrange photos chronologically from birth forward or backward through the years.
* Include photos of major life events including: religious milestones (such as first communion or bar mitzvah), high school or college graduation, weddings, retirements, and more.
* Include photos of parents and grandparents, as well as baby and early-childhood photos. Also include photos of the person's interests or activities the person participated in such as employment, military service, volunteer work, community service, church membership, hobbies, and sports.
* Include a basic family tree outlining connections to surviving relatives.
* Add quips and quotes from siblings and friends as captions for photos.
* Scan ephemera such as ticket stubs from a favorite event.
* Create photo collage pages to include multiple images on the same topic such as siblings, wedding, or birthdays.
* Decide if you want to include memorial tributes such as a scanned images of the newspaper obituary, funeral service program, or funeral guest book or a photo of the cemetery.

Appendix

Photo Organizing and Digitizing Resources

WEBSITES

* American Institute for Conservation of Historic and Artistic Works
 <www.conservation-us.org>
* The Family Curator
 <www.thefamilycurator.com>
* *Family Tree Magazine*
 <www.familytreemagazine.com>

BOOKS

* *Evidence Explained: Citing History Sources From Artifacts to Cyberspace,* 2nd Edition, by Elizabeth Shown Mills (Genealogical Publishing Company)
* *How to Archive Family Keepsakes* by Denise May Levenick (Family Tree Books)
* *Organize Your Digital Life* by Aimee Baldridge (National Geographic)
* *Preserving Your Family Photographs* by Maureen A. Taylor (Picture Perfect Press)

* *Thousands of Images, Now What? Painlessly Organize, Save, and Back Up Your Digital Photos* by Mike Hagen (Wiley)

ARCHIVAL SUPPLIERS

* Aaron Brothers
 <www.aaronbrothers.com>
* Archival Methods
 <www.archivalmethods.com>
* Brodart <www.shopbrodart.com>
* Gaylord Archival <www.gaylord.com>
* Hollinger Metal Edge
 <www.hollingermetaledge.com>

EQUIPMENT AND SERVICES

Digital Camera Accessories

* Camera Image Sensor

�֎ Eyefi Mobi SD card **<www.eyefi.com>**

✖ Joby GorillaPod (tripod)
 <www.joby.com>

Document Cameras

✖ HoverCam Solo 8 **<thehovercam.com>**

Mobile Scanners

✖ Flip-Pal **<www.flip-pal.com>**

✖ IRIScan (cordless mobile scanners)
 <www.irislink.com>

✖ IRIScan Mouse **<www.irislink.com>**

✖ LG Mouse Scanner **<www.lg.com>**

✖ Magic InstaScan Mouse
 <www.vupointsolutions.com>

✖ Magic Wand portable scanner with Wi-Fi
 <www.vupointsolutions.com>

✖ Visioneer RoadWarrior
 <www.visioneer.com>

Desktop Scanning Software

✖ Hamrick VueScan **<www.hamrick.com>**

✖ SilverFast Archive Suite by LaserSoft
 <www.silverfast.com>

Scanner Reviews

✖ CNET **<www.cnet.com>**

✖ Imaging Resource
 <www.imaging-resource.com>

✖ *PC Magazine* **<www.pcmag.com>**

All-in-One and Flatbed Scanners

✖ Brother **<www.brother.com>**

✖ Canon **<www.canon.com>**

✖ Epson **<www.epson.com>**

✖ Hewlett-Packard **<www.hp.com>**

Online Backup Services

✖ Backblaze **<www.backblaze.com>**

✖ Carbonite **<www.carbonite.com>**

✖ CrashPlan **<www.crashplan.com>**

✖ Mozy **<www.mozy.com>**

Online Photo Storage

✖ Amazon Cloud Drive
 <www.amazon.com/clouddrive>

✖ Apple iCloud **<www.apple.com/icloud>**

✖ Dropbox **<www.dropbox.com>**

✖ Google Drive **<www.drive.google.com>**

✖ Microsoft OneDrive **<onedrive.live.com>**

✖ ThisLife **<www.thislife.com>**

Photo-Editing and Project Apps

✖ KeepShot (Android, iOS)
 <www.keepshot.com>

✖ Kodak Moments for iPad (iOS)

✖ Moldiv Collage Photo Editor (Android, iOS)

✖ Mosaic Book (Android, iOS)
 <www.heymosaic.com>

✖ Photogene (iOS)
 <www.mobile-pond.com>

✖ Shutterfly Photo Story for iPad (iOS)
 <www.shutterfly.com>

✖ Snapseed (Android, iOS)

❋ TIP ❋

How to Get Mobile Apps

Unless otherwise noted, go to to the Google Play Store **<play.google.com>** to download Android apps and the iTunes App Store **<itunes.apple.com>** to download iOS apps.

✻ TIP ✻

Get Downloads From This Book

To download typable, printable PDFs of the project boards for your own use, go to **<ftu.familytreemagazine.com/how-to-archive-family-photos>**. View photo projects in full color, and find additional ideas and inspiration at **<www.thefamilycurator.com/archive-photos>**.

Scanning Mobile Apps

✖ CamScanner (Android, iOS)
 <www.camscanner.com>
✖ DocScan (iOS)
 <ifunplay.com/docscanapp.html>
✖ Genius Scan (Android, iOS, Windows Phone) **<www.thegrizzlylabs.com>**
✖ Handy Scanner (Android)
 <www.halfmobile.net>
✖ Prizmo (Mac, iOS)
 <www.creaceed.com/prizmo>
✖ Scanner Pro (iOS) **<readdle.com>**
✖ TurboScan (Android, iOS)
 <turboscanapp.com>

Photo-Book Publishing Services

✖ AdoramaPix **<www.adoramapix.com>**
✖ Blurb **<www.blurb.com>**
✖ Lulu **<www.lulu.com>**
✖ Mixbook **<www.mixbook.com>**
✖ Montage **<www.montagebook.com>**
✖ MyPublisher **<www.mypublisher.com>**
✖ Shutterfly **<www.shutterfly.com>**
✖ Snapfish **<www.snapfish.com>**

Photo-Management Software

✖ Adobe Lightroom
 <lightroom.adobe.com>

✖ Adobe Photoshop Elements
 <www.adobe.com>
✖ Apple iCloud Photo Library
 <www.apple.com/icloud/photos>
✖ Picasa **<picasa.google.com>**

Photo-Sharing Services

✖ Eyefi Cloud **<www.eyefi.com>**
✖ Facebook **<www.facebook.com>**
✖ Flickr **<www.flickr.com>**
✖ Google+ Photos
 <plus.google.com/photos>
✖ Instagram **<www.instagram.com>**
✖ Photobucket **<www.photobucket.com>**
✖ Pinterest **<www.pinterest.com>**
✖ SmugMug **<www.smugmug.com>**

Photo Products

✖ AdoramaPix **<www.adoramapix.com>**
✖ Cafe Press **<www.cafepress.com>**
✖ MyPhotoPipe **<www.myphotopipe.com>**
✖ Shutterfly **<www.shutterfly.com>**
✖ Snapfish **<www.snapfish.com>**
✖ Spoonflower **<www.spoonflower.com>**
✖ Vistaprint **<www.vistaprint.com>**
✖ Zazzle **<www.zazzle.com>**

Index

ACKNOWLEDGMENTS

I appreciate the efforts of many people who helped bring this book's three-year journey from idea to ink.

My daughters-in-law provided the spark for a book about archiving digital photos. After the publication of my first book, *How to Archive Family Keepsakes*, both young mothers said that they didn't have many family keepsakes (yet!), but they would love some tips for managing their growing digital photo collections. I hope this helps.

Mr. Curator, as always, worked an extra shift at home so I had more time for this project, and built multiple custom copy stands at a moment's notice.

My sister Deanna Craig acted as my creative project coordinator, suggesting and testing photo apps and projects. Terry Jaurequi worked through more projects, offering lunch and helpful feedback. And many friends and family members kindly allowed me to share their photos and faces throughout this book. Thank you.

I especially enjoyed the opportunity to work again with Allison Dolan, publisher, and Diane Haddad, editor, at F+W. And my thanks to editor Dana McCullough, who contributed creative family history photo ideas as well as editorial expertise.

And my heartfelt appreciation to readers and friends of The Family Curator blog who share a passion for preserving the past. Thank you. If our "eyes are the windows to the soul," surely photographs are the heartbeat of memories.

CREDITS

With thanks to

- �471 PicMonkey for use of images in Chapters 12 and 15.
- �471 Shutterfly and ThisLife by Shutterfly for use of images in Chapters 4, 12, and 14. All ThisLife Materials ©2014 Shutterfly, Inc. Reproduced by permission of Shutterfly, Inc.

Additional thanks to Adobe Lightroom, AdoramaPix, Dropbox, Epson Scanner, Flickr, Google+, Mixbook, Moldiv, Snapfish, Snapseed, Spoonflower, Treelines, and TurboScan.

ABOUT THE AUTHOR

Denise May Levenick inherited her family's photo collection in 2000, but was taking pictures with her grandmother's Brownie Hawkeye long before. She shares tips and techniques for preserving and organizing family photographs and heirlooms in her first book, *How to Archive Family Keepsakes* (Family Tree Books, 2012), at her award-winning blog The Family Curator **<www.thefamilycurator.com>**, and in many

articles for *Family Tree Magazine* and other publications.

Denise is a frequent speaker at genealogy conferences, seminars, and webinars. She is a native Southern Californian and enjoys traveling in pursuit of her Midwest and New England family roots. Denise studied journalism and literature at Pepperdine University and the University of California, Santa Barbara, and holds a master's degree in English literature from Claremont Graduate University. She has worked as a newspaper reporter, publications editor, freelance writer, and junior high and high school English teacher. Visit her at **<www.thefamilycurator.com>**.

DEDICATION

To my memory-making family: Dan, Zack, and Christian

Published by Family Tree Books, an imprint of F+W Media, Inc.,

10151 Carver Road, Suite 200, Blue Ash, Ohio 45242. (800) 289-0963. First edition.

ISBN: 978-1-4403–4096-3

Other Family Tree Books are available from your local bookstore and online suppliers. For more genealogy resources, visit **<shopfamilytree.com>**.

19 18 17 16 15 5 4 3 2 1

DISTRIBUTED IN CANADA BY FRASER DIRECT

100 Armstrong Avenue

Georgetown, Ontario, Canada L7G 5S4

Tel: (905) 877-4411

DISTRIBUTED IN THE U.K. AND EUROPE BY F&W MEDIA INTERNATIONAL, LTD

Brunel House, Forde Close,

Newton Abbot, TQ12 4PU, UK

Tel: (44) 1626 323200,

Fax: (44) 1626 323319

E-mail: enquiries@fwmedia.com

DISTRIBUTED IN AUSTRALIA BY CAPRICORN LINK

P.O. Box 704, S. Windsor, NSW 2756 Australia

Tel: (+02) 4560-1600

Fax: (+02) 4577-5288

E-mail: books@capricornlink.com.au

a content + ecommerce company

PUBLISHER AND COMMUNITY LEADER: Allison Dolan
EDITOR: Dana McCollough
DESIGNER: Julie Barnett
PRODUCTION COORDINATOR: Debbie Thomas

4 FREE
Family Tree Templates

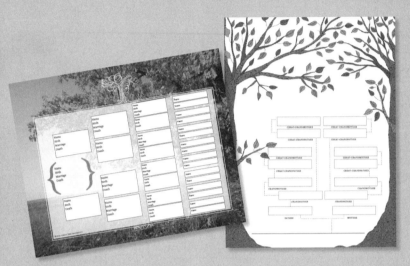

- decorative family tree posters
- five-generation ancestor chart
- family group sheet
- bonus relationship chart
- type and save, or print and fill out

Download at <ftu.familytreemagazine.com/free-family-tree-templates>

More Great Genealogy Resources

HOW TO ARCHIVE FAMILY KEEPSAKES

By Denise May Levenick

FAMILY PHOTO DETECTIVE

By Maureen A. Taylor

FAMILY TREE HISTORICAL MAPS BOOK

By Allison Dolan and the Editors of Family Tree Magazine

 Join our community! <facebook.com/familytreemagazine>